W9-AQS-818

101 PRINTS

101
PRINTS

THE HISTORY
AND TECHNIQUES
OF PRINTMAKING

BY NORMAN R. EPPINK

NORMAN : UNIVERSITY OF OKLAHOMA PRESS

The author wishes to thank the following publishers for the use of copyrighted material, specifically: The Oxford University Press for permission to use a madrigal from *The Oxford Book of English Verse*; The Print Council of America for permission to quote from a pamphlet entitled *Prints*; the Focal Press for permission to quote from *The Focal Encyclopedia of Photography*; and for the use of a quotation from *America and Alfred Stieglitz: A Collective Portrait*, copyright 1934 by Doubleday and Company, Inc., reprinted by permission of the publisher.

International Standard Book Number: 0–8061–0915–7

Library of Congress Catalog Card Number: 78–108806

TO HELEN

ACKNOWLEDGMENTS

In the preparation of this text and the prints accompanying it I am more than grateful to the many writers who furnished both information and inspiration; their books are listed in the bibliography.

Thanks are also due the publishers who granted permission to use their copyrighted material; these sources are listed on the copyright page.

I am indebted to many individuals for aid and advice, in particular to Dr. Harold M. Priest of the University of Denver, who served as editor of the manuscript, and to Kathleen Gallatin, who did the typing and also assisted in the preparation of the index.

James Fromme, Gary Mason, and David Stormont were most helpful during the preparation of the section on photography. My appreciation also goes to Carl Hoffmans for valuable co-operation during the production of the printed text and to the able Jake Wilson who did the preliminary typesetting.

I should also like to record the courtesies extended to me in the early stages of research by Elizabeth Roth, first assistant, and Wilson G. Duprey, both of the Prints Division of the New York Public Library. Without the generous and considerate attitude of the personnel of the Kansas State Teachers College of Emporia, including my colleagues in the Art Department, this project would never have been completed. In particular, the sabbatical leave which launched this endeavor, granted through Dr. John E. King, is deeply appreciated. Last, but not least, I am most appreciative of the help and encouragement given by Helen Eppink, who has so ably assisted as critic and adviser in all phases of this work.

CONTENTS

The number preceding the print process may be used to locate the print as well as the description of that process in the text.

INTAGLIO PROCESSES

INTAGLIO, MIXED MEDIA PROCESSES

x

PLANOGRAPHIC PROCESSES

STENCIL PROCESSES

PHOTOGRAPHIC PROCESSES

MISCELLANEOUS PROCESSES

CHILDREN'S PROCESSES

101 PRINTS

INTRODUCTION

The making of prints has been an activity of man in the Western world since a little before the invention of printing by movable type in the middle of the fifteenth century. However, if printmaking in the Orient, including stone rubbings, is taken into account, the beginning date will have to be pushed back to 175 A.D.

Prints of one kind or another have been the popular art form of the masses, mainly because they could be produced in quantity, they were relatively inexpensive, and their visual imagery was powerful. Communication, even with the illiterate, was possible through these media; for those who could read, the prints found in their books, periodicals, and papers helped in illuminating the written word. In home decoration these simple forms were made to serve the same desires that the wealthier classes satisfied with paintings, tapestries, and sculpture.

The development, during the nineteenth century, of photomechanical methods and their employment in the production of prints resulted in a swamping of the market with tawdry reproductions catering to the lowest possible taste levels. This debasement of graphic art persisted well into the 1920's. At this point, creative printmaking in America had only one direction in which it could move, and that was upward. A number of forces undoubtedly have had much to do, singly and collectively, with the pre-eminent state that graphic products now hold in our culture. Of the many factors responsible for this status, some have had greater influence than others. Perhaps the most significant was the emergence in the thirties of a more progressive art program in the public schools. During this same period many artists, through their association with Work Projects Administration groups, had their first contact with professional printmaking. The enthusiasm for collecting antiques prior to World War II introduced a large public to such items as Currier and Ives and Audubon prints. Since the war, the inclusion of creative art programs in almost every college and university, many with strong programs in the graphic arts, has further disseminated infor-

3

mation about prints and also helped to raise the standards. These forces have led to a slow but steady increase in print production and renewed interest in original prints. The experimental nature of printmaking that has emerged is comparable in many ways to the experiments in science and the exploratory work in painting. It is possible that future art historians will credit Hayter and Lasansky as being the chief instigators of this breakthrough in the forties.

In 1937, with the publication of Carl Zigrosser's *Six Centuries of Prints*, print classification fell into a number of well-established categories and families fairly easy to recognize. In 1941, as a direct result of that book, a class of college students in a graphic arts course under my direction produced a book called *Prints and Printmaking* in which twenty-four separate print techniques were demonstrated and explained.

For some time thereafter I experienced a growing conviction that a complete survey on the same lines as that student project could be a valuable guide to anyone studying prints and printing techniques. There are many books on printmaking, and most of them are amply illustrated with halftone reproductions; but, valuable as these may be, they are a far cry from holding an original in one's hand and reading the explanation of how it was produced. Many museums and galleries have excellent collections of prints, but there was no single source to which one could turn to find explanations of all the processes and technical variations and which also included original prints to illustrate the methods under discussion. An attempt was made to fill this gap with a book called *Graphic Processes* published by C. E. Goodspeed and Company in 1926. This volume offered a small sampling of original prints along with examples produced by various commercial processes. The prints, some serving as illustrations for other volumes, were tipped into the book, which included descriptive notes by L. A. Holman. The present work has been developed for the purpose of providing the most comprehensive study possible—short of an encyclopedia—of the entire field of printmaking. The question of whether or not this is an undertaking for a single artist is one which is futile to debate. The answer must come from an examination of the work itself.

At the outset it will be well if we discuss certain basic terms and present some of the commoner interpretations of those terms. The basic method of making prints can be described rather simply. A material, commonly wood, metal, or stone, on which the artist places the image,

that is, a design or picture, either by drawing or cutting, is referred to as the block or plate. Some sort of color or ink is applied by hand or roller to the design on this block. When it is pressed or imprinted on a flat, fairly smooth surface of some material, usually paper, the ink is deposited on that surface, reproducing the image on the paper and thus producing an original print. The plate or block is inked again for each additional print. In repeating the process, that is, in making a series of originals or an edition of prints, a press ordinarily is used to do the imprinting. The artist has at his disposal many techniques for creating the image, and the way he prepares the block in most cases provides the term by which the print is identified. Because many of these blocks are printed in a similar manner, it is customary to group prints according to the method by which they have been printed, the three basic methods being referred to as the relief printing process, the intaglio printing process, and the planographic printing process.

Among the various definitions of the term *print*, one of the most widely accepted is to be found in a little pamphlet issued by the Print Council of America, edited by J. B. Cahn in 1961.

> An original print is a work of graphic art, the general requirements of which are: 1. The artist alone has made the image in or upon the plate, stone, woodblock or other material for the purpose of creating a work of graphic art. 2. The impression is made directly from that original picture by the artist or pursuant to his direction. 3. The finished print is approved by the artist.

Undoubtedly there will be artists who will object to some of the examples shown in this book on the grounds that they are not truly prints, according to their definition of the term. It is strange to note that even the acceptance today of photography as a fine art has its problems. However, as far back as 1937 Zigrosser states, "A photograph is as much of a 'print' as an etching or a lithograph."

Obviously a limit must be drawn in the present volume in terms of the number of combinations of established techniques that have been used to produce prints. Consequently, this collection includes only those processes which are to be found in one or another of the major exhibitions or collections. There is argument, incidentally, about the legitimacy of retouching or other manipulation of a print after it has been

pulled. Contemporary practices would indicate that if the work can be improved artistically, the method is justified. To illustrate, the following is from an account of the production of Lasansky's print, *My Wife and Thomas* (Virginia Myers in 1961), in which is explained the handwork involved in this complex print using many plates. The author writes: "If any lines where the plates are joined remain prominent, a shading stub is used to blend them in."

Five hundred years have seen many printmaking techniques rise in popularity only to drop from sight for long periods of time. Part of this rise and fall is attributable to changes in taste and part to the commercialization of many of these techniques through the use of photomechanical methods. In a society such as ours, change seems to be the order of the day, and the same forces which make our houses, our cars, and our clothes outmoded in a few years' time seem to have had a similar effect on the graphic arts. The 1938 American Institute of Graphic Arts Exhibition of Prints catalog contains this statement by A. Hyatt Mayor, assistant curator of the Print Department, Metropolitan Museum: "It was hard for us to winnow the fifty prints out of a heap of over half a thousand. A good half of the heap or more were lithographs, a medium that readily serves our modern taste for the direct and personal sketch and lends itself perfectly to large editions." In 1950, while serving as a juror on a national print show for which over one thousand prints were submitted, I observed that it was not lithographs but serigraphs that constituted 50 per cent of the entries. More recently, in a national exhibition of prints called "American Prints Today, 1962," sponsored by the Print Council of America, a select group of fifty-five items contained twenty-six intaglio prints.

A student of the present work will not only come to gain an understanding of the techniques involved in the making of the individual types of print, but he will be made more aware of the extreme versatility of this branch of art, and he should develop a sensitivity to some of the relationships of technique or medium to subject matter and mood. Though the main objective has been to bring within the confines of one book the major printmaking methods employed by artists, it is hoped that some degree of pleasure will be derived from the prints themselves. No attempt has been made to create new methods or processes. The techniques demonstrated are those which others have developed; the aim simply has been to bring them all together. If the work is to

6

fulfill its proper purpose, it should be freely available to everyone interested in art, including students and teachers. Students, for example, are encouraged to use this volume as an incentive in making their own contribution to what many believe is a renaissance in American printmaking.

The explanations of techniques used to produce the prints in this book are designed to be understood by the layman, as this is not a technical manual for the professional. With the explanations are the names of the originators of the techniques, when the data are sufficient to make such designation, and the names of some of the more noted artists who have worked in the various media. Besides an index, a bibliography covering the technical as well as the historical phases of printmaking is to be found at the end of this volume.

The first edition of this work was privately published by the author as a limited edition of fifteen sets, each set comprising two sections, the first containing explanatory material related to the prints and the second containing original examples of the prints. Fourteen of the original sets are now located in the following institutions:

The British Museum, London, England
The Chicago Art Institute
The City Art Museum, St. Louis, Missouri
The Cleveland Museum of Art
The Cleveland Public Library
The Denver University Library
The Houghton Library of Harvard University, Cambridge, Massachusetts
Kansas State Teachers College, Emporia, Kansas
The Lessing J. Rosenwald Collection, Alverthorpe Gallery, Jenkintown, Pennsylvania
The Library of Congress, Washington, D.C.
The Los Angeles County Museum of Art
The Metropolitan Museum of Art, New York, New York
The New York Public Library
The Topeka Public Library

The National Gallery of Art in Washington, D.C., has matted and framed two sets of prints with short explanatory labels. These prints have been on tour as part of the Gallery's circulating exhibit program.

The National Gallery is also the repository of all the plates and blocks used in producing the original prints along with three volumes of progressive proofs.

For an explanation of the efforts, means, problems, compromises, and experiences involved in reproducing this edition from one of the original fifteen sets, see the publisher's comment preceding the index.

RELIEF PROCESSES

In the relief printing process, the imprint comes from the top surface of the block. Those parts of the surface which are not to print are cut down so they will not be inked, thus leaving the image to be printed in relief.

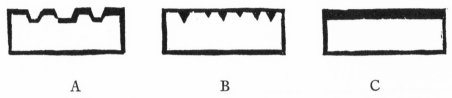

A B C

The heavy lines in the accompanying drawing (A) indicate ink on the top surface; spaces between are the nonprinting areas cut below the surface. This is the feature which distinguishes the relief method from the others, since in the intaglio process it is the image part of the plate which is cut below the surface and filled with ink (B), and in the lithographic process there is no cutting into the surface (C).

The simplest demonstration of relief processes is to be found in the use of the common rubber stamp. The name or date on the stamp has been reversed, and with the exception of the part to be printed, the material has been lowered so it will not receive ink when pressed against the surface of the inking pad. Once the stamp has been inked, it is pressed against a sheet of paper to print the image, date, or name.

In the hands of the artist, any material that can be cut, drilled, or gouged with a tool is suitable for a block, providing that it has a relatively flat surface to begin with. Wood and linoleum are the most popular materials. After the parts of the block that are not to be printed have been cut away, the surface is inked with dabber, brushes, or brayers. Inks can be of types known as oil or water based. The printing of the block on a sheet of paper, the ultimate goal, is carried out in a variety of ways. Usually the paper is first dampened moderately, then care-

fully placed on the inked surface of the block. Pressure, which is necessary for a clear print, may be applied by rubbing a spoon over the paper or by the use of a hand press or electrically powered press. When this is done, the paper is pulled free of the block, and the result is a relief print. The long-continued popularity of this particular method is due in part to the fact that the blocks used to produce the pictorial material can be printed at the same time as the text material which is set in metal type. When it is considered that prints have served until recent times primarily as illustrations for books, the economy of the above operations should be readily apparent.

The woodcut technique dates back many centuries, and the woodcuts produced have served many purposes. The earliest print that can be dated indicates that the technique originated in China in the ninth century A. D. According to the experts, the quality of work suggests that a long evolutionary period must have preceded this particular example, which is a figure of Buddha with a date of 868 A. D. The technique of cutting blocks and using them for production of patterns on textiles was well along in Europe by the twelfth century. However, after the introduction of paper into Europe, the woodcut impression on paper was developed, the earliest known example appearing toward the end of the fourteenth century. The first large-scale use of the woodcut printed on paper was for playing cards and individual pictures of saints sold to pilgrims at the various holy places they visited during their pilgrimages, expeditions which were common all through the Middle Ages. In the Netherlands and Germany during the fifteenth century, so-called block books appeared in which illustration and text were cut on a single block. Usually these did not amount to much more than pamphlet-sized picture books with a little running commentary. Extremely cheap and popular, they continued to be produced well into the sixteenth century, even though printing from movable type had been invented nearly a century before.

A point not too frequently understood is that the printmaking techniques which exist today as separate forms of art did not gain this status until quite recently. The striving to develop new print techniques and new methods of speeding up print production has for the most part been associated with the book arts. The need to furnish masses of people with pictorial material to illuminate the text of a book was only part of the problem. The basic need was to instruct illiterates through visual

imagery. There is considerable evidence to show that some prints were produced to serve purely aesthetic ends in earlier stages, but this must be regarded as a minor aspect until late in the nineteenth century.

The woodcut technique has not changed appreciably over the years, with one important exception. Back in the days when Dürer, Holbein, and the first great masters of the technique worked, the artist was simply a draftsman who made a pen-and-ink drawing on a block of wood. This was then turned over to a shop in which craftsmen, skilled in cutting wood, took over and cut the block, preparing it for printing. Today the artist is expected to perform these operations himself.

In creating a woodcut, the drawing is made in reverse on the plank surface (as distinct from end-grain surface used in wood engraving), and almost any kind of wood may be used. After the drawing is made in pencil or ink, all that remains to be done is to cut away the background to such a depth that the ink which is applied to the surface will only appear on the lines of the original drawing. All kinds of knives, gouges, and chisels may be used to cut away the background. As any schoolboy knows, it is easier to cut with the grain than across it. Consequently, this fact imposes some limitations upon the craftsman, although an inspection of the fifteenth- and sixteenth-century cuts leads one to believe that the old woodcutters were magicians with a knife. It is difficult to believe that some of these blocks were produced on the plank surface. There are prints from that period, however, which got around this basic difficulty by cutting two separate blocks, one producing the horizontal lines and the other the vertical lines. When the blocks were printed together, the resultant image produced thin lines going in the horizontal direction as well as thin lines in the vertical direction. With this method no particular trouble was experienced because the horizontal lines were running parallel with the grain of the wood, as were the vertical lines on the second block. Favored woods have been cherry, apple, and pear, since they can be prepared so that they have a very smooth surface. There is no limitation on the size of the block other than the skill of the artist. Examples one inch square have been used as initial letters, and today blocks measuring five by six feet are being produced by some of our graphic artists.

Blocks can be inked with a dabber or, more commonly today, with a brayer. Water-based inks are sometimes used, but the majority of woodcuts are printed with an oil-based ink. Printing of large blocks is

accomplished by rubbing, usually with a large spoon. Smaller prints are usually run on either a hand- or power-operated press. When properly cut, the blocks yield many thousands of impressions. For this reason, plus the fact that they could be printed with type and were inexpensive, prints from woodcuts were the most important form of pictorial expression for illustrated books, journals, and newspapers until the beginning of the twentieth century.

Most authorities credit the revival of the woodcut as a fine art medium to the German Expressionists. An organization calling itself The Bridge, an offshoot of that movement, numbered among its members Emil Nolde, Karl Schmidt-Rottluff, Ernst Barlach, and Erich Heckel, all of whom produced some dynamic woodcuts between 1911 and 1920. The influence of their style was widespread.

1

WOODCUT

Coast Line

This first example of printmaking, a black-and-white woodcut, is one of the oldest forms of graphic expression and one of the simplest. It is still as popular today as when its prime purpose was to produce likenesses of the saints in the fifteenth century.

Woodcuts today are made on many kinds of wood, some artists preferring smooth surfaces while others capitalize on the rough grain and the knots to help shape the image. New products such as plywood and Masonite have also been pressed into service, making possible some of the very large cuts seen in recent exhibitions. Contemporary artists have not been content to work within the rigid restrictions of the conventional woodcut and have devised a variety of techniques, either with or without the traditional knife work, as well as utilizing materials other than wood to produce the printing block, as will be seen in the series which follows. Some of the more noted contemporary woodcut artists are Seong Moy, Eugene Larkin, Antonio Frasconi, Arthur Danto, and Robert Conover. It should be noted that much of the work done today is large in scale, and a great deal of it is in color, a tendency also much in evidence in the intaglio and planographic processes. The works of Carol Summers have been widely exhibited and cataloged as woodcuts. Actually some are a variation of rubbings, a description of which will be found with No. 75.

For almost all the examples in this series, drawings or sketches precede the making of the block. For this print, India ink sketches were made; one of these was selected and then traced onto a cherry block previously coated with opaque white water color. The drawing on the block is just a rough guide. The final lines, tones, and shapes that appear in the print are the results of the artist's sensitivity to the material and tools employed, in this case knives and gouges. Oil-based ink was applied with a brayer, and the printing was done on a hand press.

14

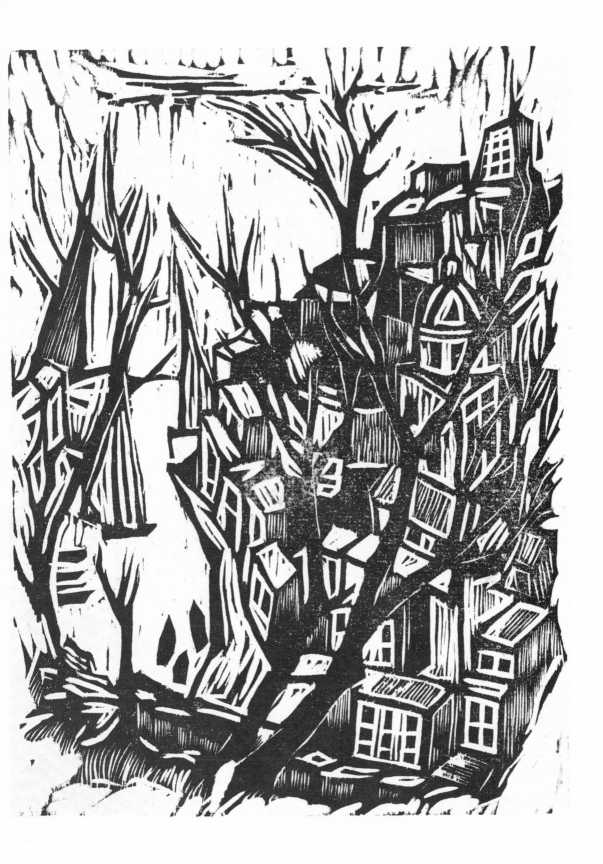

2

HAND-COLORED WOODCUT

Lost City

In contrast to many black-and-white woodcuts dependent in part on large solid areas of black for pattern, the design for a hand-colored woodcut is most effective if the block is treated as a strong line pattern with well-defined light areas. After the block has been printed with black ink, according to the standard method for a woodcut, and the print has been allowed to dry, coloring is applied with a brush by hand, using either water colors or colored inks. This may be done either freehand or, for greater accuracy, with the use of stencils. In this print water color was added freehand, and with such a procedure there are bound to be slight variations in color from print to print. The fifteenth-century examples appear to have been colored quite freely by unskilled hands.

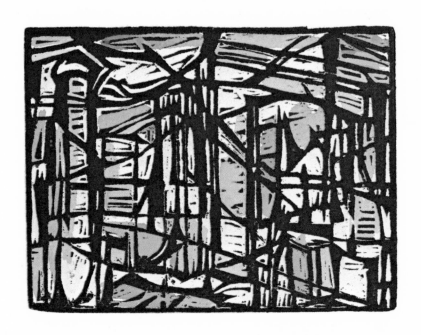

3

CHIAROSCURO CUT

Seated Figure

Only two blocks were used for this print, as the concept involved here can be better understood in its simpler form. One block was employed for the black and the second for the brown. In this print the preliminary sketches were made on a medium-toned gray paper. The shadows or dark areas were drawn with a charcoal pencil and the highlights or white spaces with white conté crayon.

As can be seen readily by studying the print, the white areas are cut out of the color block; thus in printing the first block (in this case the reddish brown), the highlights and medium tones are established, and when overprinted with the black block, the shadows are added, creating an illusion having a strong three-dimensional character.

Artists in the sixteenth century, under the influence of the new realism, were producing drawings on toned paper using white and a dark color to create strong effects of light and shade but ignoring local color. Ugo da Carpi, Lucas Cranach, and other artists working at the beginning of that century devised a method of cutting several blocks that, when inked and printed one over the other, produced effects comparable to a light and shade drawing. Chiaroscuro printing in this manner persisted all through the century and was the dominant method employed for making prints in color. This technique was widely used in Italy and Germany in the sixteenth and seventeenth centuries and was also employed in France from about 1590. It was popular in the Low Countries in the seventeenth century and in England during the following century. This method of cutting the blocks produces prints with a richness not usually found in ordinary two-color prints. Probably the bulk of historic chiaroscuro cuts were made from two blocks, but more ambitious artists produced examples employing four and five blocks.

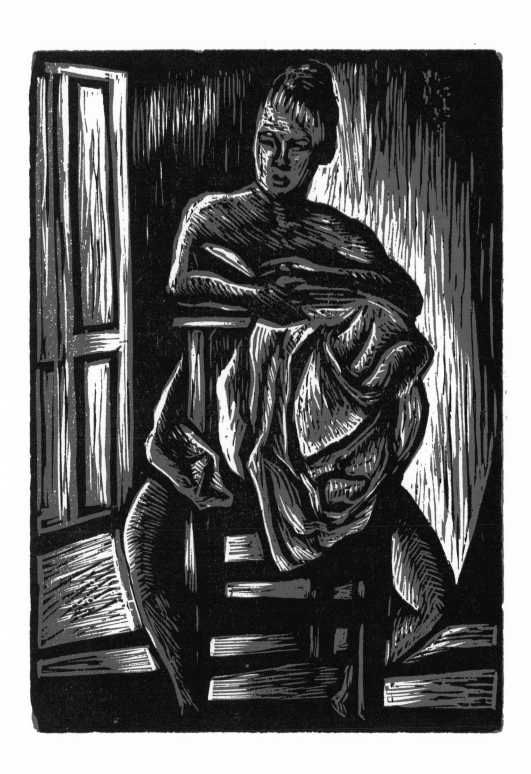

4

TWO-COLOR WOODCUT

Branches

Branches was printed in two colors; the first color, a grayed green, was printed from an uncut, unsanded, rough-sawed pine board, deliberately capitalizing on the surface texture of the wood in the print. The second color block, in black, was cut on a smooth, standard cherry block. Inking and printing were the same as in No. 1. It should be understood that this is only one method of making a two-color woodcut. Another common method would be to cut a design on each of the two blocks to be printed. Actually the chiaroscuro cut described in No. 3 is a variety of two-color woodcut, though with special distinguishing characteristics.

There is probably no limit to the number of blocks that can be cut, inked with a separate color, and then printed to produce a print in color. Colors may be clearly separated or may overlap to create more colors; for instance, yellow may overlap blue to make green. Throughout this set, color demonstrations are usually limited to examples employing two, three, or four colors. These are common arrangements, although there are contemporary printmakers who will produce prints employing ten or more blocks. In the West this is not the usual practice although in Japan it is normal procedure. As Douglas Percy Bliss pointed out years ago in his *History of Wood Engraving,* "It is doubtful whether the contemporary artists in great measure will ever resort to the Japanese multiple block technique. Here again the problem of the artist having to do the technical handwork in the block cutting is a staggering one, and very few artists have either the stamina or the desire to proceed along these lines." This book does include two such examples, Nos. 7 and 7a.

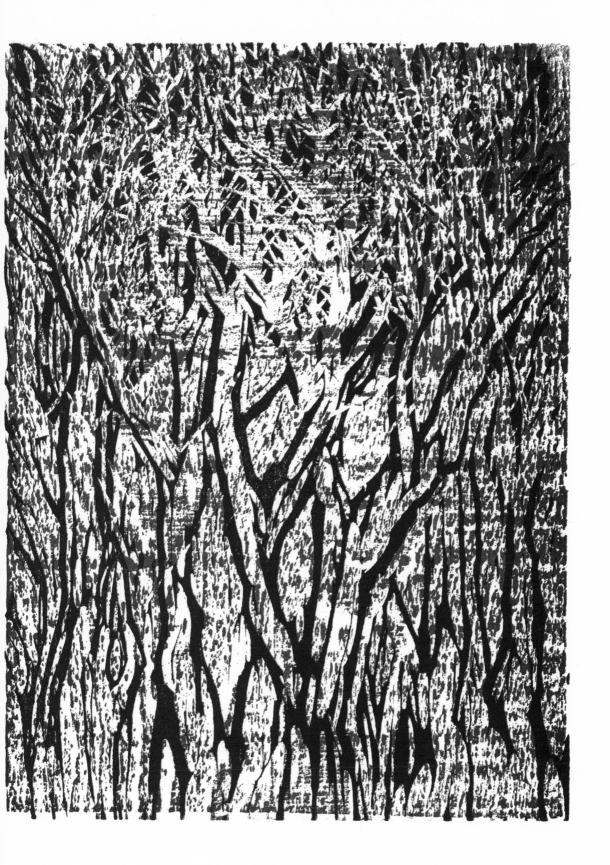

5

FOUR-COLOR WOODCUT

Pool and Rocks

In this process four separate cherry blocks were cut, each one being inked with a different color. These were then printed in sequence, the lighter colors first, the black last. Close inspection of the print will reveal subtle nuances, the result of semiopaque colors being overprinted. This is particularly obvious in the gray tones printed over the yellow and the black tones printed over both brown and gray areas.

A variation of this technique would use only two blocks, the individual color areas being designed to make possible the application of two different colors of ink to each block with small brayers. Printing these two blocks enables the artist to produce a four-color print. Only trials by the artist will reveal the number of possibilities inherent in this technique.

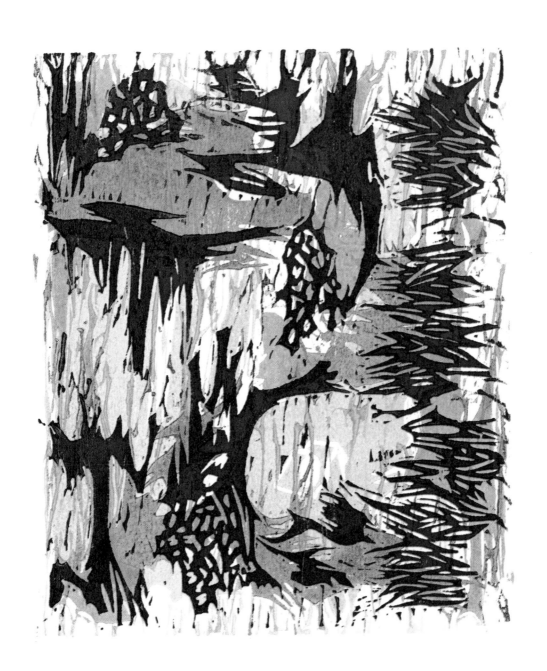

6

COLOR WOODCUT

Textures

In this age of experimentation it is not unnatural to expect that innovations would appear in the production of the traditional woodcut, and this print incorporates some of the latest concepts. A soft piece of pine was used as a base. Two areas of this block were cut out and inlaid with contrasting materials: in one, a thin layer of plywood with a distinctive grain; in the other, a string which had been arranged in a pattern and glued to cardboard. Other textural areas were created by placing wire and screen on the surface and hammering them into the soft wood to depress the surface, the resulting lines showing white in the final print. Also, carpet tacks were driven into the wood so the heads were printed in colors. Inking of the several colors was done on this one block. Some colors were applied with small brayers, while others were added with a brush. Colors applied with the brayer were oil-based printer's ink, but those added with the brush were standard artist's oil paints. By use of a small proof press the block was printed just once to produce each multicolor print.

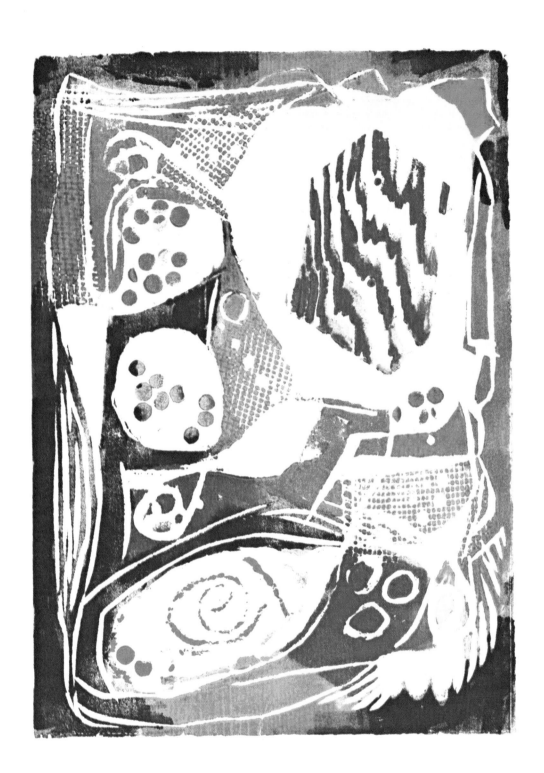

7

JAPANESE COLOR TECHNIQUE

Fishermen

Today, no writer of a survey of world art would consider his text complete without some reference to the Japanese print, probably because of the tremendous impact these prints had on French artists such as Degas and Matisse. In contrast, Japanese art experts regard this kind of multicolor illustration as a cheap popular art, a form of decidedly minor nature. The technique of producing these prints has its origins in Chinese art, but it was left to the Japanese to bring the technique into its fully developed style. Prints produced by them in large quantities were based on genre themes and other kinds of subject matter. The earliest of these prints appearing in the seventeenth century, cut from a single wood block, were sometimes hand-colored. Suzuki Harunobu introduced the method of printing from multiple blocks in the mid-eighteenth century and from that time polychrome prints were standard, with as many as twenty blocks being cut for a single print. No known innovations occurred in their production until the end of the nineteenth century when Sharaku and others started to incorporate mica in the prints for sparkle and contrasting texture.

Japanese prints in their original state are the result of the efforts of three persons: the artist, the woodcutter, and the printer. The plank surface of a block of cherry wood (in some cases other kinds of wood) was used, and a knife was the common tool employed to cut the artist's design into the block. Colorless rice paste was applied to the block with a brush, following which water colors were stroked into this moist paste surface. The colors were printed by placing a soft, handmade paper on top of the inked block and rubbing the back of the sheet with a baren. The nature of the ink is such that the color penetrates through the absorbent paper and is readily visible on the reverse side of the sheet.

To make the Japanese type of prints represented here, ten cherry blocks were cut, and inking and printing were done in the manner described above. Two prints, numbered 7 and 7a, are included to show the effects of changing the color scheme while printing from one set of

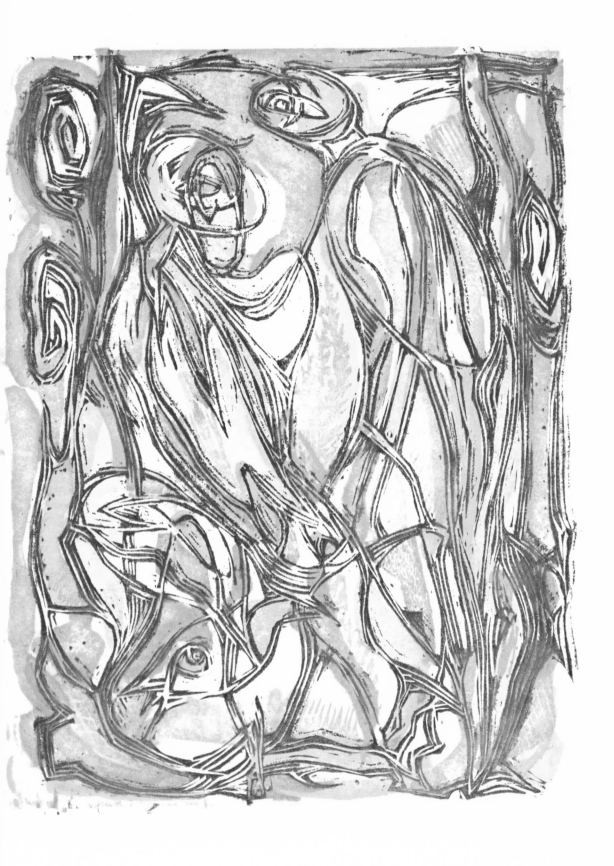

blocks. In No. 7 the colors are subdued and considerably lighter than the colors selected for No. 7a. A comparison of these two prints reveals at once that the effectiveness or mood of color prints is as dependent on the colors selected as on the images cut in the blocks.

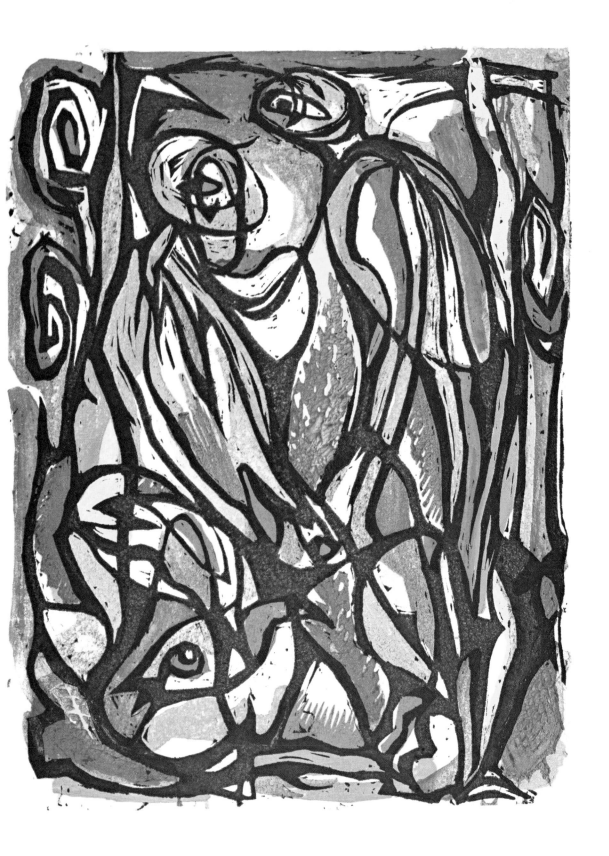

8

WOOD ENGRAVING

Ruins

Most authorities attribute the invention of wood engraving to Thomas Bewick. Although there is considerable evidence to support those who show that white-line engraving existed prior to Bewick's day, it was not until his illustrations appeared that wood engraving was popularized and became the foremost method of printing pictures in the nineteenth century.

Wood engravings are produced on end-grain blocks of boxwood or maple. The tools used for cutting are burins, also called gravers, which are sharply pointed metal tools set in wooden handles. The technique is sometimes referred to as the white-line method. Visually, the distinction between the ordinary woodcut and a wood engraving can be summed up best by saying that the woodcut looks like a black pen-and-ink drawing on white paper, whereas the wood engraving looks like a white pen-and-ink drawing on black paper.

Bewick, working in close co-operation with the printer, employed the practice of overlaying and undercutting the blocks, giving tones both darker and lighter than the original block would have produced by normal printing methods. In overlaying, paper or tissue is applied to the tympan, and the extra thickness in these areas makes for greater pressure, giving a darker impression as a result. Conversely, lightly scraping or sanding the block in spots where lighter tones are wanted decreases the pressure, and a lighter tone is obtained.

The print included here is a standard wood engraving cut on a maple block with both multiple liners and the regular assortment of engraving tools. Printing was done on a hand press, and a smooth-surfaced paper was chosen to bring out the fine lines and detail of the block.

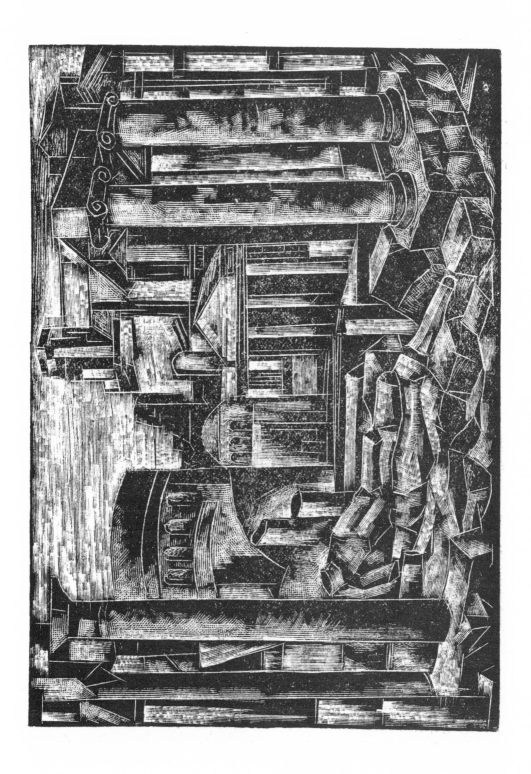

9

CASEIN CUT

Fragment

Recently several materials have been used to replace the traditional blocks for relief printing. In the case of wood engraving substitutes, two factors have been responsible; the first is the limitation of size, and the second is the cost of the engraving block. Casein, gesso, and plaster are all used today and are fairly satisfactory replacements.

In preparing the block used in this print, a half-dozen coats of casein paint were applied to a Masonite panel, producing a smooth surface which was then cut and engraved. If fine lines are desired, a dampened surface is essential to cut down chipping.

OTHER SUBSTITUTE MATERIALS

Panels can be prepared with gesso in the same manner, a method developed by Norman Gorbarty at Yale University. The gesso, applied in layers until the coating is one-sixteenth of an inch thick, is shellacked to cut down the flaking.

The latest in a long line of experiments in relief processes is the use of a plaster base as the surface from which to produce prints. A wooden frame from two to three inches high is used to hold the plaster of Paris, which is poured on a glass slab to insure a smooth surface. Upon drying, the surface is given a coat of shellac or size. After it has hardened, the usual chisels, gouges, and multiple-line tools of the wood engraver can be used to fashion the design. The one disadvantage of the technique is that the hand printing method necessary with plaster limits the size of the edition. It is not feasible to print fragile plaster slabs on a commercial press. This type of print is called a plaster relief cut or a plaster relief print. An example, and the method of making it, is to be found in the children's section under No. 100.

Plaster is also used as a base for another type of print. In this one, called a plaster print, the plaster actually substitutes for the paper; an

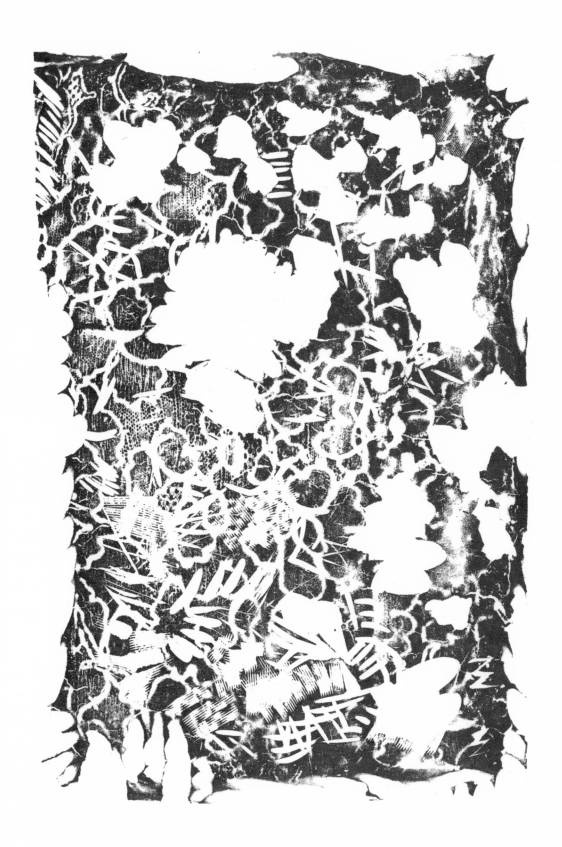

impression is taken in plaster of an inked intaglio plate. This slab of plaster two or more inches thick is then sometimes further carved and colored, producing a sort of very low bas-relief, actually more closely allied to sculpture than the print field. Obviously no example of this process is included here.

Another material that has been used as a substitute for end-grain woodblocks is Lucite. Arthur Deshaies has produced some remarkable work on this plastic, his engravings sometimes printed intaglio and other times cut so that they can be printed by the relief method, that is, in the manner of a wood engraving. Plexiglas is still another product that can be employed in a similar manner.

The commonest substitute for wood, though not for the engraving method, is linoleum, which is used for both No. 12 and No. 13.

Besides substituting other materials such as plaster, Lucite, or linoleum for the traditional wood in relief printing, there are methods of preparing relief blocks by building up a surface. Most common of these are cardboard cuts and paper relief cuts, the latter an extension of the first and developed by Edmond Casarella. In the former method, a piece of plywood or pressed wood serves as the base, and on this surface are mounted various sizes of cutout shapes of cardboard, thus building up a printing surface. The technique is an excellent one if large prints are made or if complex color prints are contemplated.

The paper relief cut follows the same procedure, using stiff, four-ply cardboard for the basic shapes. Once these have been anchored securely, further enrichment of the design is produced by cutting shapes into the cardboard with a razor blade. After these shapes have been cut, one layer of the paper is peeled away, producing areas which will not print, that is, areas of white in the final print.

One other material that can be employed for relief printing is rubber. Blocks can be obtained with a rubber surface, the material mounted in the same manner as for a linoleum cut. If lettering is to be incorporated in the design or long runs are needed there may be some benefit in using rubber, as it does not crumble; otherwise, for straight cutting, linoleum is probably more desirable. For children, a piece of an old inner tube which can be anchored to a wood base after the design has been cut makes both an inexpensive and excellent way of obtaining good prints. The chief advantage for the children lies in the use of shears in

34

place of knives to prepare the blocks. The bolder shapes that are the direct result of cutting out flat areas of rubber will probably enhance the total aesthetic effect.

10

TWO-COLOR WOOD ENGRAVING

Pickle Pickers

In 1939 the Pynson Printers issued the book *How I Make Wood-cuts and Wood Engravings* by Hans Alexander Mueller. This was the first time that American artists had an opportunity to study the technical problems involved in both black-and-white and color wood engraving production. Mueller's volume is a masterwork in printing and shows progressive proofs of complex color work. One would assume that as a result of this publication a great upsurge in wood engraving would have ensued. However, as Peterdi pointed out in 1959, the whole field has been neglected. Two factors may be responsible: the use of the medium for reproductive commercial work and the literary involvement of the British artists associated with the English private press movement. These men, who were primarily illustrators, dedicated their talents to expressing purely literary images. Almost all of the artists doing wood engraving were doing bookwork; while the bulk of the production was technically excellent, it was not on a very high plane aesthetically. In the contemporary art world the wood engraving has still to come into its own.

For *Pickle Pickers* two maple blocks were engraved in the same manner as in No. 8, using one for each color. It should be understood that a casein cut (No. 9) and the other substitutes for wood could be printed in more than one color; for instance, see the three-color lino-leum cut, No. 13.

place of knives to prepare the blocks. The bolder shapes that are the direct result of cutting out flat areas of rubber will probably enhance the total aesthetic effect.

10

TWO-COLOR WOOD ENGRAVING

Pickle Pickers

In 1939 the Pynson Printers issued the book *How I Make Woodcuts and Wood Engravings* by Hans Alexander Mueller. This was the first time that American artists had an opportunity to study the technical problems involved in both black-and-white and color wood engraving production. Mueller's volume is a masterwork in printing and shows progressive proofs of complex color work. One would assume that as a result of this publication a great upsurge in wood engraving would have ensued. However, as Peterdi pointed out in 1959, the whole field has been neglected. Two factors may be responsible: the use of the medium for reproductive commercial work and the literary involvement of the British artists associated with the English private press movement. These men, who were primarily illustrators, dedicated their talents to expressing purely literary images. Almost all of the artists doing wood engraving were doing bookwork; while the bulk of the production was technically excellent, it was not on a very high plane aesthetically. In the contemporary art world the wood engraving has still to come into its own.

For *Pickle Pickers* two maple blocks were engraved in the same manner as in No. 8, using one for each color. It should be understood that a casein cut (No. 9) and the other substitutes for wood could be printed in more than one color; for instance, see the three-color linoleum cut, No. 13.

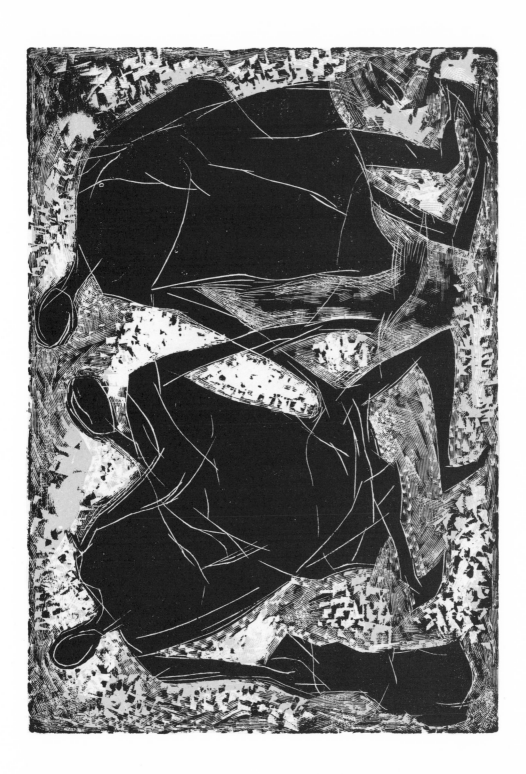

11

FOUR-COLOR WOOD ENGRAVING

Waiting

When color prints are made involving the use of four or more blocks, the establishment of the design on the separate blocks can be done by slow, tedious hand tracing. A simpler and more accurate method is to cut an outline pattern of the design on a linoleum block and then print this on the required number of blocks. If this is done carefully, an exact outline is transferred to each color block, making for both ease in cutting and more accurate registering.

Designing of the blocks was carried out in such a way that it capitalized on the overprinting of the colors to give greater variety of hues and richness to the print. As mentioned before in the discussion of color woodcuts, when yellow is printed over red, for instance, orange is added without using a separate block. Four separate blocks were cut, and the printing was executed in the traditional manner.

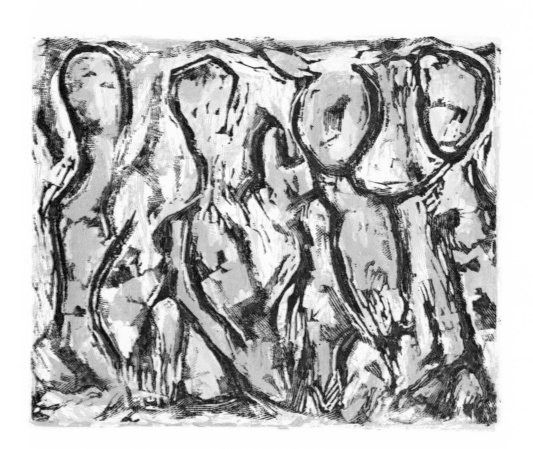

12

LINOLEUM CUT

Aquarium

 Linoleum, a relatively new material in the printmaking field, has assumed a position of exceptional popularity, mainly because it is cheap and easy to work. It is most closely related to the family of woodcuts, involving the use of similar tools and techniques. Linoleum is a floor covering material made by applying to either canvas or burlap a mixture of solidified linseed oil and cork dust or wood flour or both. It is a soft material containing no cross grain. It can be procured in a flat sheet or mounted on type-high blocks. The material prints equally well with water- or oil-based inks, but it is not capable of producing the fine quality of a woodcut because of its inherently spongy nature. While it is primarily a children's material, enough professional artists have used it to warrant its inclusion in this section of relief processes.

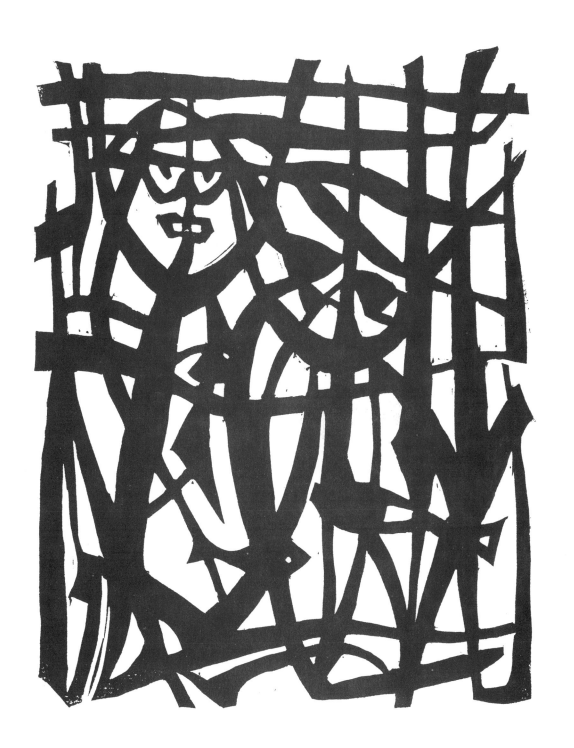

13

THREE-COLOR LINOLEUM CUT

Doors

This three-color linoleum cut is printed with oil-based inks. When this print is compared with the four-color woodcut, the lack of crispness in line resulting from the softness of the linoleum becomes apparent at once. Regardless of the number of colors used, color linoleum cuts are usually produced by the same method described under Four-Color Woodcut, No. 5; that is, a separate block is cut for each color—in the present instance three are used.

Another technique, developed by Picasso in 1959-60, uses only one block throughout the entire run. The block is partially cut away and printed in a light color. Successive cuttings on this same block and darker printings each time finally yield the color print. There is not complete flexibility with this single block method, but it does have some design unification qualities that are very desirable.

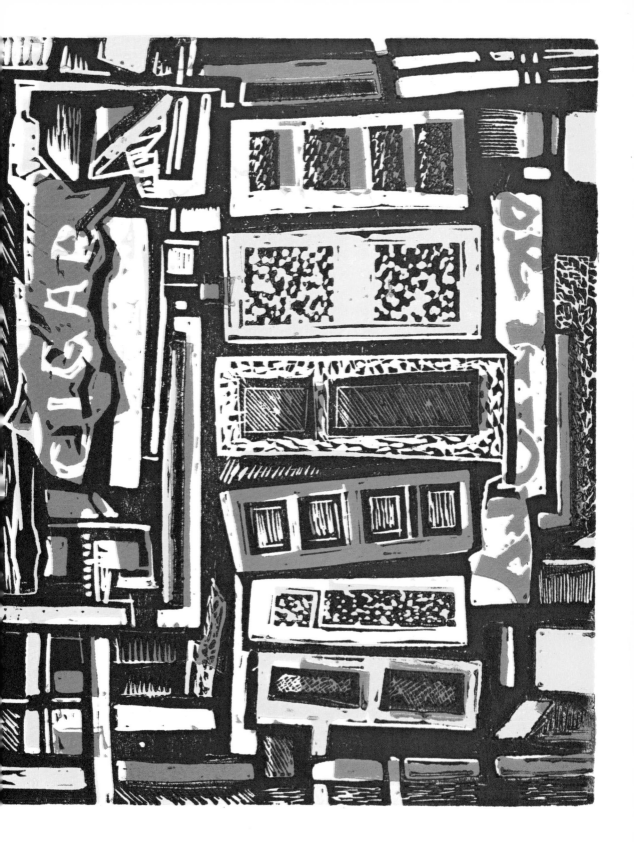

14

PASTE PRINT

Man of the Cloth

In the late 1400's and through the 1500's a type of print appeared made by impressing a metal cut (see No. 19) into a coating of paste which had been previously laid on the paper. The effect obtained is that of a low relief pattern similar in appearance to the sealing wax impressions frequently used to seal envelopes until modern times. Few prints have come down from this early period, and most of them are in poor condition. Studies made of the scarce examples indicate that several techniques were used in their production. The nature of the engraved plates used in this process makes possible their use for intaglio printing; but the method of printing paste prints, relief, led Hind to so classify them in his *History of the Woodcut* rather than as intaglio prints, which is the practice followed in this volume. In one example from the latter part of the fifteenth century, the plate was inked as a woodcut and impressed onto the paste. In some cases a thick layer of brownish paste was laid down and then impressed with an uninked plate. Crocus powder and gum tragacanth probably were mixed to form the paste material, although, no doubt, there were experiments with other substances. Application of color and gold leaf further enriched the imprint, and sometimes a layer of gold leaf was placed over a thick base of paste and the uninked plate impressed into it. It is not known whether these prints were intended to serve merely as decorative plaques and a way of keeping a record of engravings, or whether they were experiments in decorative printmaking performed on their own account.

In the small example shown here, the paste mixture was applied to a sheet of dry paper, and an engraved pewter plate, mounted on a small block of wood to facilitate handling, was pressed into the moist paste. The excess paste which squeezes out around the edges of the block is unsightly, so it was removed by cutting it away after drying. Color and gold leaf were applied sparingly by hand to the print, which was then mounted on a larger sheet of paper. For comparison, two impressions, one in relief, the other in intaglio, have been printed from the same

metal plate that was used for the paste print and are included here as No. 14a (intaglio) and No. 14b (relief).

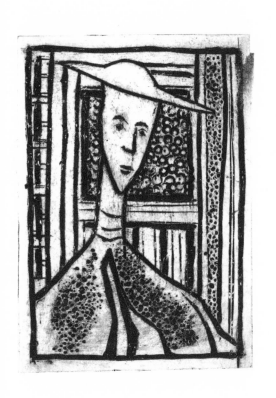 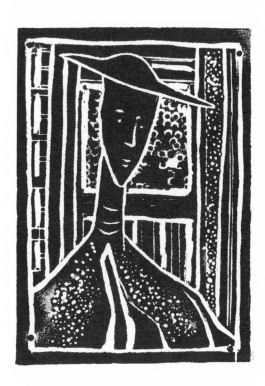

15

FLOCK PRINT

Figure Composition

Flock is a product made by grinding and cutting wool or vegetable fibers until they reach a consistency of fuzz or dust. This material may be of any color. Flock prints are closely related to paste prints and were first produced in the fifteenth century. They were made by coating an ordinary woodcut block with paste or a mixture of some adhesive with the printing ink. The block then was pressed against the paper, and before this wet image dried it was dusted with flock, which adhered only to the sticky parts of the design. The object of the technique appears to have been imitation of the textural character of fabrics. Today, flocking is primarily used by sign shops and the manufacturers of wallpaper and greeting cards.

In the example shown, the outline block used for transfer purposes in the four-color wood engraving (see No. 11) was selected for use. This block in outline needed solids before it could be used, so areas between the raised lines were filled with gesso and then sanded smooth. The block was then coated with paste and printed. Dark green flock was applied while the print was wet, and the excess was shaken off, and the print set aside to dry. Yellow-green flocking was applied to the background areas, which had been covered with paste applied from another block in a separate operation, to make a two-color design.

16

DOTTED PRINT

Trio

One type of print was executed in a style known as the dotted manner or *manière criblée*, the earliest example of which appeared in the last half of the fifteenth century, prints of which were produced until the end of the sixteenth. It was not until near the end of the eighteenth century that the English revived it. In the best of these early prints an extremely rich effect was produced.

One of the distinctions of a dotted print is that instead of wood, as in all but one of the relief processes discussed so far, metal, usually pewter, lead, or copper, is employed in its production. The basic design, which is linear, is engraved into the surface, and the lines appear white in the proof. Further embellishment is given the plate by dotting or stamping the background area with metal punches. The ends of the punches carry simple designs, making possible the stamping of allover patterns. In the early prints stars, dots, circles, fleurs-de-lis, and other designs were used. This method is not to be confused with the copper engraving method, for although the tools are much the same, the method of printing is essentially different. For the dotted print it is the surface of the plate that is inked; in the engraving, the parts cut below the surface are inked. In the example shown, the metal punches were the kind commonly used in leather work. The plate was pewter, and the printing was performed in the usual relief manner.

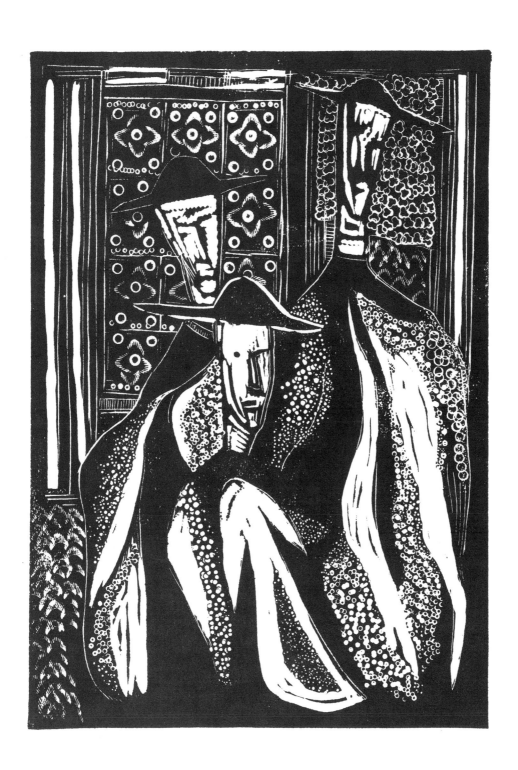

17

BLAKE TECHNIQUE

Madrigal

William Blake made a distinct technical contribution in his production of color prints, and his technique deserves a place in this volume. Blake insisted that, through a dream, divine forces revealed to him a method of color printing which he immediately put into practice. For some time his exact method was not understood. Blake caused the puzzle by making a plate from which was printed a page including not only a picture but also a text.

The problem of producing a metal plate which will print relief is, of course, simple. To make a plate which will print lettering and illustration from the same surface is something else. Hand lettering, when used in conjunction with decorative material on the same page, can be very handsome; this, of course, is the charm of Blake's best work. Lettering of quality can be produced by many artists, but lettering in reverse so that it could be printed was the feature that bothered experts studying Blake's work. Writing from left to right is simple, but to do this in reverse from right to left could be frustrating. How this reversal was probably achieved has finally been demonstrated through experiments by Ruthven Todd, William Hayter, and Joan Miró. The lettering is done in the normal manner on a paper coated with gum arabic, using a specially prepared acid resist instead of ink. The paper is brought in contact with a heated copper plate and run through the press, thus transferring the acid-resistant lettering to the copper. The plate is then etched rather deeply with acid, which eats away the background and leaves the lettering in relief. It is inked by pressing it against a copper plate that has a smooth surface on which ink has been rolled, so no ink is deposited on the background as might be the case were it inked with a softer roller.

The above procedure was closely adhered to in producing the print shown. Both colors were on the same printing plate; two inking plates, one for each color, were used. The inked plate was then printed in the usual relief method, using a screw-style letter press.

Madrigal

My love in her attire doth
show her wit,
It doth so well become her;
For every season she hath
dressings fit,
For Winter, Spring, and Summer
No beauty she doth miss
When all her robes are on:
But Beauty's self she is
When all her robes are gone.

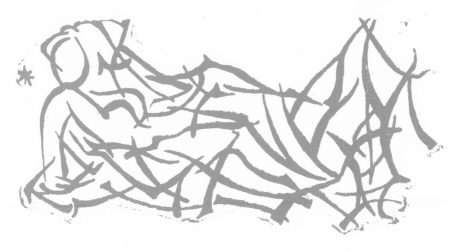

18

METAL RELIEF

Fish Count

Most of the techniques that have been discussed involved the use of wood; however, at the present time artists occasionally make relief prints from the metal plates which have been prepared for intaglio printing. In fact, the metal relief prints are also called relief etchings, and William Blake sometimes used this method plus other refinements (see No. 17). Sometimes the plate is specifically cut or etched in metal —copper, zinc, lead, or pewter—with the deliberate intent of printing by the relief process, but at other times a plate originally designed for intaglio printing is adapted. To make one of these prints, the artist simply inks the raised surface of the metal plate and proceeds as in any other relief print.

To show this process, the plate for an intaglio print has been employed but has been printed by the relief method. It was felt that it would be more interesting to compare the same composition printed two different ways. The plate was printed with oil-based ink applied with a brayer.

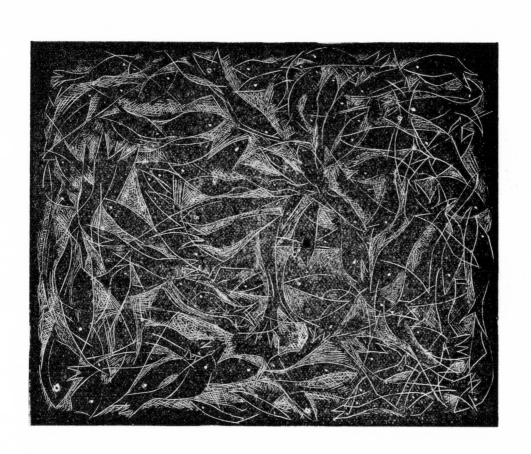

INTAGLIO PROCESSES

The intaglio printing process is just as old as, if not older than, the relief process, if one takes into consideration the development of these techniques only in Western art. The term *intaglio* derives from a word meaning "cut," "carved" or "engraved below the surface." For centuries men had practiced the art of intaglio cutting in the production of jewelry, such as signet rings designed to be stamped on wax, and the medieval armorers were noted for their engraving skill. Their exquisite workmanship can be witnessed in some of the armor exhibited in many museums. It was not, however, until the fifteenth century that this technique was specifically applied to the production of illustrations on paper.

The intaglio process applied to printmaking involves various differences in methods and materials from those of relief printing—different inks, plates instead of blocks, and an entirely different principle of printing. The majority of intaglio prints are made from copper plates, although substitute materials such as zinc, aluminum, and steel are also employed. In contrast to the wood blocks commonly employed in relief printing, which when used in conjunction with type are nearly one inch thick, the plates used in this process are about one-sixteenth inch thick. The plate is polished smooth and the artist's drawing can be cut into it by hand or, simpler yet, bitten or etched by various acids. The idea is to lower the part of the surface which is to receive the ink. Many techniques for doing this will be explained as the intaglio prints are discussed.

Once the artist has a design made up of grooves cut or eaten into a metal plate, he must then ink the plate with an etching ink so that the entire surface is covered. Skillful wiping with a stiff cloth such as tarlatan removes most of the ink from the surface, leaving a deposit of ink in the grooves and a light film on the surface.

Printing the plate involves the use of an engraver's press, that is, one having a metal bed running between rollers. On this bed is a felt

blanket which forces dampened paper into the grooves of the intaglio plate, thereby extracting the ink. The result of this impression on the paper is a black line that is slightly raised. Close examination of the print reveals that both the inked line and the paper are raised, forming a corresponding declivity on the reverse of the paper. As in the case of the relief print, the intaglio plate is used to reproduce the image many times with reinking and reprinting. Some formal calling cards and wedding invitations are produced in this manner.

Engraving as a means of creative expression was used in conjunction with other media or used separately in prehistoric times. The outlines in some cave paintings were cut into the stone and the grooves filled in with some dark substance. Almost all the primitive societies have had artisans skilled in cutting, carving, and scratching designs in bone, wood, stone, and shell. In these older cultures, whenever there were craftsmen with sufficient ability to work in metal adaptable to jewelry, tools were employed to embellish the surfaces of the various objects.

Over the centuries craftsmen had developed methods and techniques for cutting into metal for decorative purposes, and by the Middle Ages the craft of the goldsmith was well established. One of the processes practiced by the goldsmith in the fifteenth century was *niello*. The finished object, referred to as *niello*, was a small silver or gold plate in which lines cut in the manner of a line engraving were filled with a black substance also called *niello*. The black *niello* was applied as a powder rubbed into the lines and then melted to make it adhere. The plate was then burnished to a bright shiny surface against which the black design appeared. Some authorities feel that in order for the goldsmith to check the progress of his work he may have taken a paper print from these lines filled with *niello*.

We know that it was in the middle of the fifteenth century that line engraving as a separate means of producing pictures first appeared, and we can surmise that there was some relation between the niellist's shop practices and the eventual emergence of engraving as a method for producing pictures. Unfortunately, the names of the earliest masters are unknown, and their work is usually identified by appellations such as the Master A.G. or the Master of the Death of Mary. Later in the fifteenth century, important Italian engravers were Andrea Mantegna, Antonio Pollaiuolo, and Marcantonio Raimondi; while in northern

Europe, Albrecht Dürer and Lucas van Leyden are the most noted. In the sixteenth century Albrecht Altdorfer, Hans Beham, and Quentin Matsys are among those who made significant contributions.

At one time the printed book with woodcut illustrations was considered inferior to the illuminated manuscript volume. Then, as printing became more widespread and the manuscript tradition gradually disappeared, the woodcut book became elevated to a position of first rank. However, by the start of the seventeenth century woodcut illustrations had slipped again into a lowly station and were supplanted by the book with engraved plates. This was a costlier and more luxurious volume, and its appeal was based partially on snobbery. Perhaps, also, the skill of the craftsman could be revealed more readily in working with the intaglio medium. Another factor bearing on this shift to engraving was the need for a method suitable for more accurate scientific illustrations. Science was to make great strides in the eighteenth and nineteenth centuries, and much effort was expended to find cheaper and more accurate means of making pictorial records.

From 1700 to the twentieth century, line engraving was pressed into reproductive service, and very little creative work was achieved in the field of printmaking. The engraver's skills were employed to reproduce the paintings of famous artists of the time, and, as a result, the engravers were not called upon to be artists but were reduced to the state of skilled craftsmen. In order to meet the demand for longer runs, steel was substituted for copper plates. The limited number of prints in editions produced by artists today makes the steel plate an outmoded material for serious work. Steel engravings were popular all through the nineteenth century and did not wane in popularity until the advent of photoengraving, at which time the need for engraving by hand vanished. It was not until the revival of intaglio methods led by Hayter in the 1930's that the art of engraving was lifted to a plane that puts it on the level with the best work of the earlier centuries.

19

LINE ENGRAVING

Fish Count

The line engraving technique is difficult to perform but fairly simple to describe. The plate to be used is of flat, polished metal, preferably copper, and the cutting tool, a burin or graver, is the same as that used for wood engraving. It is held in a position almost parallel to the plate and is pushed across the surface of the metal, digging a furrow and throwing up a curl of metal in its path. This technique has rather serious limitations because it depends solely on lines, but subtle variations can be obtained by controlling the width and depth of the lines, and tones can be achieved by light crosshatching or by parallel lines placed closer or farther apart.

The method just described was employed to prepare this plate for printing. The technique for intaglio printing described earlier will apply to all of the prints in this group, and consequently no further reference to this part of the operation will be made.

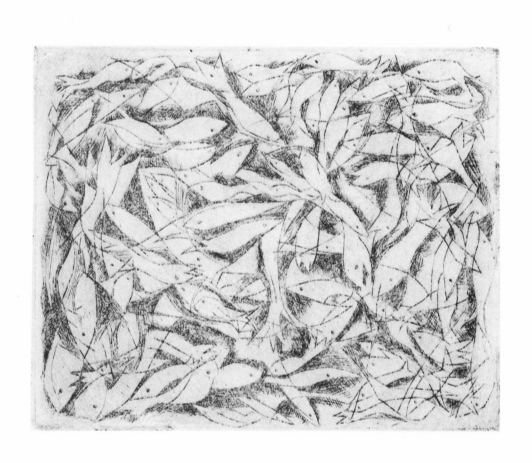

20

HAND-COLORED ENGRAVING

Pagans

Engravings gradually replaced the woodcuts which for so long had been almost the sole means for illustrating the printed book. The use of engravings may or may not have raised the artistic standard of the book, but of one thing we can be sure—it certainly raised the cost. Printing in color from several plates is possible and was sometimes employed, but the bulk of the engravings were simply printed in black. Because printing the color plates was costly, color, when needed, was usually applied to the print by hand. In some instances, no doubt, the purchasers did their own coloring. Sometimes the coloring was added many years after the printing of the book.

The miniature print *Pagans* is a straight line engraving first printed in black and, after drying, colored with light watercolor washes by hand.

21

TWO-COLOR ENGRAVING

Grasses

Any discussion of color printing in which more than one color and plate are employed must eventually face the problem of register. In print work this implies fairly exact alignment of the plates so that each deposits its respective color directly over the preceding one printed. In detailed work even a small error of this kind is noticeable, and the image is said to be out of register. Several techniques may be employed to accomplish exact register. The color prints in this section were registered by methods that best suited the particular print, and no one system was uniformly employed.

For this print process the design was engraved on two separate plates: the black portions on one and the yellow ochre on the second plate over a tracing of the first block as a guide. The plates were printed in succession, one over the other, to achieve the two-color effect, using a right-angled mask to accomplish the register.

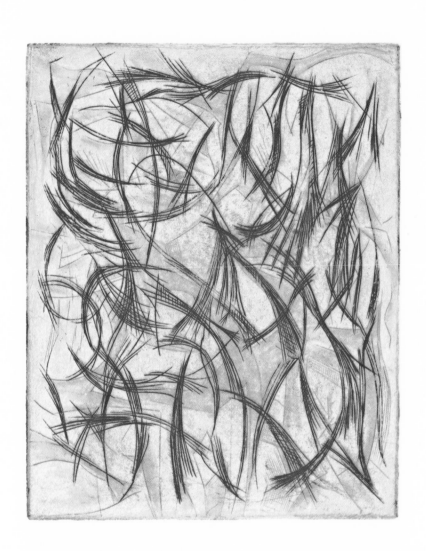

22

DRY POINT

French Street

In this process, which resembles engraving in many respects, a special tool for drawing the design is used which has a very hard, sharp metal point or a diamond fastened to the cutting end. The tool is held in the hand at an angle, as a lead pencil is held, and the drawing is done directly on the polished copper plate. Pressure of the point on the metal produces a furrow in the copper surface. The metal is not removed as in engraving, but is merely displaced to one side. This ridge, which rises above the plate and lies along the side of the drawn line, is called the burr. It is not removed with the scraper but is capitalized upon. In the inking operation this burr catches and holds ink on the surface; when the plate is printed, the lines have a very attractive, soft, velvety quality. The first ones in an edition are the best, as the pressure in printing will eventually flatten the burr, making it impossible to retain ink. For the original edition of this book, twenty good prints were needed, and to avoid breaking down the burr the plate was chromium plated.

Dry points are known to have been produced as far back as 1480; however, the technique was usually used in conjunction with etching and engraving, and it was not until recent times that much of consequence was produced using the dry point method described above. Aside from Rembrandt's work in this medium, only a few isolated cases appear before the mid-nineteenth century, when it became a popular technique. Today dry point is used alone or in combination with other intaglio processes.

In his book, *Processes of Graphic Reproduction in Printing*, Harold Curwen describes a process which he calls linoleum dry point. The base material is old, brown, hard linoleum. The surface is painted with a thin coat of white water color to furnish a legible background for the drawing which is done with pencil. A cobbler's awl which has been sharpened to a knife-edge is then used to work over the pencil outline. Inking is applied with oil colors daubed on with a brush, after which the surface

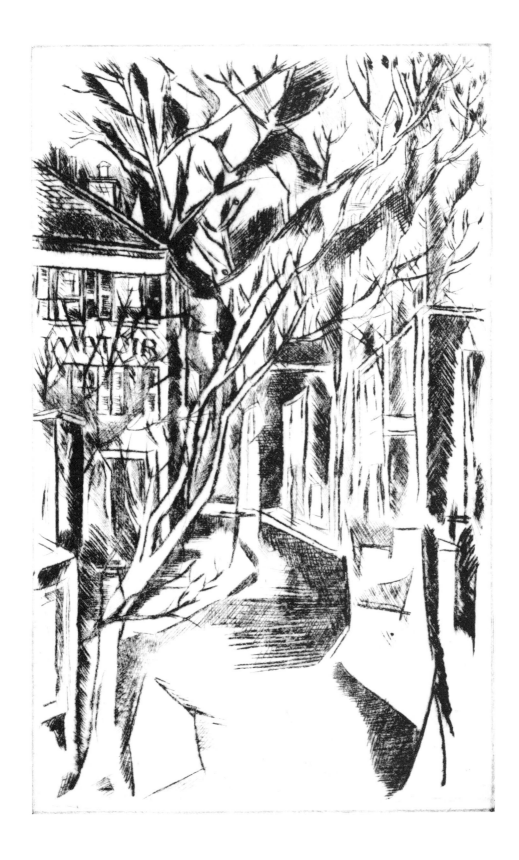

is wiped as in other intaglio processes. Printing may adopt one of several methods: by using soft paper and rubbing the back, or by running linoleum and paper through a household wringer or a roller-type press.

23

ETCHING

Krieman's Fish Heads

The origins of this technique, like those of line engraving, are not very clear. Most of the literature repeats the story that etching evolved from the work of the medieval armorers. The armor worn by the knights, with its large surfaces of metal, was admirably adapted to decoration. Embellishment was achieved by engraving or by etching the lines of the design in the metal with various acids. It would appear logical that from these beginnings the use of the technique to produce prints would inevitably evolve.

To make an etching, a line drawing is first made on a metal plate, usually copper, that has been entirely coated with an acid-resistant material referred to in professional parlance as "hard ground." A pointed tool called an etching needle is used to draw through this coating or ground, exposing the metal where the lines on the plate are desired but not digging into it. After the drawing has been completed, the copper plate is immersed in a nitric acid bath or one of Dutch mordant. The result is a bitten line, one that lies below the surface and that has square ends rather than the tapered ends typical of an engraved line. The lines which are to be kept fairly light in the finished print are covered with varnish after the first acid immersion, and the plate is again placed in the acid to further etch the uncovered lines for greater depth of tone, a process which may be repeated many times. The deeper the line, the more ink it will hold and the darker it will print. The plate is inked, wiped, and printed in the same manner as that used in other intaglio processes.

The earliest etchings were thought to have been made as shortcuts to engraving. In some cases these early plates were engraved through a hard acid-resistant ground, then reinforced with acid. Although a goodly number of prints suspected of being older are in existence, the first dated print is one by Urs Graf in 1513. It is a small print, about five inches by two and three-quarters inches, and was etched on iron. Etchings made on iron plates were produced in Europe during the entire sixteenth

century while copper was being used for engraving, which was still the dominant technique. Iron finally gave way to copper as the basic material for etching as well as engraving.

Excellent etchings were produced in the mid-seventeenth century, and in the work of Rembrandt a really high level is reached in the use of this medium. He produced some three hundred plates, and contemporary critics rate him as one of the greatest etchers of all times. Other significant etchers of the period were Jacques Callot and Hercules Seghers, both of whom are worth studying. Later practitioners were Antonio Canaletto, Giovanni Piranesi, William Hogarth, and Charles Méryon.

After 1650 a variety of techniques using the intaglio process were developed which gradually replaced line etching. Pure line etching did not regain status until the French and English artists revived it in the middle of the nineteenth century, when it then became, for the most part, the plaything of the dilettanti. Even so, some serious creative work was done by a few artists. Notable among these were Jean Baptiste Corot, Camille Pissarro, Édouard Manet, James Abbott McNeill Whistler, and Anders Zorn.

The etching in this set was produced on a copper plate covered with a hard ground. Etching needles with points of various sizes were used to make the drawing, and the plate was etched in a Dutch mordant bath. Several bites were given to produce tonal variations in the lines.

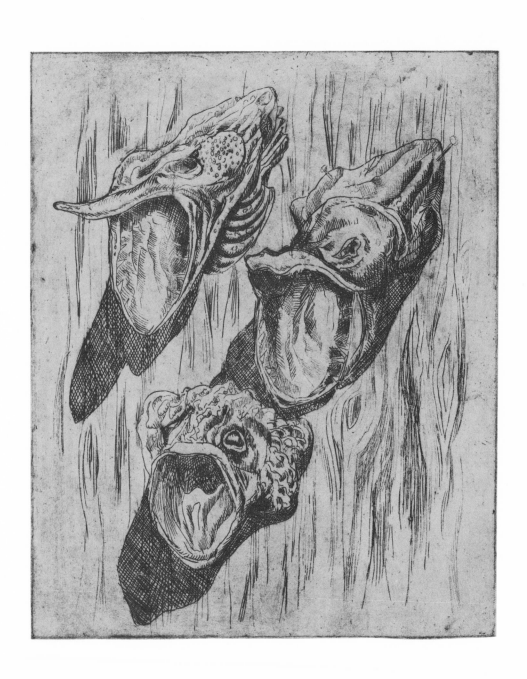

24

COLORED ETCHING

Dock

In this technique the plate is prepared as described under etching. As in printing other intaglio plates, the entire plate is covered with ink and the surface wiped clean, leaving the ink, usually black or a dark color, in the lines. The several additional colors are then painted on the surface of the etched plate with a brush, applying ink to the lines and the color to the surface again after each printing. Obviously, there will be variations from print to print, as each one is an individual painting, so to speak, except for the etched line duplicated with each printing. The dark line and all the various colors are printed at one time from ink both in the lines and on the surface. Care must be exercised in applying the oil color to the plate, for too thick an application, as well as too many colors, produces an unsightly print.

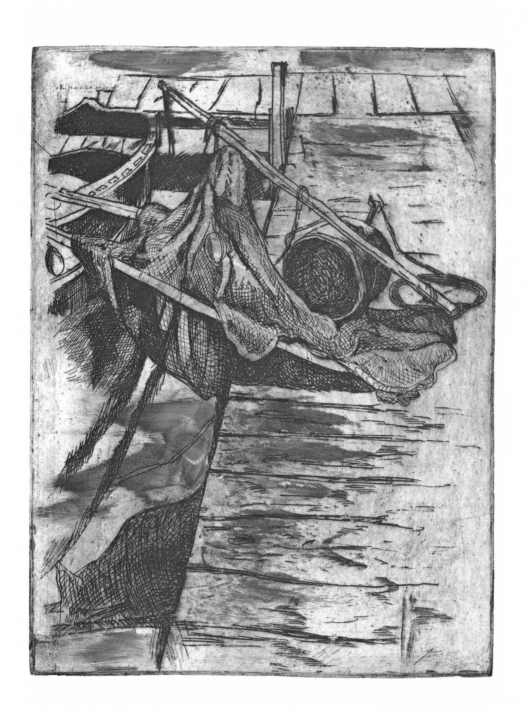

25

HAND-COLORED ETCHING

Decay

As in No. 23 the plate is prepared with a deep bite which allows a cleaner surface wipe, after which it is printed in the usual manner of intaglio plates. In this type, the color is applied with brush and water color to the open spaces of each finished print rather than to the surface of the plate. Only the etched lines are printed; the additional colors are handwork causing variation from print to print.

The hand-colored print is not acceptable in most contemporary print shows. This restriction may be due in part to the flood of hand-colored etchings that were sold in department stores during the 1920's and 1930's. These products, artistically, were not much above the usual run of present-day greeting cards and were referred to in the trade as "bedroom etchings." A more liberal approach would be concerned more with the aesthetics of the final product rather than the means used to produce it.

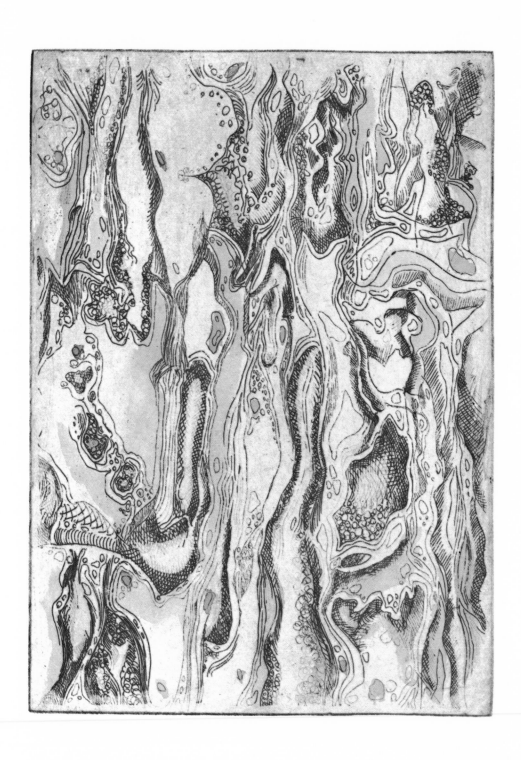

26

THREE-COLOR ETCHING

Skeletal

In contrast to those prints which have been colored by hand, the colors in this etching were printed from individual plates. A color sketch was produced, and from this tracings for each of the colors were made on separate sheets of tissue. The plates were grounded and the designs transferred and then needled. Close inspection of both color plates would reveal textural areas produced by rubbing through the ground with a medium-coarse sandpaper, although some traditional needlework was also used. Each plate was inked with a different color by applying ink to the entire surface, then wiping the surface and leaving ink in the lines. The color prints are the result of printing one color over another. This is a true color printing process in that the design etched in the plate determines the exact delineation of each separate color, and, as a consequence, there is little variation from one print to another.

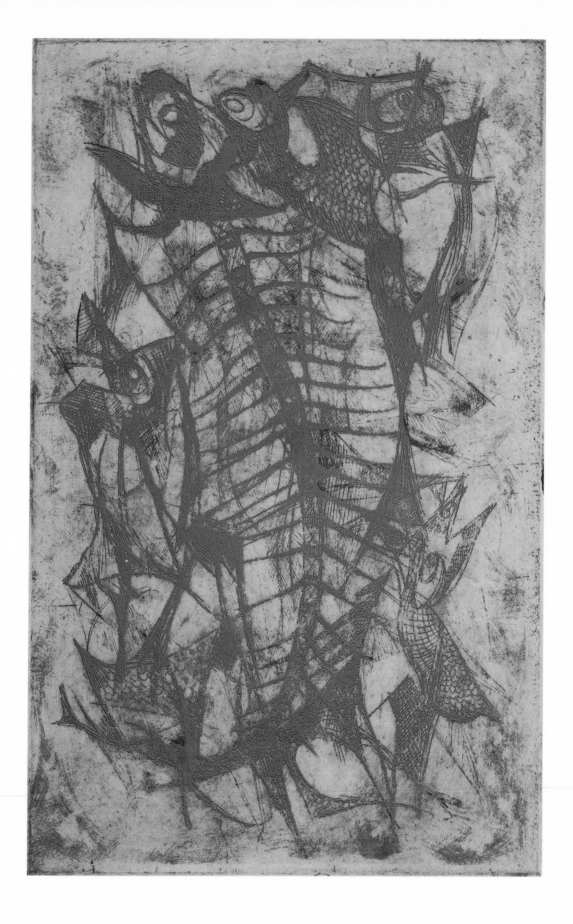

27

AQUATINT

Growth

Aquatint has been widely employed in the reproduction of water-color paintings because it is capable of reproducing delicate washes with considerable fidelity. The method is frequently used in conjunction with the other intaglio processes to give tonal variations.

Most authors attribute the invention of aquatint to Jean Baptiste Le Prince, who produced dated prints in 1768. François Janinet, another Frenchman, introduced color. The process soon spread to England, where it was used to produce the thousands of colored sporting prints so dear to the English heart as well as countless reproductions of the English landscape originally rendered in watercolor. One genius of the nineteenth century, the Spaniard Francisco Goya, used the aquatint method to create some of the most powerful graphic images in the history of printmaking.

This process differs from engraving and etching in that tones and shadings are employed rather than lines. Two principal methods of achieving tones are in use, the dust ground and the spirit ground. In both of these resin is the acid-resisting material.

In the first method a copper plate is dusted with resin powder, leaving a light film on the plate. When the plate is heated, the resin adheres to the surface of the copper and, if properly applied, leaves very small spaces of exposed copper between the resin specks. The pure white areas of the design are painted out with varnish, and the plate is then etched with an acid bath. This first bite produces the lightest tones, as the acid does not eat very deeply into the metal. Successive stages of protecting parts of the plate with varnish and etching other parts make it possible for the artist to secure a variety of tones ranging from pure white to black.

In the spirit ground system the resin is dissolved in ether, which, upon evaporation, leaves particles of resin spread evenly over the plate. The rest of the technique duplicates that used with the dusting method except for the heating necessary with dust ground. Immediately after

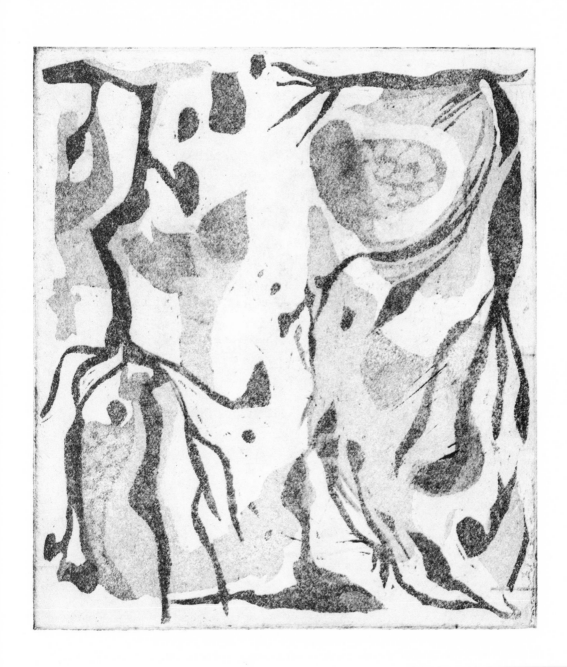

evaporation of the ether, the pure white areas are painted out with varnish. Contemporary artists use the dust method almost exclusively, as it is easier to control. The size of the trays needed for the spirit method would make it an impractical way to process the large plates being used today.

There are many techniques available to the artist for obtaining the tonal ground, some of them chemical in nature, others physical. Technical manuals may be consulted which explain in detail the procedure for sandpaper ground, salt ground, offset ground, *manière noire*, and spray methods. These are only slight variations in ground laying and not of sufficient importance to call them separate printmaking methods. The processes are dissimilar but the end results so nearly alike that examples would be merely repetitious. However, soft-ground etching and lift-ground etching are sharply differentiated methods of laying grounds and will be described in detail later with examples shown.

In this print the dust ground method was used, and several tones were produced by alternately varnishing areas and immersing the plate in acid.

28

COLORED AQUATINT

Plant Forms

Colored aquatints may be produced in several different ways. In the earliest examples of color aquatints, several plates were used, one for each color. Later on, prints were produced with colors painted directly on the paper prior to printing the darkest color, usually black, with a single aquatint plate. In the most popular technique, colors are applied one at a time with a felt stump or *poupée* to their respective areas on a single aquatint plate which has been inked and wiped. One run through the press produces the print. In another system a black and white aquatint impression is made, and then the prints are colored by hand.

In the nineteenth century, experiments were conducted using blocks for flat color impressions over which intaglio plates were printed to

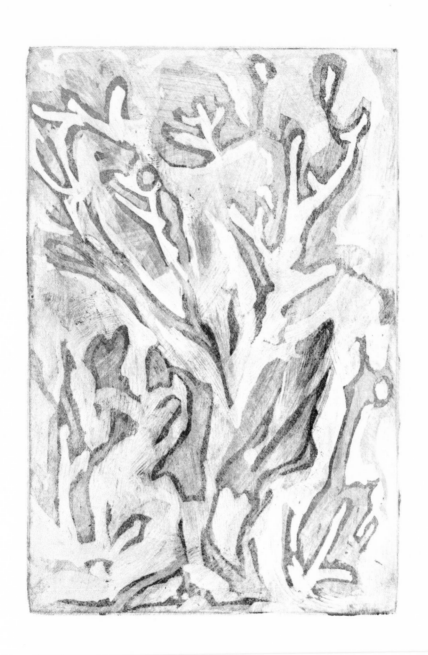

produce variation in tone. The Baxter process was a patented color print method of this type which at times combined as many as twenty wood blocks with intaglio plates. This piling up of ink on the paper through repeated printings frequently produced a tasteless product.

In *Plant Forms* four separate bitings were given the plate to produce four tones. The plate was inked with black and then wiped as in No. 27. Rag stumps were used to apply the additional colors to their proper places on the inked aquatint plate. One pull through the press was all that was needed for each colored print.

29

HAND-COLORED AQUATINT

Quartet

In this example an aquatint plate was planned to achieve strong contrasts in the tones. For this result a fairly heavy biting of the plate was necessary to prevent the hand-applied colors from appearing to float on the surface. The plate was prepared as a black and white aquatint; in this particular case, four bites were given. Water-color washes were applied freehand to the printed aquatint, which had been inked with black. If more accuracy had been desired, stencils could have been employed. Prints produced in this manner are also called tinted aquatints.

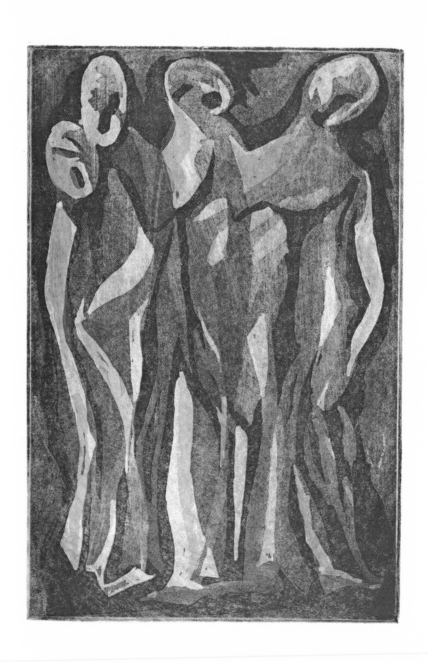

30

THREE-COLOR AQUATINT

Park

In most commercial printing the primary colors, red, yellow, and blue, are used and then overprinted with black. This has certain advantages in that the overlapping of these four colors makes possible the production of most other colors, a system which may also be used in printmaking. Colors may also be chosen without regard to their overlapping characteristics.

In this print three different greens were applied to three separate plates. The three plates were first etched, using an aquatint ground. For the finer tones the dustbox was used, and the coarse-grained areas were laid on with a dustbag from which the resin was sifted by hand. Each plate was inked in a separate color. Printing started with the lightest color and progressed to the darkest. The method of inking and printing was the same as for other intaglio prints.

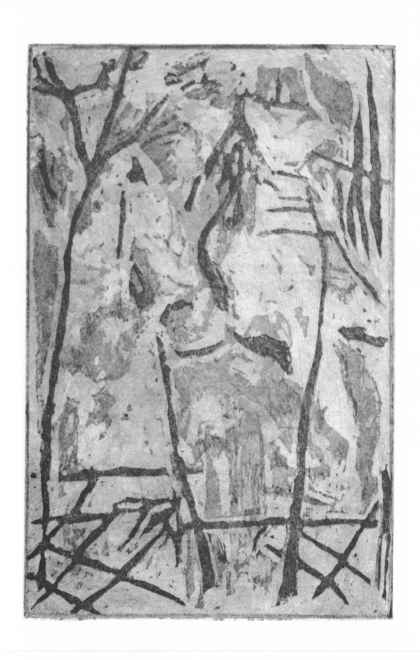

31

COLLAGE AQUATINT

Nude

Collage is the making of pictures or compositions by pasting bits of fabric, paper, tin foil and other relatively flat odds and ends to a canvas or board. The technique usually is associated with the early work of the Cubists, the first examples appearing about 1918. Braque and others employed it in their painting as a means of achieving greater variety in color and texture. Since then collage has been employed by artists to create all manner of effects, some of which are designed solely to startle and shock.

The use of collage in conjunction with printmaking is fairly recent and may have been inspired by the availability of colored tissue, a material flat enough to allow the intaglio plate to print over it. Picasso, Misch Kohn, and others have produced prints using this technique. A drawing or design is needed that has a rather bold outline with some open areas.

In this print the image was made on a copper plate using the lift ground (see print No. 33) and aquatint technique. The plate was inked and wiped, then bits of thin colored tissue paper lightly coated with paste were laid paste side up over the etched base in their proper color positions. The plate and paper bits were then run through the etching press with the printing paper, firmly cementing the tissue to the paper and at the same time superimposing the tones of the aquatint plate over the whole.

Probably the same results could be achieved more easily by preparing the collage on paper first and then printing the intaglio plate on the collage. It might also be feasible to use previously gummed colored papers as well as those types of papers in which the adhesive is of the contact type. Of the newer forms of color printing, the collage aquatint is one of the most promising for the experimenting artist.

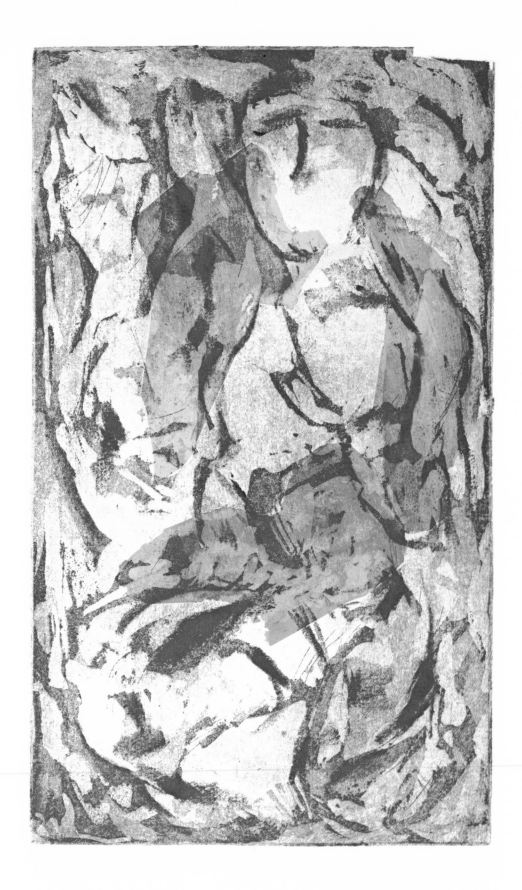

32

SOFT-GROUND ETCHING

The Remains

Soft-ground etching was introduced in the latter half of the eighteenth century, making possible the reproduction of pencil and crayon textures. At that time, when pencil- and crayon-textured drawings were extremely popular, the technique was used by itself. Today the soft-ground process is almost always combined with other methods. Contemporary artists impress lace, cloth, wire, and other textured materials into the soft ground, and when printed these can give some very interesting textural effects. A variation of soft-ground technique called stylotint was developed by the Munich artist Alexander von Kubinyi forty years ago. The prints made by this method are so similar in character to soft ground that no example is included.

To produce a soft-ground etching, a copper plate is heated, and a ground made of half hard ground and half axle grease is applied to the plate with a felt roller. The ground does not dry completely but remains tacky. A sheet of paper is laid over this sticky surface, and the drawing is made directly on the paper using pencil and crayon. The pressure of the drawing implement forces the paper into contact with the sticky ground. The ground adheres to the lifted paper only where the drawing has been made, leaving an exposed textured line on the copper which, when bitten in an acid bath, produces a facsimile of the pencil or crayon stroke.

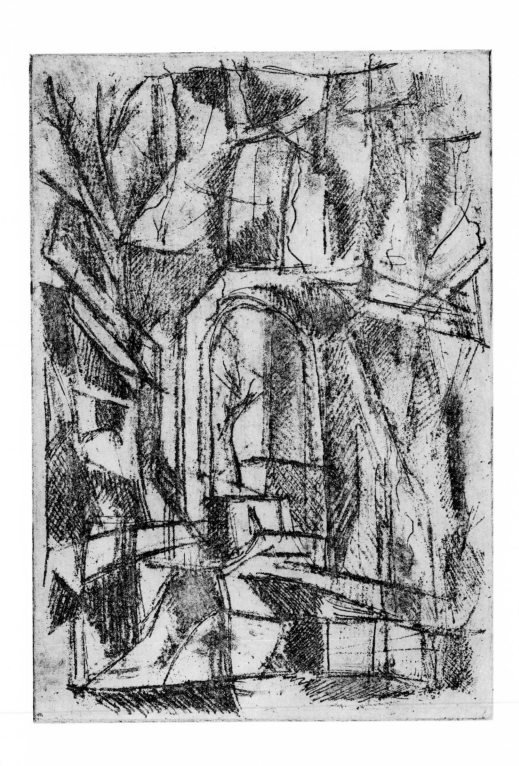

33

LIFT GROUND

Lovers

This is also known as the pen method and the sugar bite. The technique was first discussed in the treatise on etching by Maxim Lalanne in 1880. His methods have since been improved upon by the Hayter group, and it is the process of the latter that is described here.

A mixture of sugar, soap, and India ink is prepared, and with this the artist can produce a monochrome painting on a bare copper plate. The brush is used the same way as if the artist were making a brush drawing on paper. After the drawing is completed, the plate is covered with a liquid hard ground and allowed to dry. It is then immersed in warm water, and wherever the brush strokes have been applied, the ground will peel or lift from the plate. It is sometimes necessary to pinprick through the ground that lies over the drawing, permitting the water to gradually seep under the ground to aid in removing it. After the plate has been dried, resin dust is applied and the plate is processed as an aquatint. An alternate procedure is to lay the aquatint ground first, as was done in this print. Two bites account for the change of tones in the brushwork. In this example reinforcement of the image was produced with the graver and the dry point tool.

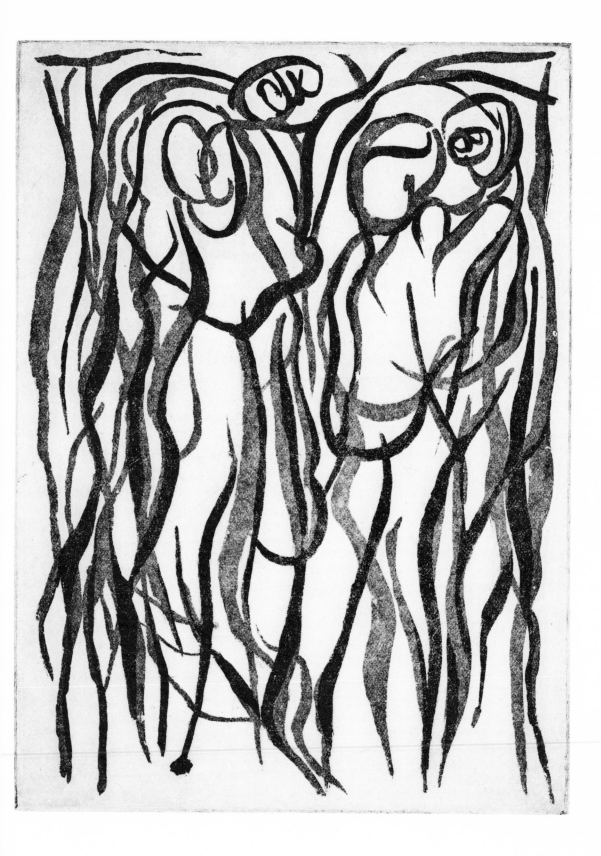

34

MEZZOTINT

Artichoke and Pepper

The invention of the mezzotint is ascribed to Ludwig von Siegen in 1642. Prince Rupert of Bavaria and Abraham Blooteling forty years later finally perfected the method. Both von Siegen and Prince Rupert made prints which we call mezzotints although they differ from Blooteling's.

In the work of the two men first mentioned, a typical line etching was made after which the areas they wished to tone were dotted with a roulette. When the roulette (a toothed wheel fitted at the end of a handle) is rolled over the bare surface of the plate, its sharp points prick holes, which, being printed by the intaglio method, are black in the final print. The number of dots per square inch and the depth of these dots regulate the tone. Corrections can be made with the scraper; that is, the dots may be removed or their depth regulated so that they will hold less ink.

Blooteling introduced the use of the mezzotint rocker, a tool with a curved metal base and a serrated surface. The multiple-toothed curved piece is attached to a short handle, and to produce tones it is rocked back and forth with considerable pressure over the entire copper plate with strokes that must be angled in many directions to insure an even distribution of indentations. If the plate were printed at this stage, nothing but a solid black image would result. To achieve a pictorial image, the artist must, by scraping, remove all the indentations in those areas which are to remain white. These white areas are further burnished and polished. The gray tones are controlled by scraping over the indentations to make them shallower and hold less ink, thus printing a lighter tone. The example presented here was produced by this standard method.

From the very outset the technique was employed mainly for noncreative, that is, commercial, purposes, a fact which is difficult to understand because it has a tremendous potentiality for creative work. The rich tonal qualities in the best intaglio portraits can be achieved in

92

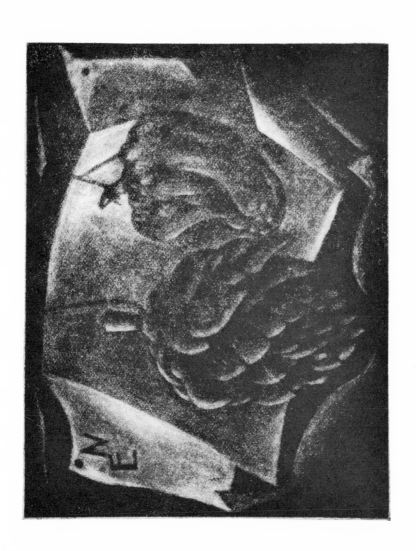

no other way. The bulk of commercial mezzotints were produced in England.

Rocking the plate is dull, tedious labor, and attempts have been made to circumvent this drudgery in preparing the plates. In one system carborundum powder is placed on the copper plate, and the surface is grained in the same manner as a lithograph stone. The action of a heavy weight rotated on the plate exerts the pressure necessary to produce the graining of the surface. Prints produced in this manner are referred to as carborundum prints. Another method uses coarse sandpaper or emery paper. The rough side of the material is placed in contact with the plate, and repeated turns through the engraving press under extremely heavy pressure will produce a sort of grained plate.

35

STIPPLE ENGRAVING

Milkweed Pods

Stipple engraving, crayon engraving, chalk engraving, and pastel engraving are all names which the specialist employs to make distinctions in finished prints. These changes are so slight that only one of the group, the stipple technique, is included.

The method, which was originated in France in the mid-eighteenth century, was widely used to reproduce crayon drawings in black and white. After a copper plate has been covered with a ground in the same manner as for an etching, a line drawing is made with an etching needle. Then roulettes of various sizes and the etching needle are used to make dots which penetrate through the ground. The plate is then etched in the usual way to create the various tones. After removing the ground, the work is reinforced with dots and flicks, which are very short strokes produced with the graver directly on the copper. The manner of printing is the same as that used in etching and engraving.

94

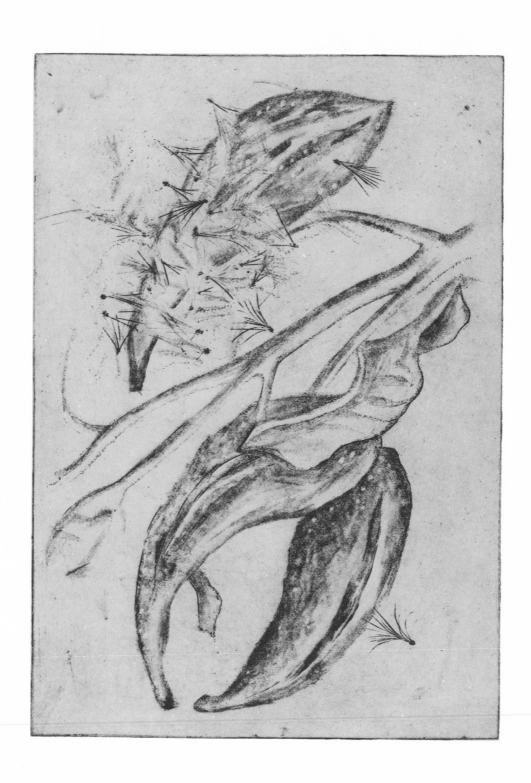

36

THREE-COLOR
STIPPLE ENGRAVING

Venetian Theme

This stipple engraving in color was produced by using three separate plates, one for each color. The preparation of the plates, as well as the printing, followed the same procedure as No. 35.

This method, a slow, tedious way of producing color prints, has never been as popular as either the aquatint or mezzotint processes. At one time, however, there were authorities who felt that of all the hand methods for direct color printing, stipple engraving was the best way to obtain clear color for the reproduction of paintings. With the use of modern photoengraving to reproduce paintings with great fidelity to the originals, techniques like this will probably never be revived. Three-color stipple engraving was just one of the steps in the drive to find cheaper and easier methods of reproduction which lies at the heart of many of the innovations and techniques in printmaking.

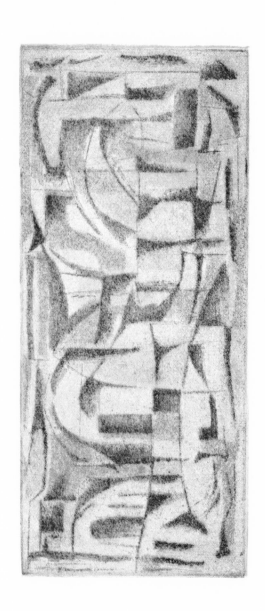

INTAGLIO, MIXED MEDIA PROCESSES

Nos. 37 through 44 form a group of prints demonstrating some of the common intaglio combinations artists use today. The practice of combining, for instance, engraving with etching goes considerably beyond that of simply reinforcing a few etched lines with an engraving tool. Historically, etchers have made alterations and corrections to their plates with engraving tools, but when the printmaker deliberately designs with the idea of contrasting two kinds of line and produces a plate which is approximately half engraving and half etching, he is apt to label the finished print etching and engraving or mixed media. This is a comparatively recent practice.

The prints in this section do not cover all the latest experiments in printmaking. Others are covered in the section called Miscellaneous Processes. Nos. 46 and 47 are recent innovations in which various processes are employed. Because they depend largely on the intaglio method, they are included in this section.

To make this mixture of techniques more easily understood, two series of prints are presented. In each set a simple etching serves as the base. The plate is then processed with another intaglio medium and prints are pulled. A succession of processes and printings follows. By showing the sequence of prints built from the single plate, the various effects obtainable are demonstrated. In the two sets that follow, the numbers and names of the processes of the entire group are listed first. The explanatory material follows and the changes in method are referred to by number.

37-41

Two Figures

The title, which is set in italics, is used for all of the prints demonstrated in the following five stages: 37, Etching and Engraving; 38, Etching, Engraving, and Stencil Color; 39, Etching, Engraving, and Aquatint; 40, Etching, Engraving, Aquatint, and Stencil Color; and 41, Etching, Engraving, and Color Aquatint.

It was known in advance that one plate would serve as a base for the changes needed to produce five different kinds of prints, and a drawing was made that would be adaptable to these ends.

In No. 37, the first stage in this series, the two techniques appear which are to be used throughout the series: etching and engraving. The basic design was etched, and tones were added to some of the spaces with the graver.

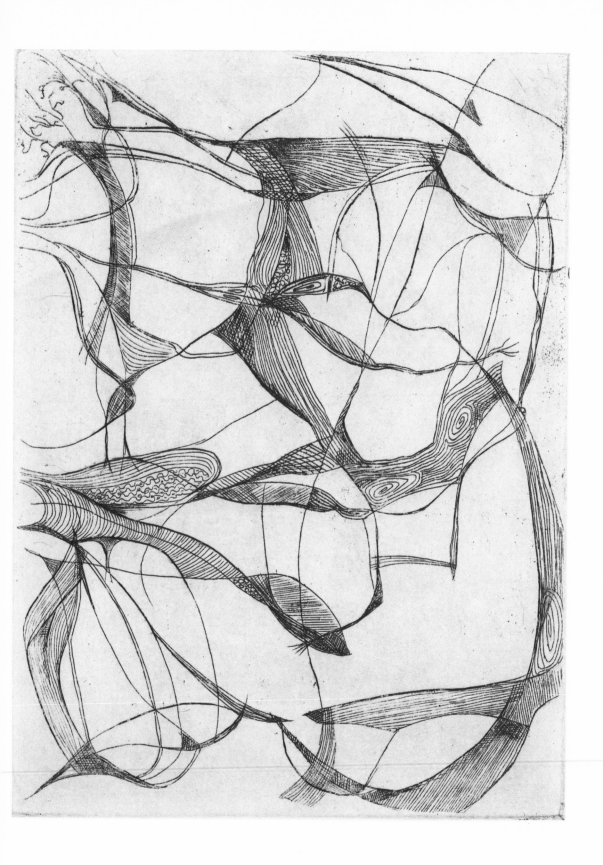

In No. 38, stencil color was added to the above combination. A color scheme was prepared, and from this stencils were cut. Seven colors were applied to the paper by brush through the stencils with waterproof inks prior to the overprinting of the same plate that was used in print No. 37. Waterproof colors are necessary because the paper must be dampened to get a good impression from the copper plate.

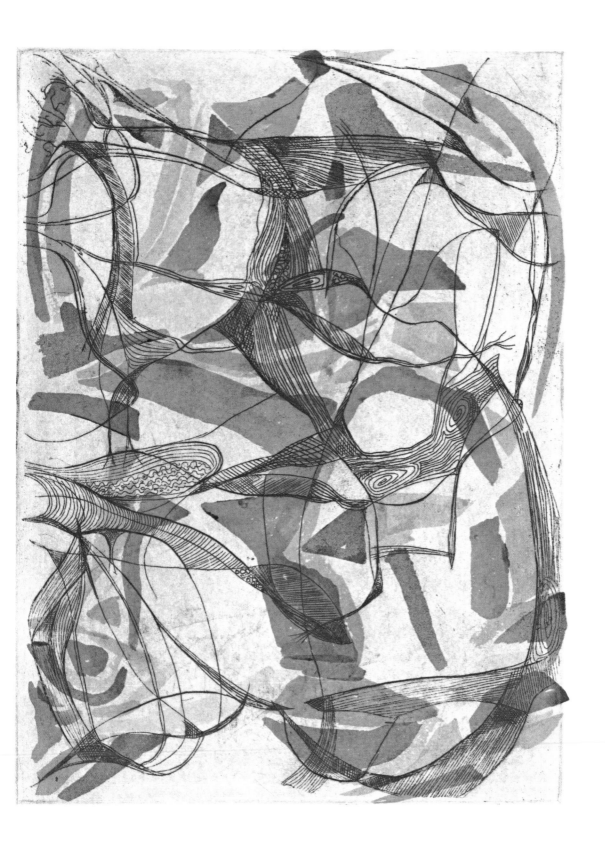

One of the most common of the mixed media methods is shown in No. 39, Etching, Engraving, and Aquatint. In this print the addition of aquatint to the plate previously etched and engraved makes it possible to create a greater variety of light and dark tones.

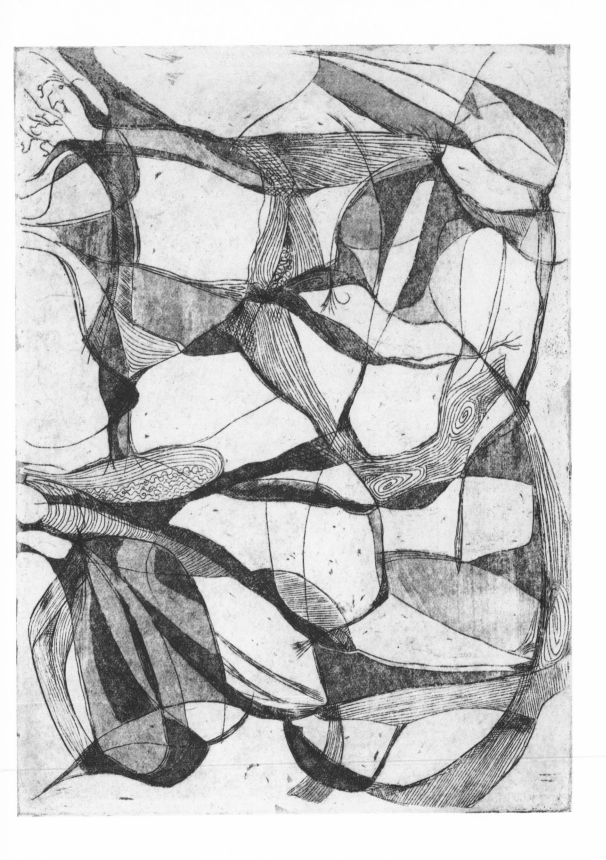

Print No. 40, a combination of Nos. 38 and 39, also employs a stencil, this one cut with three widely separated openings. Very small brayers were employed, and three colors of printing ink were applied directly to the surface of the inked intaglio plate. One run through the press was all that was needed to produce the color print.

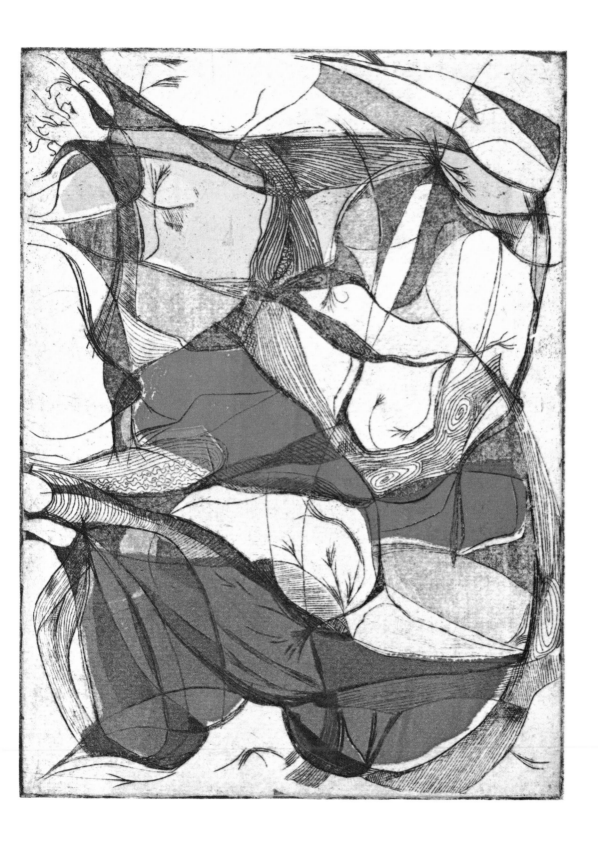

In No. 41, which involves a combination of aquatint with the etching and engraving, two plates were used. Three openings were sawed through the plate at the start of this series. The shapes of these openings were traced on another copper plate, and aquatint tones were etched in these spaces. Three separate colors were applied with stumps to the aquatint areas on this second plate. The plate with the cutouts was inked in black and placed directly over the inked aquatint plate. Paper was positioned over the two plates and run through the engraving press, printing both the color aquatint areas from the bottom plate and the black line work from the top plate in one run.

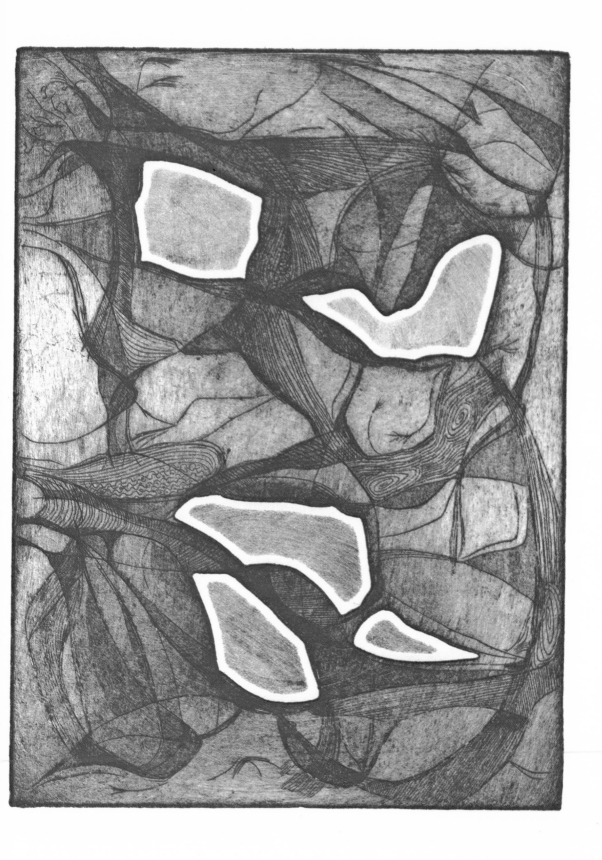

42-44

City Complex

The title, set in italics, is used for all of the prints demonstrated in the following three stages: 42, Etching, Engraving, and Soft Ground; 43, Etching, Engraving, Soft Ground, and Aquatint; and 44, Etching, Engraving, Soft Ground, Aquatint, and Embossing.

No. 42, the first example in this new series of mixed media, uses etching and engraving to establish the linear pattern, and the soft ground is added to produce textural effects. Soft ground was applied to an etched and engraved plate, and on this surface pieces of nylon hose were placed and run through the engraving press. After the nylon was removed, the plate was etched in an acid bath. (For fuller details see explanation of print No. 32.) In this print, stopping out was employed and the plate was etched several times to create the desired tones.

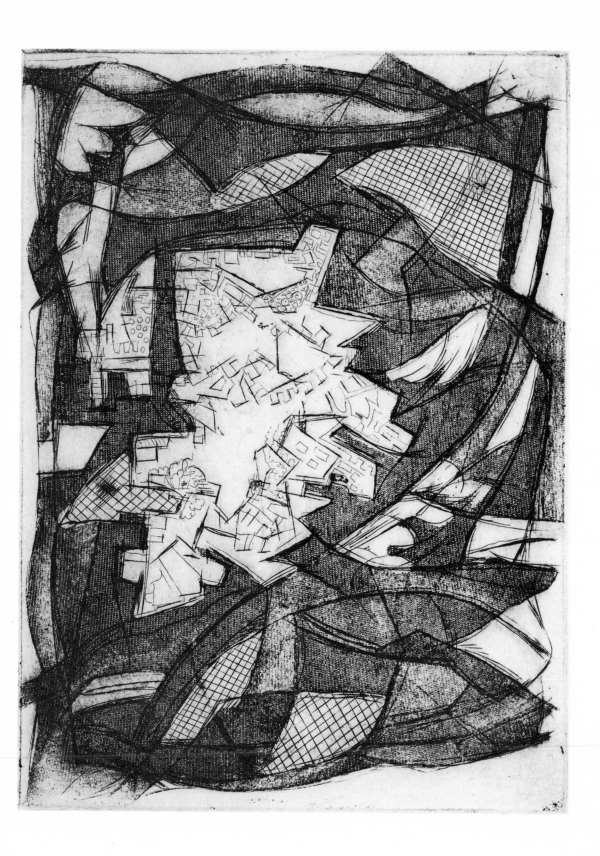

In No. 43, aquatint tones have been added to the plate to create a still greater variety of tones and a richer image.

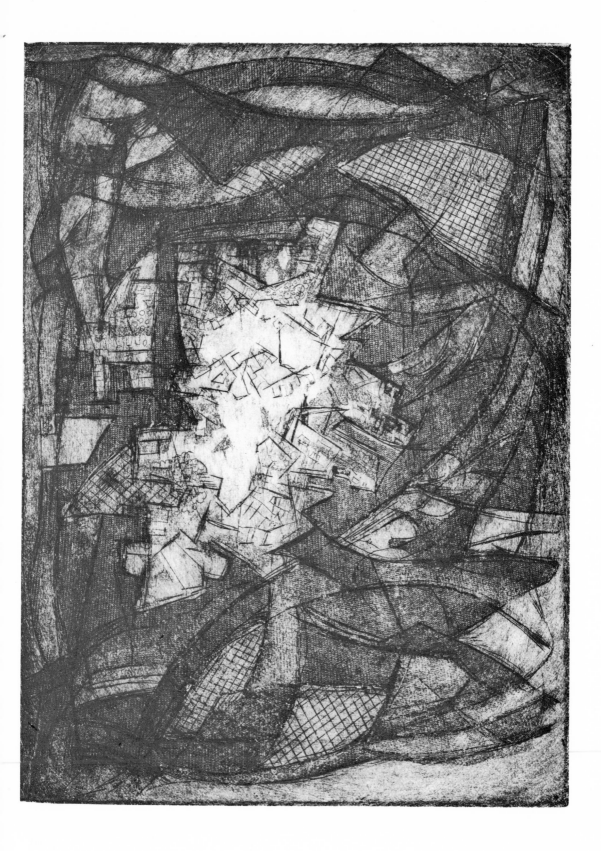

Pure white areas are seldom found in intaglio prints, but they can be produced as in No. 44 by simply sawing holes in the metal, creating areas in the print which receive not even the light tone usually found in the background areas of an etching or engraving. At the same time, due to the greater depth (the full thickness of the plate) these cutout areas are embossed when the paper and the inked plate are run through the etching press. The felts on top of the paper force it not only into the small depressions of the inked areas, but also into the deeper, larger shapes, causing them to be raised in the print.

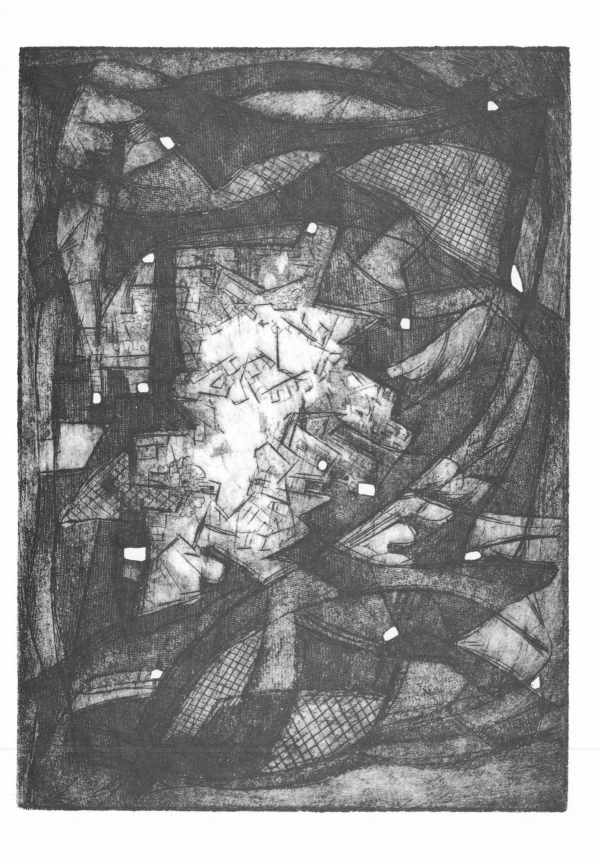

45

PHOTOGRAVURE METHOD

Bathers

The photogravure method is one of two in this collection which are in part dependent on photomechanical means. A painting or a tonal drawing is prepared by the artist. The size of the print is established, and the art work is then photographically reduced to that size by photo-engravers and made into an intaglio plate using the photogravure method.

Bathers, the example shown, was made from a large oil painting. The oil was reduced photographically, and from this black and white photo a commercial engraving firm prepared the basic intaglio plate. At this stage the writer used gravers, burnishers, roulettes, and a small power grinder to add darks, lights, and texture; and it is this aspect of the process which entitles the print to be included in the collection. Inking and printing were performed in the usual manner.

Many of the prints produced by Rouault were executed in this fashion. Original oils and water colors served as the images from which the plates were mechanically prepared, and then, employing the method just described, Rouault worked the plates into shape for final processing as original prints.

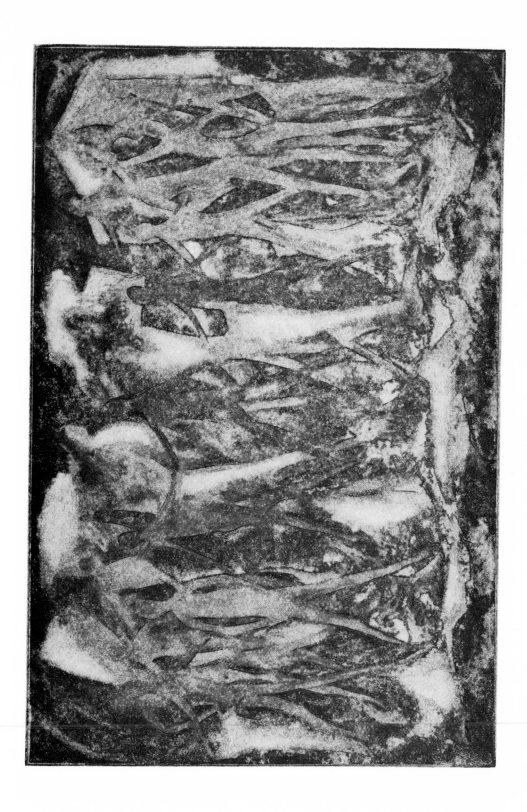

46

ETCHING, ENGRAVING, AND COLOR OFFSET FROM LINOLEUM

Webs

This is an innovation in color printing which has been found particularly useful for making extra-large prints. The job of inking plates in color of the size that have been used in this set offers no serious problems, but when one uses plates that are measured in feet instead of inches, the operation becomes extremely complex. It is possible to apply color to large plates with cloth, fingers, and little rag stumps, and it has been done; but to speed up this part of the work, other solutions were sought. Offsetting from linoleum is one system employed to solve the problem. After the line work on the copper plate has been established by standard etching and engraving procedures, the color areas, usually large and flat, are mapped out and traced on a linoleum block; then the background is cut away. The several different colors are applied with small rollers to one linoleum block prior to printing. This is then printed or offset on the copper plate, which has been previously inked for intaglio printing. The sample included used four colors offset to the intaglio plate, which was inked in black, and as the color lies on the surface of the metal, only one run through the press was needed to produce the print.

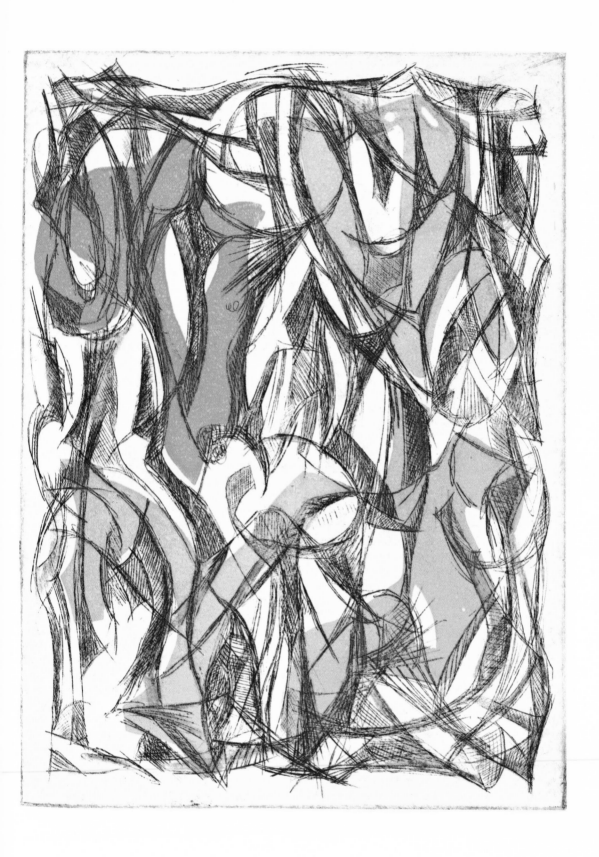

47

THREE-LEVEL INTAGLIO

Shore Patterns

The development of this technique is attributed to Sam Kaner. J. B. Wright, in his book *Etching and Engraving*, tells us that Kaner, an American, went to Paris to study graphics in the workshop of Picasso's printer, Roger Lacourière. While there, he perfected this system of color printing, which was an outgrowth of experiments in deep etch. This process is best adapted to images which are abstract in character.

The first step in the making of the present print was the creation of two levels on the plate. Inspection of the print reveals ten large irregular shapes as part of the pattern. These shapes were traced on the copper and painted with asphaltum. The plate was then etched in a strong nitric acid bath until about half the thickness of the exposed areas of the plate had been eaten away. The asphaltum was removed and the plate was then covered with etching ground. The line design which flows over both the raised and lowered surfaces was next needled and etched. Black ink was first applied to the etched lines and the plate wiped, after which the flat lower surface of the plate was inked with color laid on with small, soft brayers. The top surface of the plate was then inked with a third color by a roller, this time a very hard one to prevent smudging the lower area of the plate. One pull through the press is all that is needed to produce the color print. As a result of the various levels, some embossing is evident.

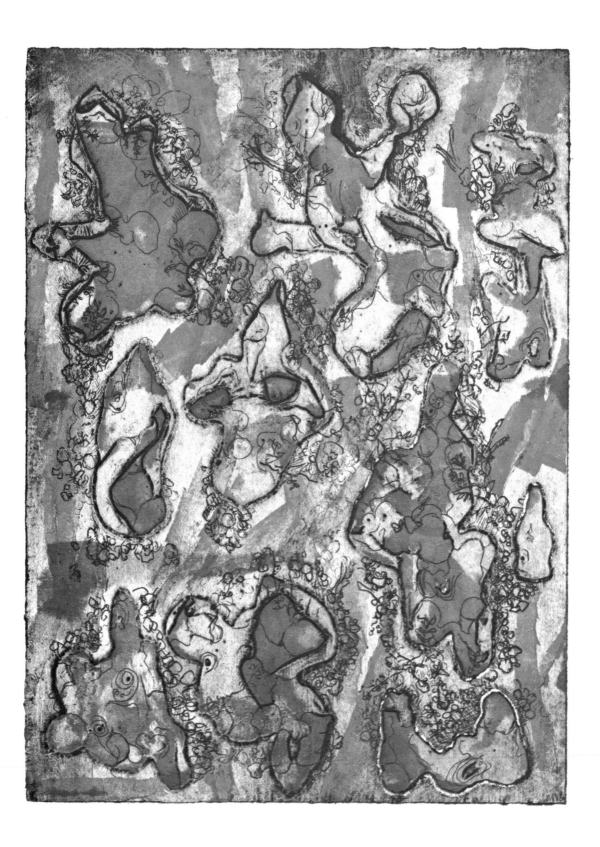

PLANOGRAPHIC PROCESSES

In the planographic category, the third of the major methods for making prints, there are no raised or lowered surfaces from which the impression is made as in the case of the relief and intaglio systems. As the term planographic implies, the printing is done from a plane or flat surface. Two major methods of printing have been developed, collotype and lithography. Collotype is almost exclusively a commercial process, being one of the finest means of achieving high-quality reproductions in black and white or color. The printing surfaces are prepared photomechanically; therefore, this process need not concern us here. Lithography, however, even though widely employed commercially, has unlimited potentiality as a fine art medium.

The term *lithograph* means "stone drawing," and a stone properly planed has been and is still the preferred material on which the artist draws his design, though other materials have been used, among them zinc, aluminum, and specially prepared paper. A lithograph stone, a flat slab of limestone several inches thick, is prepared for drawing by graining it. Graining is the imparting of a tooth to the stone by grinding it with various abrasives and so making it possible to print both gray tones and solid blacks.

The process is a complicated one, even for the simplest black-and-white lithograph. Initially it will be well to describe the procedure in rather simplified terms, reserving the discussion of refinements until the appropriate points in the treatment of specific operations for various types of prints. The image is drawn on the face of the stone with a greasy material, either a crayon, pencil, or liquid. All of these drawing materials are mixtures of a black pigment and grease. The pigment is essential in the process only in order that the artist may gauge the amount of grease he is depositing in a given drawn area. In the steps which follow after the design has been completed, the drawing is removed from the surface

of the stone, leaving only the faint, greasy image which has penetrated into the pores. In printing, the stone is dampened and a roller charged with lithographic printing ink is rolled over it. The moist areas repel the greasy ink while at the same time the drawn areas attract it, thus proving an old household adage that grease and water don't mix. Once the stone is inked, it is printed by placing it on a special press which exerts a heavy scraping pressure and transfers the image, in reverse, from the stone surface to the paper. These impressions, which are called lithographs, may be in black and white or color.

Probably no other method is capable of producing as many completely different effects. Lithographs are made that have the appearance of engravings, wash drawings, crayon drawings, and pencil drawings. They may represent quick and free expressions with the pen or brush or be the result of the artist's painstaking work on each square inch of gray tone. Even in the range of prints shown here, only a limited number of techniques for achieving varied textural effects could be demonstrated and explained.

At the beginning of the nineteenth century Aloys Senefelder invented stone printing, now known as lithography. His book, published in 1818 in Germany and soon after translated into English and French, provides us with the basic method which he used. In his first experiments the background of the image drawn on the stone was eaten away by acid. The results were similar to the relief prints that Blake produced by etching on metal. Later, by experiment or sheer luck, Senefelder discovered the secret of surface printing on which he then obtained patents. By 1809 he was inspector of the Royal Lithographic Establishment in Munich.

Music printing was one of the chief uses of the process in Germany in the first part of the nineteenth century. By 1850 the technique had been adopted on a large scale for making reproductions of paintings hanging in Munich galleries. These reproductions, most of them in color, must be considered as everyday commercial work. In the meantime, amateur artists in England and France had taken up lithography as an easy means of multiplying their drawings. Some of the artists whose work in the nineteenth century helped establish the technique as an art form were: Isabey, Daumier, Manet, Delacroix, Géricault, and Fantin-Latour. The finest lithographs produced in France and England were by Alphonse Legros and Whistler respectively, men whose names are

more familiarly associated with etching. In Spain, Goya was responsible for producing some outstanding lithographs, among them his series of four bullfights which was printed in 1855. The lithographic technique spread rapidly through Europe and within one hundred years had evolved into a cheap method of quantity printing. It is possible that the mass of tasteless commercial material produced by this method in the nineteenth century discouraged many an artist from using it as an art form.

The twentieth century has seen a revival of interest in the use of the lithographic method in the work of such masters as Matisse and Picasso, but even as late as 1929 the state of lithography was still at such a low level in this country that Bolton Brown, in his Chicago Art Institute lectures, stated that he was the only American artist-lithographer who could pull an edition of prints. We have come a long way since then; many artists today not only produce lithographic prints in black and white but have made remarkable strides in the field of color printing. One of the most recent revivals of lithography as a creative medium has been on the West Coast at the Tamarind Lithographic Workshop. The initial idea was launched by June Wayne when she applied to the Ford Foundation to set up the program for three years and they agreed to support the experiment. The objective is well stated in the group's exhibition catalog: "The design of Tamarind proposed a three-year rescue operation, a self-liquidating experiment intent on creating conditions for the survival of the medium."

48

CRAYON LITHOGRAPH

Roman Cats

Until recently most of the lithographs that were produced looked like shaded pencil or crayon drawings. The drawing materials used on the stone for these crayon or chalk lithographs come in the form of small square sticks called crayons or in the shape of pencils and are numbered according to their grease content. The stone is prepared for drawing by graining it, imparting a tooth, and at the same time removing all grease from the surface.

The image may be developed quickly and directly on the stone, or the artist may follow a carefully planned preliminary sketch. The varied gray tones so characteristic of this type of lithograph can be secured by careful, tedious pencil drawing, by laying in areas with the side edge of a crayon, or blending previously drawn areas by rubbing with a piece of flannel or chamois wrapped around the finger. Tones can also be added to undrawn areas by rubbing with a chamois which has had crayon or rubbing ink applied to it. Small corrections can be made with a pumice stick or razor blade.

Once the drawing is completed, it is etched with a solution of gum arabic and nitric acid. This etch holds the ink in position even though it removes the substance of the crayon drawing, and it also opens up the pores of the blank areas, making them more water absorbent. It should be understood that this etch does not raise or lower the surface but does set off the proper chemical reactions.

The stone, having been placed on the bed of the press, is moistened, and then the roller charged with greasy lithographic ink is rolled over the drawing. After the stone is properly inked, the paper, either dampened or dry depending on the kind used, is placed on the stone and covered with several blotters and the tympan. The scraper bar is brought into position and the whole is cranked through the press. The wetting of the stone and inking have to be repeated for each print.

Roman Cats was drawn with both crayon and pencil, and some rubbing was used. This technique is seldom employed by contemporary

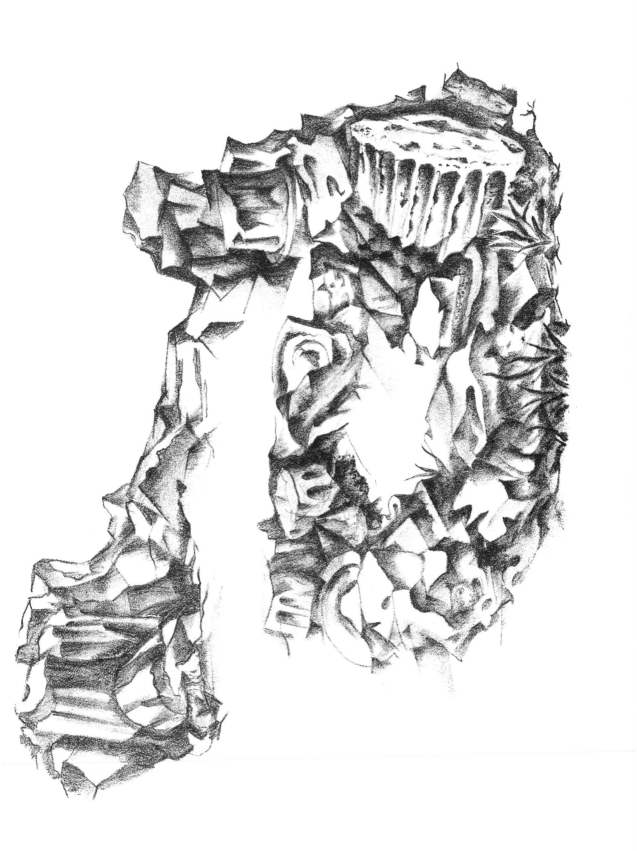

printmakers, no doubt because a great deal of time is required to produce the blacks and darker tones used by many artists today.

49

LITHOTINT

Whitefish Bay

Of all the lithographic techniques, lithotint is perhaps the most difficult process, and some authors warn the beginner not to try his hand at this until he has had considerable lithographic experience. The prints produced through this method look like black-and-white wash drawings. The technique was developed by Charles Hullmandel and Richard Cattermole, who appear to have been the first to achieve successful prints of this type.

The drawing is made on the stone by applying washes of lithographic ink with a brush. To achieve gradations of tone the ink is thinned with water. To control the light and dark gray areas is difficult, because a stone will look dark when simply moistened with water. If too much water and not enough ink is used, no tones will print, and if too much ink is used, these areas will print solid black. The problem is further complicated when the etch is applied. The grease layer in a wash is much more delicate than in a crayon drawing where the pressure of drawing forces the crayon into the pores of the stone. Consequently, if too strong an etch is used, all the light tones will disappear; if too weak an etch is applied, the image will clog up and print black, making the printing of an edition impossible. In this print, some of the problems were avoided by falling back on an old commercial lithographic practice. After pulling a proof or two, the inked stone was dusted with resin powder which was then burned in with a blowtorch. Melted resin is acid-resistant, thus making it possible to use a much stronger etch. After this was done, no difficulties were encountered in running off the twenty prints needed for the first edition.

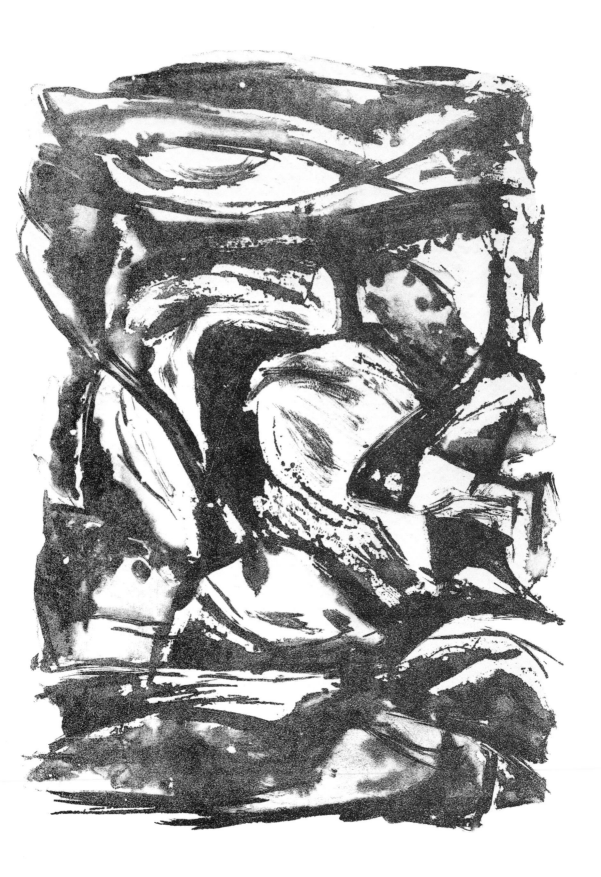

50

LITHOGRAPH ON TINT

Lakeside

One of the simplest methods of obtaining color in a print is through the use of a tint block. These blocks are employed to print flat background colors, and their use is not restricted to the planographic process. After the flat tint has been laid by imprinting the first stone, a second impression with a design, usually a dark color or black, is made over this same area. The first color, generally being light in tone, gives the name *tint* to the process.

To produce the print shown, two stones were used; on the first a rectangle was laid out and painted in solidly with tusche, a black greasy ink, while on the second a design was drawn matching the first rectangle in size. The drawing was made by first blocking out the pure white areas of the design using gum arabic applied with a brush. The blended tones were made with a chamois impregnated with rubbing ink, the final touches being added with lithographic pencils. Preparation of the stones and the printing are the same as for a crayon lithograph.

The method described here provides an easy and inexpensive way to achieve a second color and was frequently employed in book work at the turn of the century.

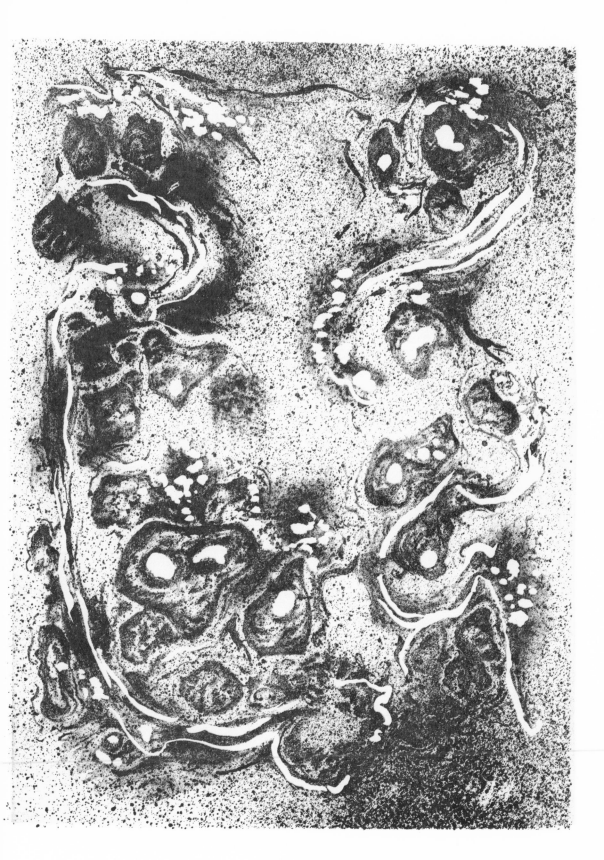

51

FOUR-COLOR LITHOGRAPH

Elliptical

Color printing using the lithographic technique first appeared in 1837 and was patented in France by Gottfried Engelmann, who called his process *chromolithographie*. Prints made in this manner first appeared as illustrations in English books about 1840. The word *chromo*, according to Webster, is synonymous with chromolithograph, but its usage in print circles today implies a low-quality reproduction. Unfortunately, the bulk of the work done in the last half of the nineteenth century was tasteless in character, but a few artists did produce work of significance. The posters of Toulouse-Lautrec and the prints of Pissarro, Manet, and Degas immediately come to mind. In the present century Matisse, Picasso, and Braque, employing commercial printers, have produced bold, powerful work in color.

Only recently has much been done in the United States, but, spurred on by organizations such as the Tamarind Workshop, a considerable increase in activity and improvement in quality are observable, and artists may yet produce lithographs on a par with the best of the European work.

In a prospectus for an international print show, a color print was described as one in which the image was printed in color. Thus a simple linoleum cut, if it were inked with green ink instead of the usual black, would be classed as a color print. Undoubtedly this is an accurate designation, but printmakers, by and large, think of color prints as involving more than one color and it is this concept that has been adhered to throughout this volume.

In the print shown, four colors were used: yellow-green, orange, red-orange, and black. A water-color sketch was made first from which outline tracings of each color were made. These color separations were then traced on four lithographic stones and painted in with tusche.

The work may be printed on either dampened or dry paper, depending on the nature of the original drawing. If the printing paper is moist, some stretching and distortion takes place as it is pulled through the

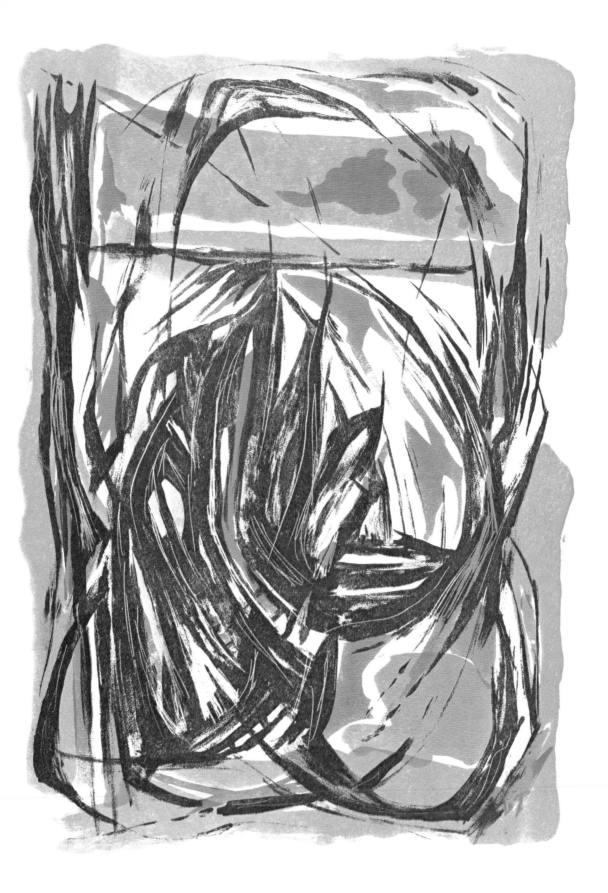

press; therefore, if very close register (the accurate placement of one color next to another) is important, it is probably wise to print dry. The problem of register is discussed further under No. 52. It will suffice here to mention the method used in the present print; namely, the placing of a line at the top and another at the side on each stone, measured out from the edge of each color separation drawing, to serve as guides for the top and side edges of the printing paper. Composition rollers are used for inking all but the black stone, and it is usual, as was the case in this print, to start printing the lighter colors first, although interesting color results may occur in working from dark to light. Obviously, the print goes through the press once for each color.

52

ELEVEN-COLOR LITHOGRAPH

Puppet Cupboard

This lithograph differs from the four-color example in several respects: the first being the number of colors employed; the second, the gradations of tone that occur; and the third, the manner of registering the colors.

For this print eleven stones were prepared, one for each color. A water-color sketch served only as a rough guide in making the color separations, no attempt being made to create an exact reproduction of the original.

Regardless of how free the interpretation may be, an outline of the image has to be established and transferred to the stone, and each color area must be translated into tones of gray. (The drawing on the stone with the greasy crayon is in black. Hence, if the stone for printing the red areas is being prepared, the shadings of light or dark red will be achieved by lighter or heavier pressure on the crayon or by the use of crayons containing more or less grease.) Every stone, when completed, represents a single color in the print; and the light and dark gradations are rendered, in the present case, with lithographic crayons or pencils. In preparing the separate stones for the various colors, some images were drawn on the stone directly and some were done on transfer paper. (For this technique, see the explanation to No. 56.) After processing they were rolled up in their respective colored inks for printing. There is a wide range of opaque and transparent colors available to the lithographer, a combination of which are frequently used in order to achieve more subtlety and greater richness.

Register in color lithographs is achieved by a variety of means, a simple method being used in this print inasmuch as hairline accuracy was not needed. Three fine crosses were marked on the master sketch for guide points, one at each of three corners, all about an inch and a half away from the picture area so that when the print is completed they can be cut off, as they will lie outside of the margin of the print. These crosses are registered on each stone. After the yellow color, the first to

be printed, had dried, the individual prints were turned over and placed on a tracing box, and the crosses were marked exactly on the back of each print. A hole was then made at the intersection of each cross with a paper punch, thus forming a little peep hole, the ends of the cross still showing. The print, now ready for the second impression, is laid down over the inked stone and gently positioned until the crosslines on the stone match those on the back of the print, and it is then pulled through the press.

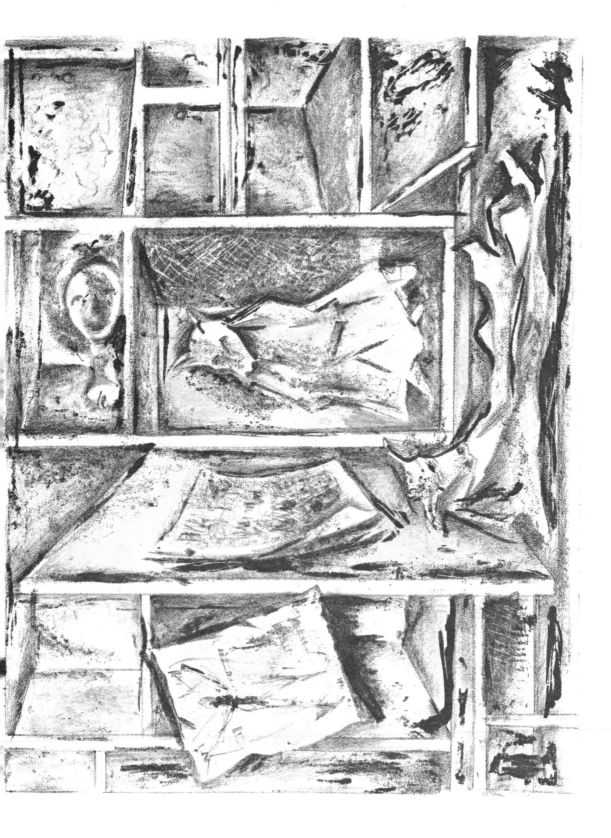

53

HAND-COLORED LITHOGRAPH

Landscape

A lithograph is printed as described in No. 48 in either black or a dark color, and the prints are individually colored by hand with water colors. In this print three colors were applied with a brush to the white or open areas of the abstraction. Some of the unpleasant qualities associated with hand coloring stem from the application of color over the gray or tonal areas in the print, an effect purposely avoided here.

If the inclusion of a hand-colored lithograph annoys some purists, perhaps they should try to understand Adolf Dehn's point of view. In his book on lithography he states that he is aware of the antagonism to hand coloring but that he personally likes to hand color some of his prints and is not averse to sending these to major shows. Certainly there are enough good historical examples to justify his doing so, if such justification is needed. And while Dehn does point out that for some reason landscapes do not lend themselves to hand coloring, this still leaves the artist a wide range of subject matter.

The gray tones in this print were achieved with lithographic pencils and crayons. The solid blacks were painted in with tusche. Black and white flecks which appear in some areas were made by jabbing a pointed lithograph pencil against the stone over a lightly drawn gray tone. The force of this action makes a dark mark and simultaneously removes a bit of underlying gray to make a light fleck. Close inspection will reveal some thin white lines at the ends of the branches and on the edges of the drawing. These are achieved by using a sharp engraving needle to cut through the tones. In doing this, a small portion of the stone's surface is removed.

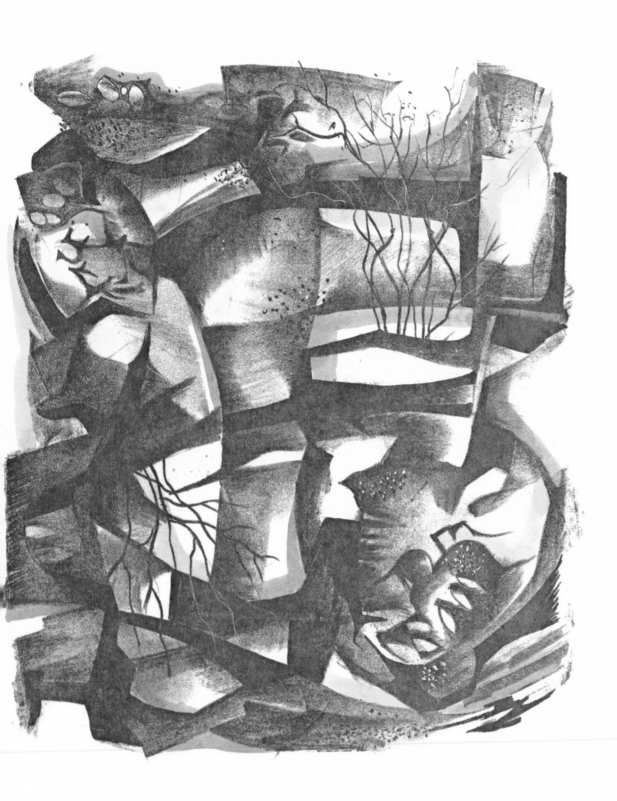

54

LITHOGRAPH, TUSCHE METHOD

8 A.M.

Tusche, as mentioned before, is a prepared greasy compound in liquid form, used with a pen or brush as a drawing material. A rectangle is laid out on the stone and then, using a brush, tusche is used to paint this area solid black. Several coats are applied, allowing each to dry before adding the next. The image is drawn by using sharp-pointed tools to scratch through the black surface, revealing the light-colored stone. Larger areas can be cleared out with the flat edge of a razor blade. If desired, the artist can block out areas of white with a solution of gum arabic applied with a brush prior to the application of the tusche. After completing the drawing, the stone is treated to a stronger etch than is usual for a standard lithograph.

This lithographic method makes it possible for the artist to produce quite a wide range of effects. These may be very detailed and have the character of a wood engraving or, as in our example, may be handled very loosely. In this print solid black areas of tusche were painted in with a brush. Scraping over these areas with a razor blade produced the gray tones. Some of the textures were made with an etching needle, while others were produced by rolling a brayer over a screen.

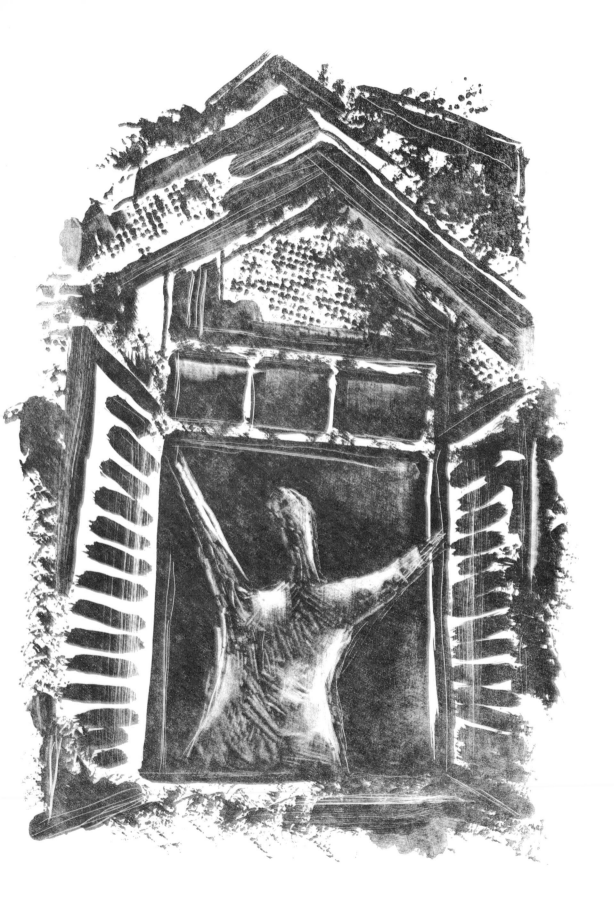

55

PEN-AND-INK LITHOGRAPH

Woods

Undoubtedly the lithographic medium is best suited for work in which gradations of tone are used to convey the image. However, it is also capable of producing the quality of a pen-and-ink line drawing. Some authors point out that a stone is not the best surface on which to make a pen drawing, and it is true that if extremely delicate lines are wanted the drawing should be done on transfer paper. (See No. 56.) If the drawing is to be made directly on the stone, and no halftone quality is necessary, the surface of the stone should be as smooth as possible. This is achieved by graining it with a very fine carborundum grit and finally polishing it with a Schumacher's brick.

Most authorities mention the use of a crow-quill pen as the drawing tool. In this print a drawing was made using both crow-quill and other drawing pens, making it possible to achieve greater variety in the width of lines. Corrections were made with a scraper. The ink must be of a greasy type; either tusche or lithographic stick ink diluted with water or turpentine may be used. Preparation for printing, as well as the actual printing, is the same as for print No. 48.

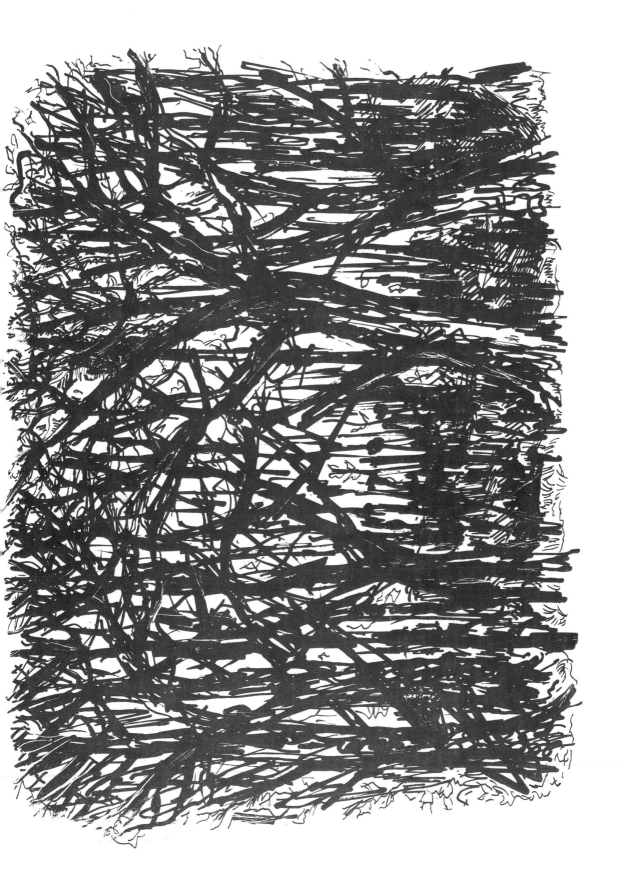

56

TRANSFER LITHOGRAPH

Miscellany

Lithograph stones are not only clumsy but also heavy; they are not the sort of material one carries around when sketching. The transfer method is the answer to this problem. The technique depends on the use of a specially prepared paper that can be purchased or prepared by the artist. It is on this paper that the artist makes his drawing.

Transfer paper has a coating, usually some mixture of starch paste and plaster of Paris, which when dampened makes possible the transference of the lithograph image to the stone by pressure. This paper can be drawn on by using any of the conventional lithographic materials. Upon completion of the sketch, the transfer is placed face down on a dampened stone, protective paper is placed on top, and the whole is pulled through the lithographic press several times. The protective sheet is removed and the transfer paper is dampened and run through the press several more times. After several dampenings, the paper is peeled back gently and, if all has gone well, the drawing will have been transferred to the stone. At this stage processing is carried out in the normal manner. Not long ago transfer prints were regarded as inferior products, a belief held by many artists who thought working on the stone directly was the only legitimate method. This assumption may have been valid in the days when the lithographic artist spent hours putting down tones with a pointed crayon. But it is doubtful whether very many people looking at today's lithographs could tell a transfer print from one produced by drawing directly on the stone.

The drawing for this print was made on commercial paper using a hard crayon. A comparison with print No. 48 reveals some coarsening of the tones in the transfer. Aside from the obvious advantage of less weight, transfer paper is also useful if the image must be printed without reversing as in the case of lettering.

144

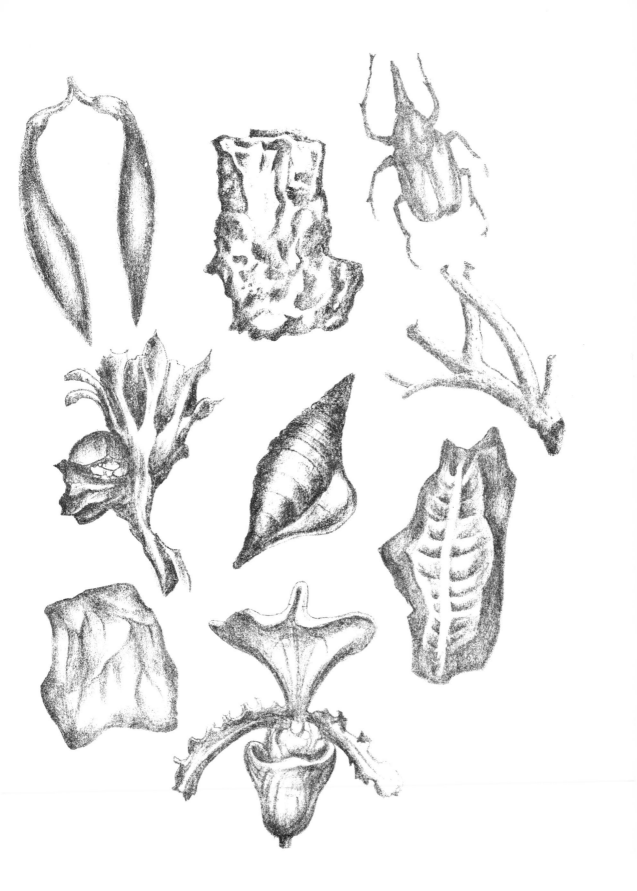

57

LITHOGRAPHIC ENGRAVING

Weeds

The process of stone engraving, while capable of producing art works, is essentially a nineteenth-century commercial process used chiefly for script and linear drawing. Sharpness and precision are possible, and it was admirably suited for the making of maps and stock certificates.

Blue and gray lithographic stones are used, and the surface is prepared by first graining and then polishing with a Schumacher brick. A solution of concentrated oxalic acid is applied to close the pores of the stone, which is then polished with a cloth to make the surface shiny. The drawing area is coated with a solution of gum arabic to which soot has been added to enable the artist to judge the progress of his work, for the engraved lines will stand out sharply against the dark ground. When the gum has dried, the drawing outlines are traced on, and the actual engraving is done with either an etching needle or a diamond pen.

The tools used in the drawing not only remove the gum from the surface but cut into the stone. When the drawing is completed, lithographic printing ink is rubbed into the lines. The gum is washed off and the stone then processed in the usual manner.

The intaglio character of the lines makes inking and printing more difficult to do than in normal lithographs. In making this print a soft paper was used that had been dampened prior to printing. Felt blankets were placed over the back of the sheet in place of the usual blotter to force the printing paper into the engraved lines in the same manner as for intaglio printing.

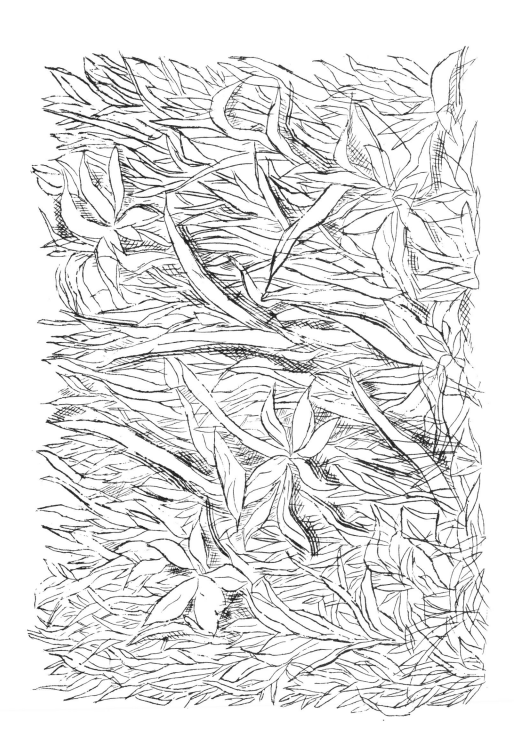

STENCIL PROCESSES

Stenciling, that is, the use of an open pattern through which color is applied, has been in use for centuries as a means of imparting designs and marks on a great variety of objects. Stencils were extensively used in making decorative patterns, particularly where many repetitions were needed, as in textiles. Patterns also have been applied to wood and to paper, the latter being of particular interest here.

The craft originated in China some time between 500 and 1000 A. D. and was passed on later to the Japanese, who used it extensively. The technique was also employed by craftsmen in India and Persia, and the Romans and Egyptians were also adept in this field. Hind, in his *Introduction to History of the Woodcut,* mentions that one of the earlier uses of stencils in Western Europe probably was the coloring of wall hangings and playing cards in France and Italy during the fourteenth century.

During the sixteenth century, stencils were used to add color to woodcuts, in particular those that were used as broadsides, and to monochrome illustrations in books, a practice which became particularly popular in France in the seventeenth and eighteenth centuries and which is still used there for small editions of books. *Pochoir,* the name given to this method of adding color to line or tonal drawings, whether printed from hand-processed plates or photomechanically produced ones, now uses celluloid or very thin copper or zinc stencils through which the colors are brushed by hand. It is a technique admirably suited to small editions in which a great many colors are used, as it is more economical than the use of photographically prepared plates and additional runs through the press for each color.

Materials used for stencils in the past have varied from tough paper to fabric or wood; today's stencil is usually made of a waxed sheet of paper or a thin metal plate. Results as complex as the Oriental type require not only a very high order of craftsmanship but the right material from which to make the stencil. The Japanese had at their

149

disposal a tough mulberry bark paper of very fine texture which was waterproofed with persimmon juice, a combination which made possible the cutting of amazingly detailed openings which would still be strong enough for the subsequent process of coloring. Until recently, a suitable material for stencil printing was not available in the United States. The product sold as stencil paper was actually a stiff sheet of oiled cardboard, a difficult material to cut. It was satisfactory for the simple, bold letters used on shipping crates but not good enough for most artistic requirements. The situation improved when Professor Emy Zweybruck, recognizing the potentiality of the technique as a fine means of expression for children, persuaded the American Crayon Company to manufacture a stencil paper that is translucent, tough, and yet easily cut.

One of the basic problems in all stencil cutting can be best explained by the following example. Assume that someone wishes to make a picture of a doughnut or the simple letter "**O**." Whether he cuts one or both the two circles representing the object, all that is achieved is a round hole. The problem is easily solved by the use of connectors or bridges which act as a support to hold the inner section in place; but, when this method is used, the doughnut or letter "**O**" will have a break in its form and will look like this: "**()**." The Oriental method of supporting these centers is to glue them to a light silk net or anchor them into position with strands of human hair which, being thin, will not appear in the finished print. Regardless of the particular method, the stencil technique had not gained very wide recognition among serious artist in the Western world until the late 1930's, though there were some works by Miró, Picasso, and a few others in this medium.

The invention of the silk screen process shortly after 1900 solved the problems of the stencil bridges and connectors in a simple, direct fashion widely employed today commercially and by fine artists. In its most elementary form a silk screen stencil is made by stretching a piece of silk on a light wooden frame. The letter "**O**" which we discussed earlier can now be painted on this taut surface with a brush and shellac. When dry, the painted area of the silk has been rendered nonporous while the other areas of the silk remain open. The frame, silk side down, is placed over a sheet of paper and is now in position to print. The paint is poured into the frame at one end and a squeegee, a stiff rubber blade in a wooden handle, is pushed over the surface of the screen from one end to the other. This operation forces paint through the open areas

of the screen but not through the shellacked areas. Assuming that the paint is red and the paper white, removing the paper will reveal a print of the letter "O" in white against a red background. Duplicates are made by repeating the squeegee operation on fresh paper for each print. Because the process is simple and inexpensive, it has been used extensively for multicolored work. There are several ways in which stencils can be prepared, each method having its own distinct characteristics. Several of the techniques most frequently employed by professional printmakers are shown in this section, and in the children's section there is an example of the simplest type of screen stencil. (See print No. 95.)

Information relating to the early history and development of this technique is not clearly established; we do know, however, that patents were issued in 1907 to Samuel Simon, an Englishman, which describe the silk screen methods much as they are followed today. In 1915 a multicolor process which was being used in California to print banners and pennants was also patented. From here the craft spread to the East Coast and was taken up rapidly by advertising men. The textile industry was the next major user, and from there it moved into all the areas where printing was employed. Until 1938, however, there had been no application of the technique to printmaking; it was then that Anthony Velonis encouraged the New York WPA Federal Art Project to start experiments exploring the process as a fine art medium. Within a few years it had become extremely popular. On the occasion of one of the first exhibits of silk screen prints in New York, Carl Zigrosser gave the name *serigraphy* to the process. Since then this term has served to distinguish the fine art product from those items produced solely for commercial purposes.

58

STENCIL, WATER COLOR

Opposition

The preparation of stencils for a color print requires careful planning in advance, as the technique is not suited to express concepts directly. For this print, drawings and then a color sketch were made. The various color areas were numbered on this color dummy to facilitate transferring the different areas to the stencil paper. A separate stencil was made for each color. Thin stencil paper, the material used, has a waxy surface impervious to water. Its semitransparent character makes the task of tracing and registering the stencils fairly simple. Five stencils were cut using sharp knives and razor blades. Water colors mixed with white to make them opaque were painted through the openings with a water-color brush, the lighter tones being applied first.

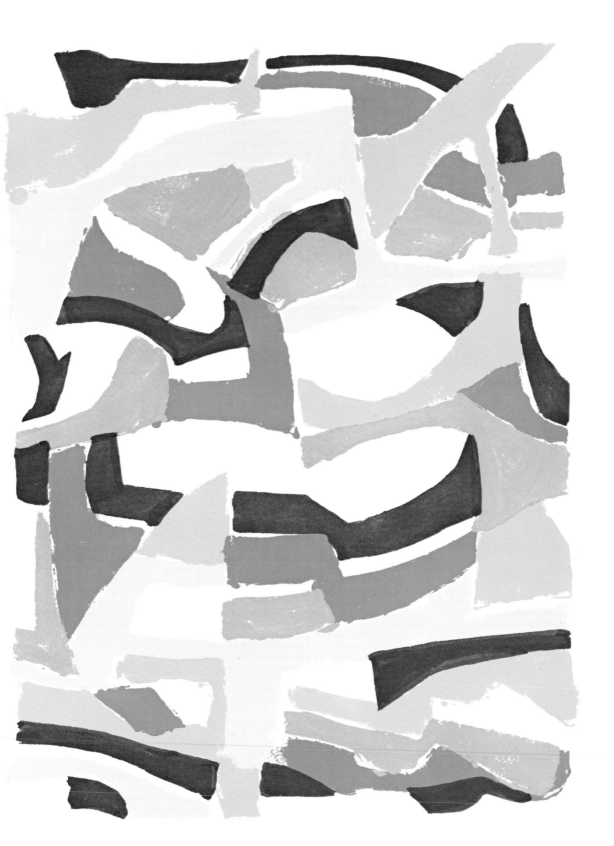

59

STENCIL, COLORED INKS

Waupaca

Precise pen drawings from nature served as guides from which six stencils with many small, clearly defined openings were cut using a frequently sharpened cutting tool. Color can be applied through these minute openings with a brush or by spraying. In this print, transparent colored inks were sprayed on with an air brush. To create the total image the individual stencils were placed in more than one position in the pictorial scheme, as well as being reversed, and each time their positions were changed another color was employed. Thus superimposing the colors and shapes can lead to complex and varied effects, while a rearrangement of the six stencils will create different compositions. Richer effects are obtained by using transparent colors, as their overlapping creates new tones and values not possible when using opaque media.

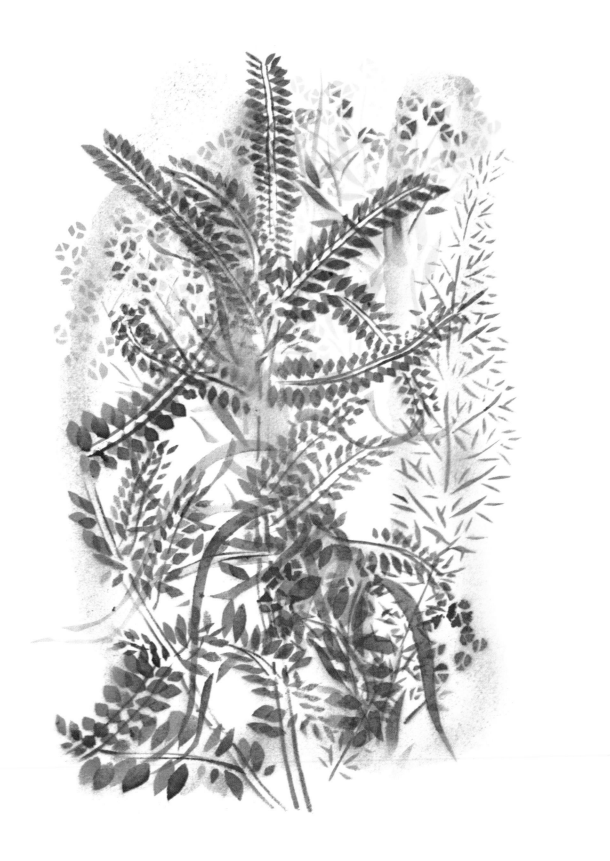

60

SERIGRAPH, BLOCK-OUT METHOD

Patches

The silk screen process, when undertaken by a serious printmaker, raises many problems which must be resolved before work on the actual print begins. The decision of which technique to employ to express the image in mind is just one and perhaps the simplest to make. Several of these techniques will be described later.

Another problem, the selection of the right materials when so many are available, can be frustrating. The choices, including cloth for the base, block-out materials, and printing colors, depend in part on the length of the run, that is, the contemplated number in the edition, but mainly on the expressive qualities of the image. The size of the print and crudity or fineness of the work must be considered, not to mention the cost factor of production.

While most authorities agree that silk is the best base for most work, today organdy, as well as bronze, copper, or brass wire cloth, may be used. All of these materials may be obtained in various meshes and widths. As for block-out materials, a number are available, among them glue, lacquer, varnish, or prepared screen fillers. Any of these will cover the areas that paint should not penetrate during the printing process. The choice of printing colors is also wide: oil paints; specially prepared screen colors, both oil and water based; metallic paints and dyes; and enamels and lacquers.

Once these decisions on technique and material have been made, the artist is ready to prepare the screens from which the print will be made. In the following set of serigraphs, because the prints are small, silk was chosen as the base material. Because silk is semitransparent, any drawing placed beneath it can be seen, making the problem of registry and the disposition of color areas relatively simple. Screens may be developed by working from carefully prepared color sketches placed under the silk, the area for each color being carefully plotted, or they may be improvised freely, one for each color, using a proof of the preceding color as a rough guide for following ones.

156

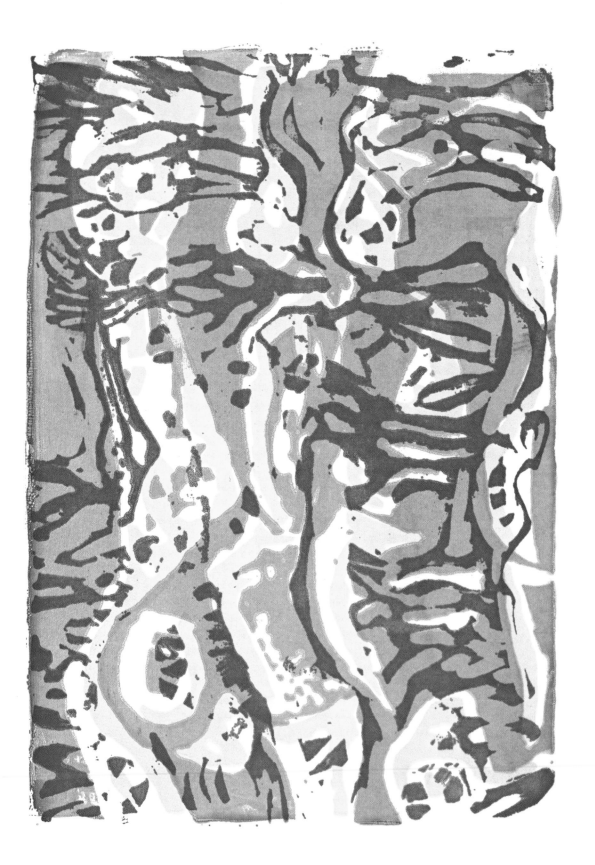

First a rather free color sketch was painted, to be used as reference but not to be traced. Further preparations for the first stencil of this block-out type of print included stretching silk on a frame, hinging the frame to the printing base, and painting with a sable brush and glue filler those areas of the stretched silk which were not to be colored in the first stencil operation. This screen was used to print the lightest color, which penetrated the unprotected areas of the screen during the printing process previously described. Oil paints were employed for better color quality in the printing of this and all of the serigraph prints to follow in preference to the standard commercial-process paints. The method of application of the paint was the standard one for serigraphy: spreading with a squeegee. Each color in the print required a separate screen blocked out in all the nonprinting areas. These stencils could have been prepared in advance on separate screens; in this particular case, after the first color had been printed, the screen was washed out entirely and prepared for the second color with new areas blocked out, the process being repeated for the third color. It should be added that the block-out method is not suitable for long runs; neither does it lend itself to work in which crisp edges or subtle gradations of tone are wanted.

Most authorities suggest that the standard-process colors be used because of technical problems in printing and drying the separate runs of prints. These colors dry rapidly, an advantage they have over oil paints, but to the author the disadvantage of poorer color quality does not recommend their use for fine prints.

61

SERIGRAPH, RESIST METHOD

View from Above

The resist method, which is the one used by most fine artists in making serigraphs, is advantageous for making prints requiring precision of outline and detail or producing gradations of tone. In this

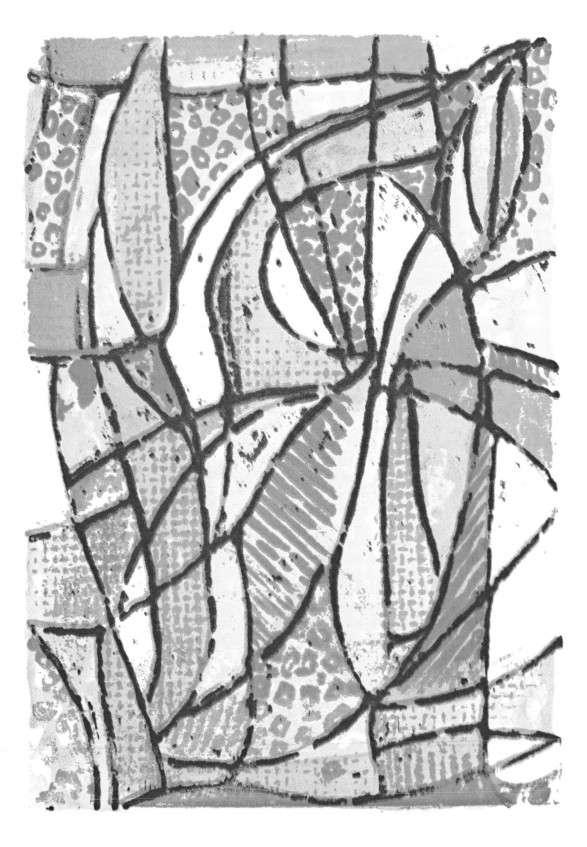

process the areas which are to be printed are painted directly onto the screen with a substance referred to as a "resist," after which the entire surface of the screen is coated with glue. The resist technique is based on the fact that there are mediums which resist the action of some solvents but are readily soluble in others. Various materials may be employed as a resist, but lithographic tusche, the most widely used, was chosen for this print. Tusche, which is greasy, is soluble in turpentine, whereas the glue covering the nonprinting areas is soluble in water.

Preparation of the resist stencil is the same as for the block-out method up to the point of establishing the drawing on the silk. Upon completion of the tracing on the silk, a cornstarch sizing is applied to the underside of the silk with a sponge, temporarily closing the pores of the silk screen and making it possible to apply the tusche without its seeping through and damaging the drawing underneath. The whitening of the silk makes tracing easier, and it makes sharper edges possible as the tusche has less tendency to spread out. The tusche can be applied to create both solid and dry brush effects that will eventually be printed. Lithographic pencils used in conjunction with lithographic crayons and tusche make it possible to achieve a wide range of textures. After the resist materials have dried, a mixture of glue and water is applied to the entire screen, covering over the clear silk as well as the drawn or painted areas. The printing areas must now be opened, and this is accomplished by removing all of the tusche and crayon work. An old toothbrush can be used to apply turpentine, and gentle scrubbing dissolves the drawing and also carries off whatever glue may have adhered in these drawn areas.

The screen is now ready to print; any oil colors may be used, as their solvents will not affect the glue which covers the nonprinting areas. Five colors, similar in type to those in No. 60, were used to produce this print.

62

SERIGRAPH, FILM AND PHOTOGRAPHIC STENCIL

Carnival

The increasing use of the silk screen process by the advertising world created a demand for a smaller and more carefully executed product than was normally encountered in the sign shops. Working on this reduced scale, it was difficult to establish sharp, crisp edges of a pattern by painting with a brush on a porous piece of cloth.

In the early thirties the problem was solved when both a lacquer and a shellac stencil film were placed on the market. Both of these materials are made up of two layers, one being the film and the other a glassine sheet which serves as the base or support. The films are used in the same way, the only difference in use lying in the way they are anchored to the silk; a hot iron is used to bond the shellac stencil, while lacquer thinner is used for affixing the lacquer film. Color separations are made by placing the transparent film directly over the art work or sketch and with a sharp stencil knife cutting the outlines of those shapes that will eventually be the printing areas. Just the film layer is penetrated, leaving the base intact. After the shapes have been cut, those portions which are to print are peeled away from the backing, a step known as stripping the film.

The stencil is then positioned, film side up, under the silk and either fastened by ironing if a shellac film is being used, or by gently rubbing over the silk with lacquer solvent if the film is lacquer, the material used in the present print. The film, softened by the solvent, is pressed firmly against the silk, fastening it securely. After the film has dried, the glassine backing is peeled away from the film, and after whatever edge blocking needed to make the screen leakproof is done, the preparation of the stencil is complete. The process, of course, must be repeated for each color employed in the print.

For this print, two of the screens have been prepared by the stencil film process described above, and a third screen was prepared by the

photographic method, which is widely employed for commercial purposes but not yet adopted by many artists, although Heller suggests the possibility in his book, *Printmaking Today* (1958). To prepare a screen which will reproduce the type faces and the merry-go-round horse used in this example, it was first necessary to have transparent positives of the various letters as well as the horse.

A commercial product known as Ulano "Hi-Fi" Presensitized Screen Process Foto-Film is placed in contact with the positives in a photographic printing frame. Exposures vary, but normally two or three minutes is long enough if the frame is forty inches from an arc lamp. Developer is furnished by the film makers and needs only mixing on the part of the operator. The film is left no longer than two minutes in the developing solution, after which it is washed in hot water, an action which removes those areas which have not been hardened by exposure to the light. The film is then immersed in cold water and, still wet, placed emulsion side up on a firm backing, after which the silk screen is gently placed in position over it. Newsprint is used to tamp the surface and remove the excess moisture which seeps through the silk. After drying, the film is anchored securely to the silk; at this stage the backing which served as the support for the film is peeled away. The screen is now open and ready to print.

PHOTOGRAPHIC
PROCESSES

Prior to the invention of photography, artists wishing either to save time in drawing or to render a more faithful copy of nature had since 1569 employed a device called the camera obscura (and later the camera lucida) to accomplish these ends. This relatively simple tool made it possible to project an image of an actual figure or landscape onto a canvas, but making it permanent still required the tracing of the projected outlines by hand.

The history of photography is a record of the people who made equipment and developed new techniques. The materials and methods discovered and discarded were all directed toward devising a means of retaining an image without having to draw it. By 1832 Joseph Niepce had made the first permanent photograph, but because of the length of exposure, which was several hours, the method was impractical. However, by 1839 Louis Daguerre had made public his process, which was the first satisfactory one.

In the sixty years following, most of the creative energy involved in photography was directed to technical ends. Films, cameras, and processes followed one on the other. Unlike the other print processes discussed, these intermediate technical stages in photography are not of interest except as sidelights of history, since none of these techniques are practiced today. The average photographer during this period never questioned Niepce's doctrine that his goal was "to copy nature with the greatest fidelity," although there were some who began to sense the pictorial effects possible with this new tool. In the search for beauty it was only natural for them to turn to the work of the painters for guidance and inspiration; it is unfortunate that much painting of the time was either sentimental or pseudoclassic. From these labors emerged the art photograph, a posed studio picture mixing sentiment, moralizing, and storytelling, a form which with few exceptions offered little of aes-

thetic significance. The condition of photography by the end of the nineteenth century is excellently stated by Paul Strand: "For the history of photography, despite its numerous and varied phases, is almost entirely a record of misconception and misunderstanding . . . its use as a medium of expression reveals for the most part an attempt to turn the machine [camera] into a brush, pencil, whatnot; anything but what it is, a machine."

With the coming of Alfred Stieglitz, whose pioneer efforts started in the 1880's, photography received the impetus needed to establish it as an art form on its own merits. Steiglitz fought for acceptance of the camera as a machine with a unique potentiality of registering the world directly through the use of optics and chemistry and as a result producing images and tonalities beyond the range of the human hand. Men like Edward Steichen, Edward Weston, Arnold Genthe, and Paul Strand were among the first to express in their work this new philosophy and to recognize that a sensitive eye and a feeling for shape and form were as necessary to the production of an art work as the tools at hand.

During the last fifty years, important new cameras, films, and processes have been introduced; in the mid-twenties the 35-mm still camera appeared, in the thirties the popular 35-mm color film and Harold Edgerton's electronic flash were introduced, and in 1963 Polaroid perfected a method of color photography which made it possible to shoot a picture and have a finished paper print in full color sixty seconds later. All of these new tools, unfortunately, are no guarantee of a creative product, but to the artist they do give an almost unlimited range of technical possibilities.

Man Ray and László Moholy-Nagy, who are responsible for creating the photogram, used photographic materials to produce exciting images, mostly abstract in character, that were not dependent on the use of a camera. These experimental prints, while in no way reducing the quantity of purely pictorial photography, had much to do with strengthening its design factor.

Three types of prints are shown in the photographic section. The first group consists of prints in which images are created by hand using photographic materials but no camera. The second group of prints is produced with photographic materials but without the use of either drawing or camera. In the third group the photographs are dependent on the use of a camera to create a basic negative.

166

63

CLICHÉ-VERRE, TYPE 1

Erratic Wasp

A cliché-verre is a print produced by either drawing, painting, or scratching an image on film or glass; the resulting hand-drawn negative is then printed by standard photographic techniques. The first account we have of clichés-verres or glass prints indicates that they were produced by William Havell in England about 1835, but none of his prints have survived and nothing came of the process. Several years later, in 1841, three French amateur photographers, unaware of Havell's work, reinvented the technique, which was then popularized by a school of French painters known as the Barbizon Group. Several methods of producing prints were developed by these early practitioners of the craft, these variations all being related to the making of the negatives.

In the example shown, a sheet of photographic film was exposed to light and developed, thus producing an intense black surface. After the film was dry an etching needle and a roulette were used to cut through the blackened emulsion. Progress of the work can be ascertained by placing the film on a sheet of white paper or on a tracing box. After the design had been completed, it was printed on a matte photographic paper, following standard procedures for developing photographic prints. The difficulty of establishing a pencil outline drawing on the black emulsion led some artists to produce their own plates. A clear piece of glass was inked over with a brayer, applying an even black coating of printer's ink which was dusted, while wet, with white lead. Upon drying, this coating made an adequate foundation for drawing. Another method used by the Barbizon Group is described as Cliché-verre, Type 2 (No. 64).

168

64

CLICHÉ-VERRE, TYPE 2

Convention

This type of cliché-verre is fairly simple to execute and, other than the standard photographic papers and developers, requires only some black oil paint, brushes, and a sheet of clear glass. Using these materials the image may be drawn or painted on the glass either directly or with the aid of a previously prepared sketch placed under the transparent surface. All of the variations possible in preparing black and white monotypes (see prints Nos. 76 and 78) may be used to create the image; however, in this process the oil drawing on the glass is allowed to harden completely, after which lines can be scratched into the surface for further enrichment or correction. If the paint has been laid on unevenly and is not completely opaque, these areas will appear gray in the final print; with careful application of paint the artist can, if he wishes, achieve a wide variety of tones. After the plate has dried, it is processed in the dark room in the same manner employed to produce a photographic contact print.

The technique just described was brought to the attention of the painter Corot, and he in turn introduced it to other members of the Barbizon School. Prints produced by this group are the first known examples that have any artistic merit. Artists from time to time have tried to revive the technique (the lumiprint which follows is one variation of it, and the prints of Caroline Durieux and others at Louisiana State University represent another) but it has never become popular.

65

LUMIPRINT

Graffito

Lumiprint is the name given to a process developed in the 1930's by Joseph Di Gemma. In this method a sheet of frosted plastic with a slight tooth was used. A drawing was made on paper and the plastic sheet placed over this. Using the drawing as a guide, water-color washes and solid blacks were painted directly on the plastic. This painted tonal sheet served as a negative. Placed in contact with photographic paper, it was exposed and processed in the normal manner.

To obtain a richer print, the example shown was made by printing through three plastic sheets at once. A preliminary sketch served as a guide for the final drawings. The soft tones in the print were painted on the first frosted sheet with water-color washes, the carefully shaded areas were drawn on the second film with crayon, and the line work was drawn on the third sheet with India ink. These films were then placed one over the other in their proper positions and taped to a glass plate. The three superimposed plates then served as a single negative from which the prints were made. Printing is carried out in the same way as for any standard photographic negative.

66

CLICHÉ-VERRE, COLOR METHOD

Figurative

In 1957 Caroline Durieux, inspired by seeing some of Corot's clichés-verres, started experiments using materials and techniques employed in color photography. The prints produced by Miss Durieux

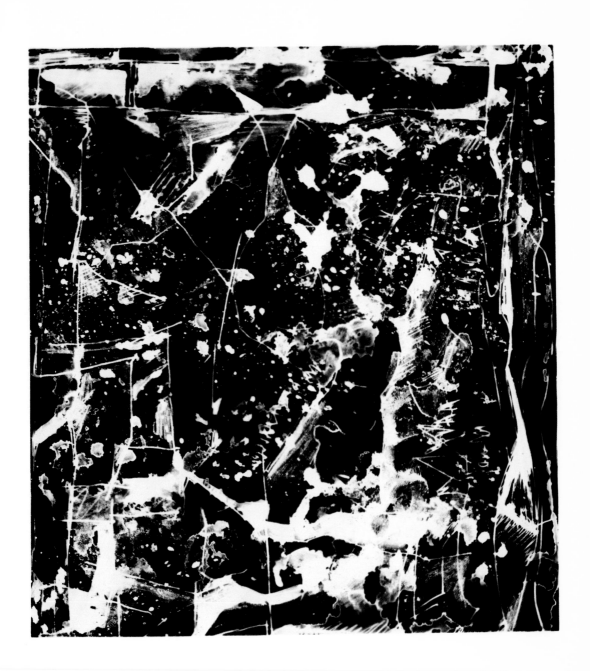

and others at Louisiana State University are made by the dye-transfer process.

The writer sought outside advice for the present print. The problem was presented to James Fromme, a professional photographer, who suggested that results similar to the Durieux method could probably be obtained using more recent techniques in color photography.

This is perhaps the first time that a cliché-verre has been made with Ektacolor film and paper. Using these materials, both multilayered, eliminates many of the steps used in other processes. To make the print shown, a four-by-five-inch sheet of Ektacolor sheet film was soaked in one-hundred-degree water while exposed to light to make the film emulsion soft enough for art work. The drawing was made by impressing the design into the soft emulsion with a variety of objects from knife or pencil to a fingernail. The film, which is made up of three color-sensitive layers, can be scratched through only one or several layers by varying the pressure. Lines and areas also can be cut through to reveal the clear base. After the drawing was completed, the film was fixed, washed, and then hung up to dry.

Chemicals supplied by the Eastman Kodak Company to process Ektacolor film are referred to as C-22; by experimenting with these as well as with both dry and wet emulsions, many effects can then be obtained.

After drying, the film is placed in an enlarger to project the image onto Ektacolor paper through a number of color filters for as many different effects. Several films can be projected one at a time or together, and more variety is possible through the use of filters with different degrees of density. For this print a simple image on one film was projected through a filter chosen to produce the desired color. After the exposure had been made, the paper was processed in chemicals which the manufacturer calls P-122.

Caroline Durieux, along with Harry E. Wheeler, is also the inventor of the electron print process in which drawings made with a mixture of radioactive isotopes and India ink are put in contact with photosensitive paper to make a print which is then processed in the usual manner for a contact print.

174

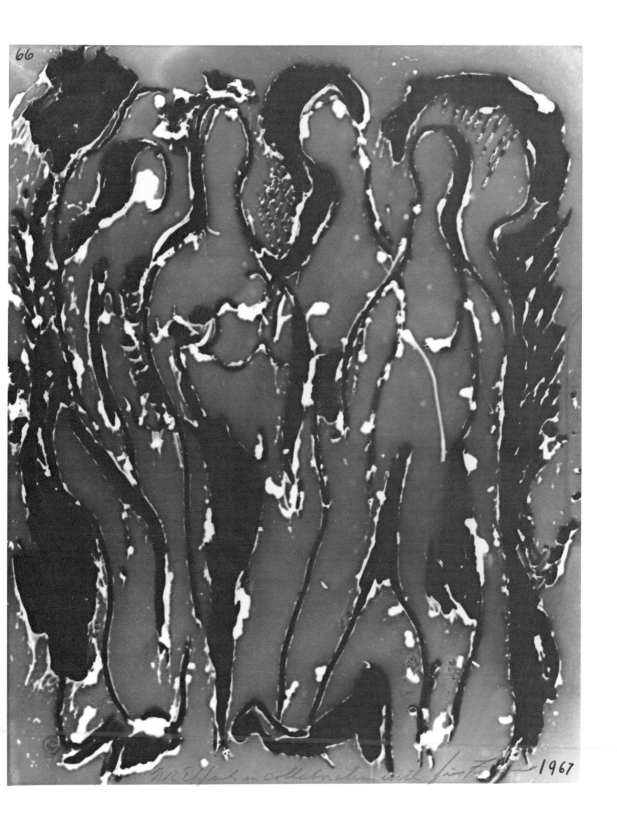

W.R.Elffers in collaboration with Sam Francis 1967

67

PHOTOGRAM

Taken From an Onion

In 1843 Fox Talbot, one of the pioneers in the development of photography, placed leaves and pieces of lace on a sensitized sheet of paper with the sole intent of reproducing an image of the objects as realistically as possible. Using this paper print as a negative, Talbot was able to produce a positive silhouette. He called these prints photogenic drawings. Prints were made around 1910 using paper cutouts placed on sensitized photographic paper and exposed to light. The resulting overlapping shadows and patterns formed resemble somewhat the early work of the Cubists. These prints may be thought of as a revival of Talbot's work, but the motivation was design, not naturalism. In the early twenties, two artists, Man Ray and László Moholy-Nagy, working independently in Europe, experimented with abstract patterns created by placing three-dimensional objects on sensitized paper, exposing the paper to light, and developing it. Thus the modern photogram was created. When Man Ray first showed his prints he named them Rayographs, but the term is associated only with his work; the common term is photogram.

Solid shapes as well as translucent ones can be placed on the paper, the light source can be fixed or swung back and forth over the objects. The intensity of light and the angle of the beam can be manipulated to create unusual shapes and shadows. To produce the prints needed for the first edition, onions, onion skins, and crumpled tissue were lightly glued to a sheet of acetate, making possible some degree of uniformity in the run.

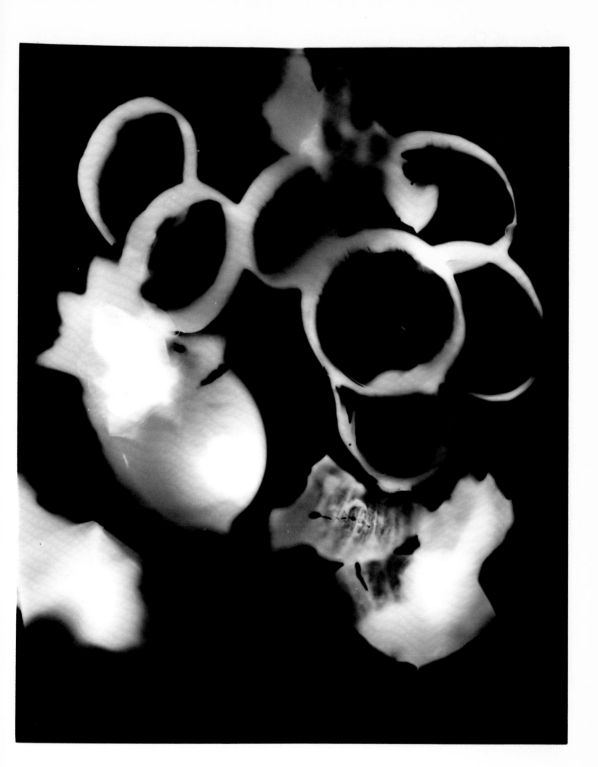

68

PHOTOMONOTYPE

Decayed Wood

A unique way of producing prints without a camera is described in *Printmaking with Monotype* by Rasmusen. The technique makes exact duplication impossible and accounts for the monotype designation. The process capitalizes on the fact that hypo applied to paper or film neutralizes the area of contact and prevents any development from taking place.

For the print shown here, a very rough, weathered piece of board was cut slightly larger than the print paper. Hypo was applied to this board with a paint brush; then, working in a darkroom with a safelight, a sheet of enlarging paper was placed face down on this damp surface and rubbed vigorously on the reverse side to bring it into contact with all of the raised parts of the board. Still working in the darkroom, the paper was then exposed to a controlled light source and developed in the normal manner. Wherever hypo came in contact with the paper it acted as a resist, and those areas which are the light and white areas in the print did not develop.

If more control of the image is wanted, many possibilities suggest themselves. Designs and patterns could be cut into all kinds of relatively flat, absorbent surfaces, or pieces of lace, net, and other fabrics could be permanently affixed to a card or board, creating a variety of shapes and textures. The photographic paper could be handled partly as a photomonotype; after the hypo is dry, it could then be further enriched and experimented with by combining it with photogram or other photographic techniques.

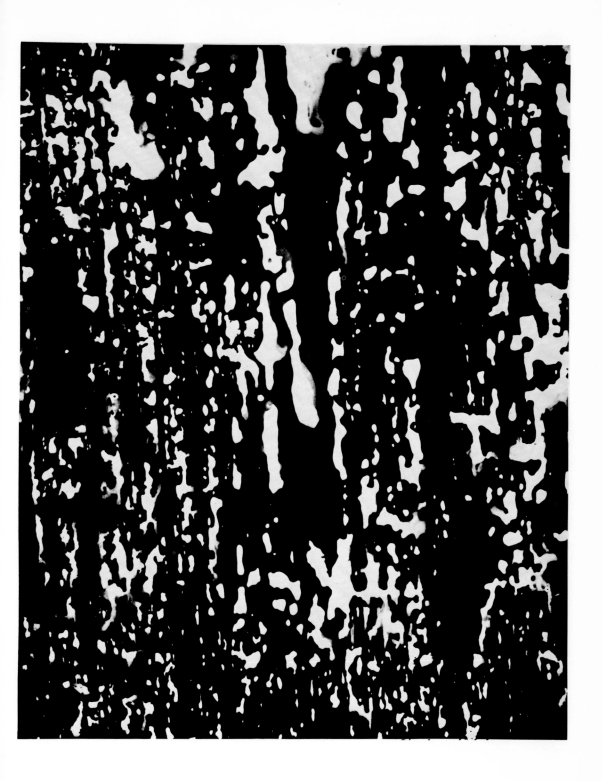

69

PHOTOGRAPH

Rocks

Almost everyone has made, at one time or another, a black-and-white photograph, in most cases a record of someone or something that can later be recalled. Either in reproduction or as a snapshot it is the dominant visual image of our day. Of the millions of photographs that stare out at us from newspapers and magazines, plus the personal pictures of the baby, the trip, and the grandparents, very few have aesthetic value.

Photography is the only one of the print processes in which the picture is not dependent on any hand skill in its formulation, leading some critics, even today, to say that photography is not an art form. To other observers, as well as this writer, the sensitive and selective human eye of the photographer is the one redeeming factor; an individual with this necessary requisite can produce a photographic print acceptable as a work of art.

The serious worker interested in creative photography has at his disposal an unbelievable array of cameras, lenses, enlargers, lighting equipment, chemicals, film, and paper. He may be interested in carrying out the entire operation from taking the photograph to the final matting of his print for exhibition. Others may prefer to do just the shooting, letting professional processors do the developing and finishing but retaining sufficient control over the operation to ensure the quality of the final prints. Regardless of the equipment and techniques employed in photography, the basic principles remain the same; the simplified description which follows is an account of these.

The camera consists of a box or container that has fastened to it a lens and a shutter. Some means of housing the film in complete darkness must be provided. The film has a transparent gelatin base on which there is a coating of silver bromide. The film coating is affected to varying degrees by the intensity of the light striking different areas. As the

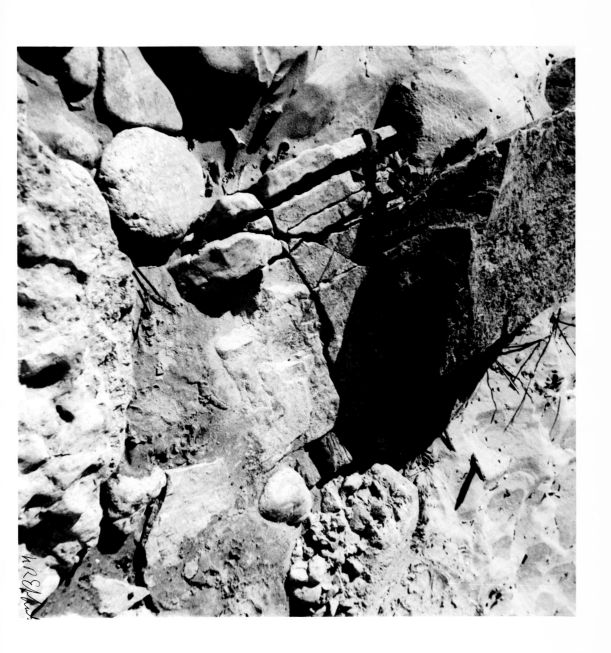

shutter is opened momentarily, an image of the scene in front of the lens strikes the film. When this material is processed in the proper chemical solutions, the bromide changes to a metallic silver, and those areas affected by the brightest light become the darkest or most dense granules on the film. The film is then washed in a solution called hypo which dissolves out all the coating not affected by light. The result is a negative, a sheet of film on which the image is reproduced in reverse, the dark areas appearing light and the light areas dark. When the negative is dry it is placed in contact with a photographic paper and exposed to light, after which the paper is chemically developed in the same manner as the film. The unaffected areas are washed free in a chemical fixing bath and then rinsed in water, completing the print which is a positive.

In the simplest camera, only a pinhole is needed to get an image on the film, but the small amount of light coming through the opening might call for an exposure of hours. Fine, precision-ground lenses in the camera, in place of a pinhole, speed up the process, making it possible to take pictures under the most adverse lighting conditions. A shutter device controls the timing of the exposure of the film to the light, and a diaphragm regulates the size of the opening through which the light passes, thereby regulating the amount of light striking the film at a given instant. The diaphragm control makes the camera adjustable to a wide variety of desired effects varying from pin-point sharpness over the entire picture area to a concentration of detail in one part only.

Prints can be produced by the contact method mentioned or by projecting light through the negative and an enlarging lens to make a larger image on the paper positioned beyond the lens. Enlarging makes possible a great deal of manipulation on the part of the artist. He can control the size of the picture, its contrast, and its composition. For instance, he can make an eight-by-ten-inch print from a small portion of a negative that measures three by four inches.

In this print a Rolleiflex camera was used, the shot was taken on a bright summer day, and the lens was "stopped down" (the diaphragm aperture was reduced to a relatively small diameter) to increase the effect of sharp detail.

There are some types of photographs that are dependent on various technical manipulations other than the usual enlarging and crop-

ping. Of those mentioned in the literature on photography, the two examples which follow, the solarized and bas-relief prints, seem most adapted to creative ends.

70

PHOTOMONTAGE, TYPE 1

Green Bay

The term *photomontage* is defined by *The Focal Encyclopedia of Photography* as follows:

> Composite photographs made by cutting out and pasting together several photographs to achieve a particular effect. The technique of making a single positive by printing several negatives, or even by multiple exposure of the negative material, is sometimes known as photomontage, however, these techniques are generally given special names, e.g., combination printing, etc.

In this volume both types are shown but are kept under the single heading of photomontage.

Print No. 70 was made in accordance with the latter definition of photomontage. In this print, two negatives were superimposed, moved around until a satisfactory image was secured, then fastened together and placed in the enlarger. The final print is the result of light being projected through these two negatives to produce one single image.

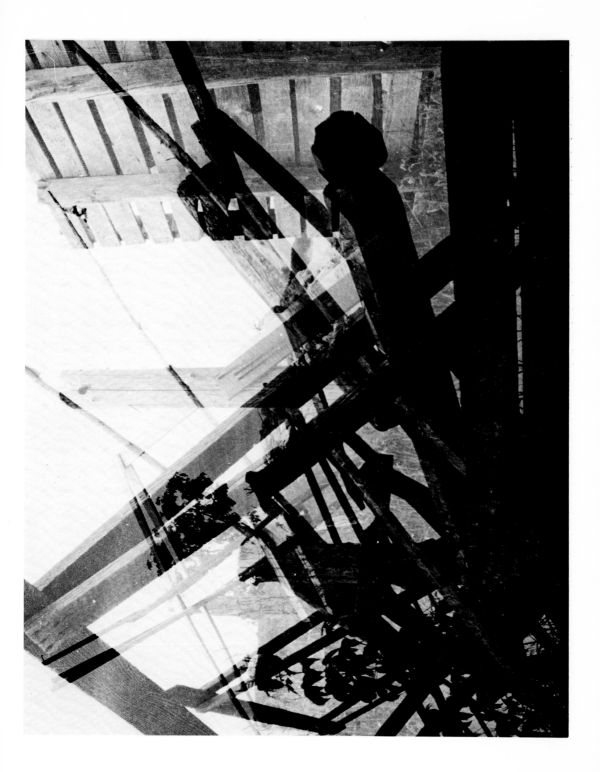

71

PHOTOMONTAGE, TYPE 2

What's Your Number?

In print No. 71 the first definition of the encyclopedia is illustrated. A straight black-and-white print was used as a base, and to strengthen the design, some of the areas were blocked out with white. After superimposing a center section made up of typed numbers and a small cutout of a human figure, a photograph of the composition was made. The combination of the three elements creates an impact and a unique visual concept not obtainable in the parts in isolation.

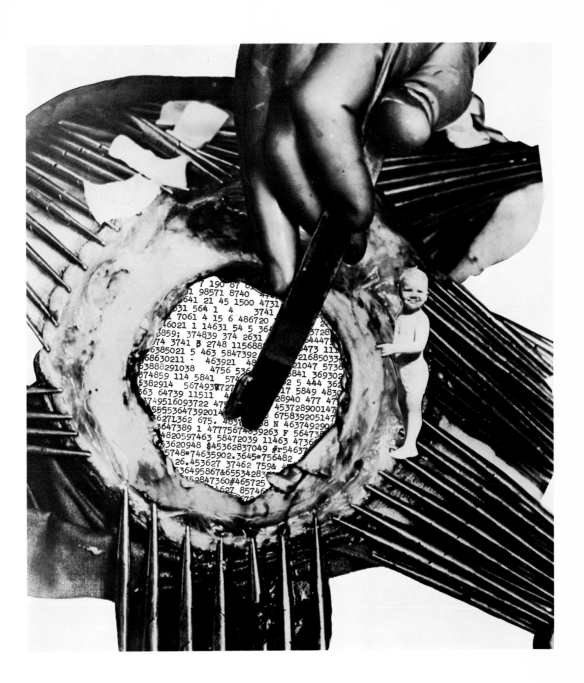

72

SOLARIZED PRINT

Barbed Wire

The term solarize simply means to affect by exposing to the light and the heat of the sun or any other light source. In strict usage, when a film is very much overexposed, as much as a thousand times over the light needed for normal negatives, a reversal of the image takes place and is known as solarization. In ordinary work the material so affected would be regarded as injured or damaged.

Over the years the original meaning has been supplanted, and professional photographers use the term to describe a technique of producing a partly reversed image by exposing the negative to light during its development, a phenomenon known as the Sabattier effect.

In the technique employed to make this solarized print, another step has been added, namely, the making of a solarized paper negative which is produced in the following manner. A negative is needed which, when enlarged, will produce sharp contrasts and a strong linear pattern in a standard print. Using such a negative, experimental prints are made by first controlling the light source in the enlarger until a normal print is produced in ninety seconds of development. Once this control has been established, a fresh sheet of enlarging paper is exposed in exactly the same manner as the control print, placed in the developer, and frequently agitated. After about a minute in the developer the immersed print is exposed for five seconds to a fifteen-watt light placed eighteen inches away. Developing continues until the full ninety seconds have elapsed. Processed in the normal way, this paper print then serves as a negative from which the final contact prints are made.

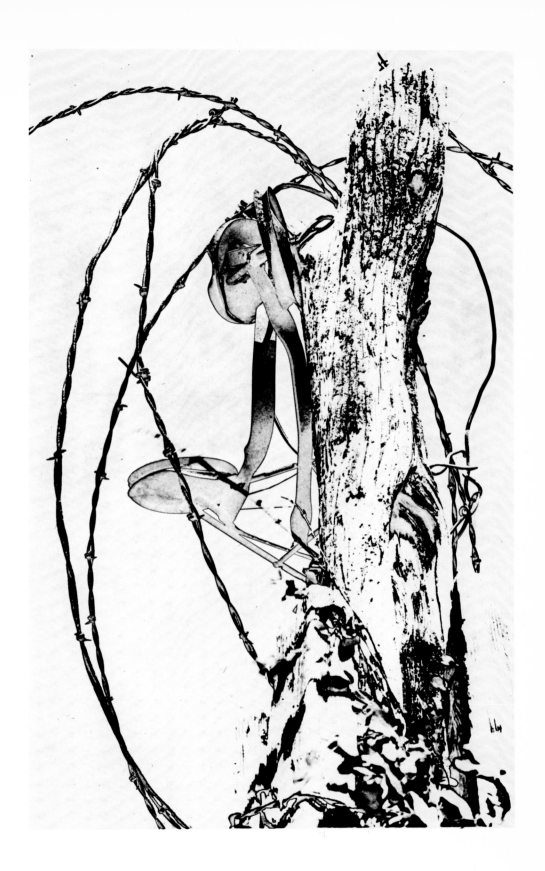

For the purpose of comparison, a standard print (No. 72a) of the original negative from which the solarized print was produced is included.

The solarized print in this set is a straight example of the type. The current practice of combining all manner of techniques in a single production suggests the use of this method in combination with other photographic processes, such as montage, to achieve other forms.

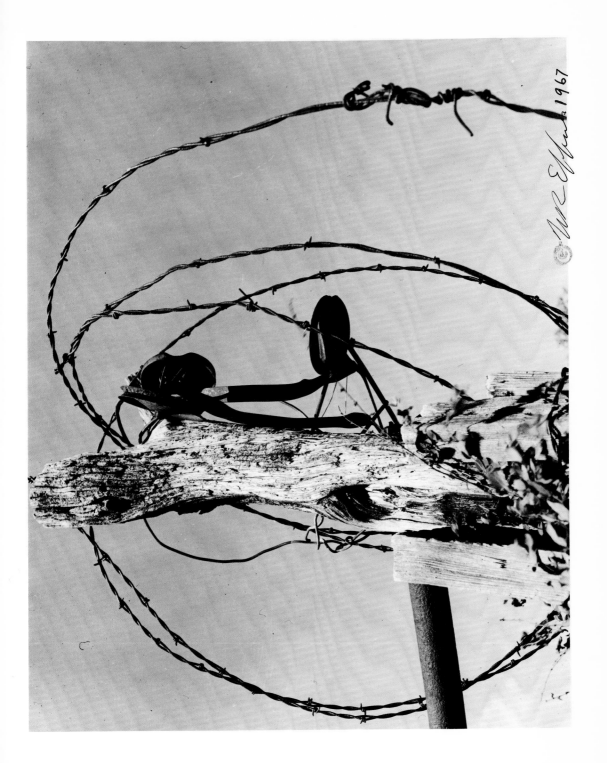

Ray E. Spence 1967

73

BAS-RELIEF PRINT

Variety in Unity

In some quarters the term *graphic photo* is applicable to those prints produced by the bas-relief and solarization techniques, implying perhaps that these lend themselves to artistic expression more readily than straight photography.

To produce a bas-relief print the artist needs a negative with strong contrasts of dark and light and relatively simple, bold shapes. This negative is used to make a contact print on another piece of film, producing a positive image, and is processed as any standard film. After drying, it is placed on the original negative, emulsion sides together, in such a way that they are slightly off register. They are secured between two pieces of glass to keep them in position, placed in the enlarger, and projected onto the photographic paper.

In this print, slices of green pepper were photographed on four-by-five-inch cut film, and after both the positive and negative were completed, experiments were conducted to determine the amount of offset needed to produce the illusion of three dimensions wanted in the final print; these experiments in overlapping or offsetting of the two films ranged from one thirty-second to one-half inch, with one-eighth inch as the final decision for the present print. Enlargements were made using glossy paper.

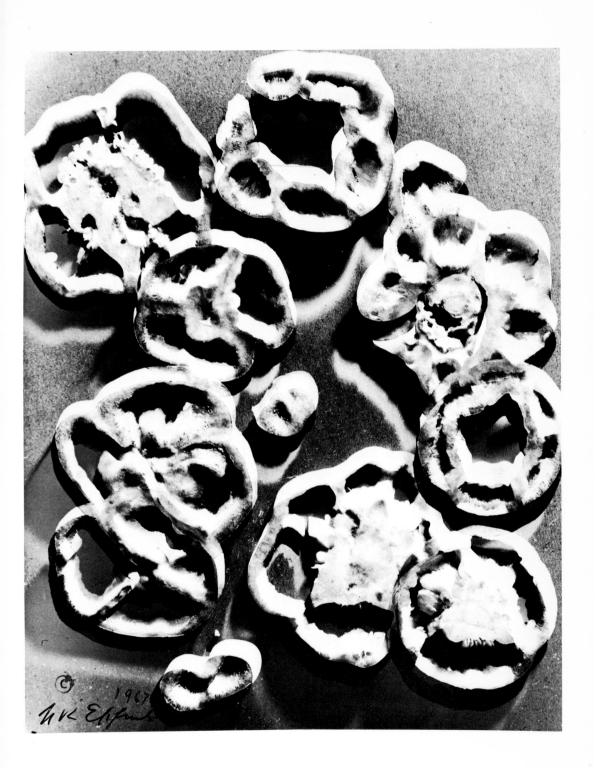

74

COLOR PHOTOGRAPH

Lichen

To the men who made even the earliest photographs, the absence of color was obviously disturbing, because their prime objective was the recording of nature. The record indicates that to supply this lack, hand coloring was resorted to even on early daguerreotypes. Soon after, other attempts were made to capture the colors of nature, but nothing practical developed from these early experiments.

The first break-through came about as a result of an experiment conducted by James Clerk Maxwell in 1861. In it he demonstrated that mixtures of red, green, and blue light projected on a white surface are capable of recording the colors of nature. A tartan ribbon was photographed on a lantern slide through a red solution; another slide was exposed, this time through a green solution, and a third through a blue solution. The plates were developed and placed in three lantern slide projectors so beamed that the images would be superimposed on the screen. In front of the projectors were placed the colored solutions through which the slides would be projected. When all was in readiness the three images projected at once created the illusion of the colors to be found in the actual ribbon. The results were probably crude but served as the first practical base on which to build. At this time, however, neither materials nor technology was available to put Maxwell's theories into practical use.

Basic to any understanding of color photography is the concept of dealing with light and not pigments. Red, green, and blue light are the primaries, and mixtures of these produce the other colors of the spectrum. All of the color processes depend on making a record of the red, green, and blue light reaching the camera from the subject. In the additive systems, three black and white records of the primaries are made. When they are projected through red, green, and blue filters the intensity of each color is modified by the amount of black, grey, or clear area in the record. Each of these separate color records, when properly projected and aligned on the screen, creates the illusion of the

194

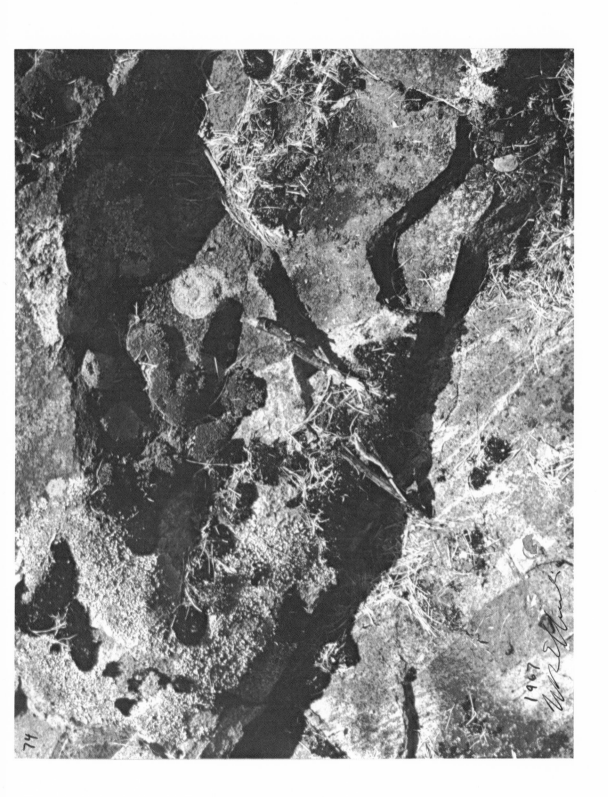

original scene. In those areas where the beam of red light overlaps rays from the green light, yellow is the result. Processes and techniques to make color photographs developed on these principles were extremely complicated and laborious, depending for the most part on the use of three color-separation negatives which then had to be recombined through projection to produce a color image on a screen. As a result, because of the costs and the technical involvements, most color photography was employed only for commercial and scientific purposes.

The subtractive process used in Kodachrome and Ektachrome film produces the same end results but achieves them in a way which is much more practical, projection being from one film rather than several. In this system, red, blue, and green are registered on a film made up of three layers, each of which absorbs one color when the subject is photographed. When the processed transparency is projected, the dyes in the three layers, which are cyan (blue-green), magenta, and yellow, cause their complements, red, green, and blue, to combine in the previously recorded amounts to make an image on the screen duplicating all of the colors in the subject. In 1935 the process of coating the film base with three color-sensitive layers before exposure and then converting them to the proper dye images after exposure was invented in the United States by Leopold Mannes and Leopold Godowsky and was called Kodachrome. At about the same time in Germany, Agfacolor was invented, and both of these provided the means of producing a positive color transparency on a single film.

From this time on, the use of color photography became widespread, although processing of the material was still out of range of the photographer; the exposed film had to be finished by the manufacturer, who undertook the complicated techniques to convert the negative image to a positive transparency. A suitable system was still needed so that the photographer could develop the film himself. The inventors of Kodachrome solved the problem; in 1950 Ektachrome film was introduced, making it possible for the photographer to process his own work. Since then other materials have come on the market, making the production of transparencies and color prints on paper much simpler for both amateur and professional.

The color print included was made on a bright summer day using 35-mm Kodachrome film in a camera fitted with an f:1.9 lens.

196

MISCELLANEOUS
PROCESSES

In this section are placed all of those processes which do not fit logically into standard categories; some of these, such as stone rubbing and mono-type, are old, while others are comparatively recent. Much experimentation has taken place in printmaking in recent years, and there are a few examples that are the result of some of these innovations. No attempt has been made to include prints of every new development, but there are examples reflecting some of the major contemporary trends. The production of the hundred-or-so prints in this set has convinced the author that there are still many areas to be explored and that future artists will be working with techniques unheard of today.

75

STONE RUBBING

Surfer

Rubbings, which are sometimes called stone prints, date back to 175 A.D. The Chinese Ts'ai Yong had ordered that the Holy Books of Confucius should be engraved on stone slabs to preserve them for posterity. According to tradition the earliest examples of stone prints were made from these slabs. Since the ninth and tenth centuries, the technique has been employed in the East as a method of reproducing

197

not only text but also pictures. Some sources suggest that the practice of making rubbings was directly associated with ancestor worship. In the Orient the custom of visiting the graves of the deceased was difficult for those who lived at a distance; to enable such relatives to venerate the dead, they were sent rubbings of the gravestone made on paper, a practice which did not deface the marker. The technique was elevated to a fine art, with masters making not only stone rubbings but also impressions from bronze plaques and other artifacts. For centuries the English have been making rubbings of church brasses, that is, the decorative memorial plaques set in church floors between the thirteenth and sixteenth centuries. The rubbings are made on English bank note paper with a very hard wax which was used by English soldiers in India to blacken their boot heels. Japanese fishermen have also employed the rubbing technique to record the type and size of fish they have netted.

The Oriental rubbing method used to make this print is simple; a stone with an engraved image was overlaid with a thin sheet of Japanese paper which was then thoroughly soaked with water. With a variety of dull-pointed tools the paper was pushed into the engraved areas following the undulations of line. Oil-based ink was then applied to the surface of the paper with a dabber, care being taken not to get ink in the grooves. Upon drying, the paper was removed, the result being a print in which the image is on top of the paper and is a duplicate of the engraving rather than a reverse as it is in most of the printing processes.

The preparation of the stone image is similar to the cutting of a wood block, with chisels and engraving tools being used to cut into the surface; in contrast to the wood block, with its normally smooth surface, the stone need not be flat. The texture can be as polished as gravestone marble or as rough as a piece of weathered field stone; if the surface is smooth, the inking can be done with a brayer, if rough, with the fingers or a dabber. In this particular example a design was engraved on a stone which had a rough but interesting texture. The possibilities of using some slabs just for texture or color in conjunction with other print processes are unlimited. Besides the use of varying textures as a starting point for creative work, rubbings of raised designs and symbols found on many manufactured objects may be combined with each other or used with various printed forms to create new graphic images.

It seems only logical that with all of the experimentation in print circles, artists would recognize the possibilities of the technique as more

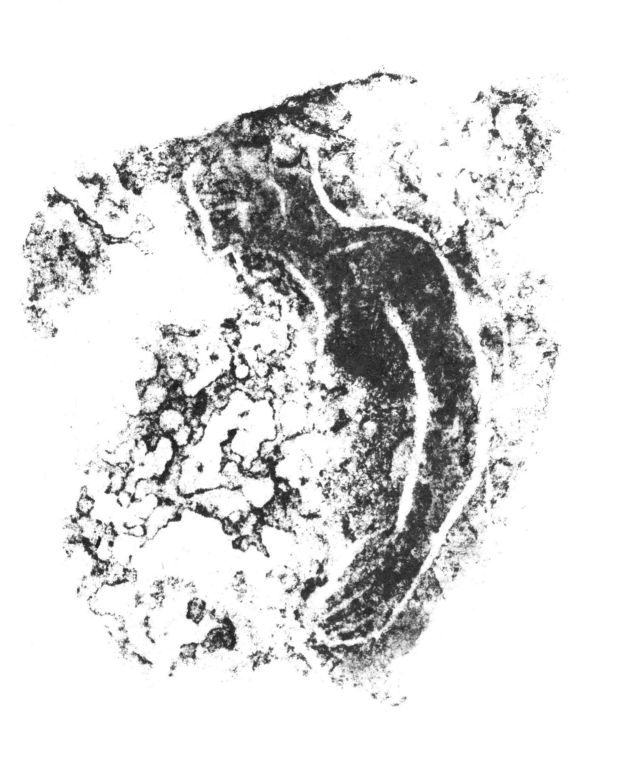

than a way of duplicating the creations of others. An article in *Artist's Proof* (No. 7, 1964: "Rubbings as a Print Technique") may help to increase activity in this particular field.

The prints classed as color woodcuts by Carol Summers are among the most powerful of contemporary images; however, no imprint is involved in their production. According to his description, blocks of wood are cut in rather bold shapes, paper is placed over these, and the inking is done directly on the paper, making them fit the classification of rubbings rather than woodcuts in the usual sense.

76

MONOTYPE, GLASS BASE

Pears in a Basket

A monotype or monoprint is a print produced by painting or drawing an image on a plane surface and then transferring this to paper. Only one good impression can be made. Occasionally artists will try for a second print, but this impression is usually so weak that it is discarded. While it is true that only one good print can be made, justification for including the monotype as a print process lies in the fact that a quality appears in the print as a result of the transfer that can be achieved in no other way. Monotype and monoprint are the most commonly used terms to describe the process. The first term, probably the most widely employed, is the one used here.

Credit for invention of the method is usually given to Giovanni Castiglione, an Italian painter working in the middle of the seventeenth century. In the following centuries not much serious work was done, and it was not until the late nineteenth century that the process was widely used by artists such as Degas and Gauguin, while more recently Picasso, Rouault, and Matisse have experimented with the technique.

A great variety of techniques, materials, and presses are employed

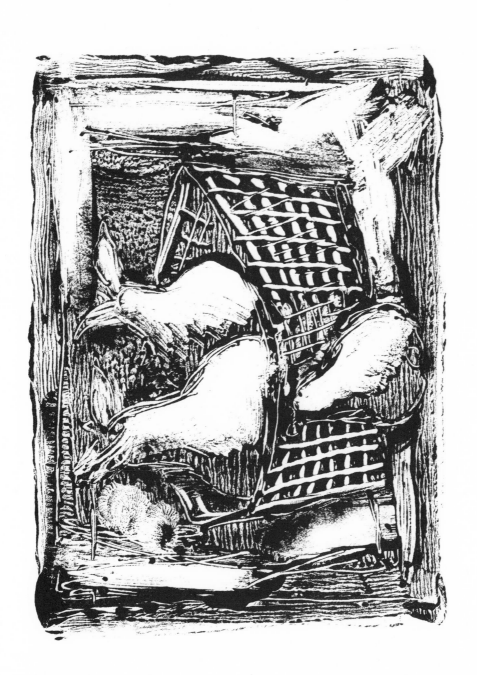

to make monotypes. Four distinct types have been included in this set to give some idea of the range of possibilities inherent in the process.

In this first example a piece of plate glass served as the base, and on this surface a rectangle of solid color was painted the same size as that desired for the final print. Either brushes or a brayer can be used for this step; in this case a brayer and oil paint were used. The edges of the rectangle were straightened by removing the irregularities with a cloth. Drawing was done directly into the wet paint, and the design was completed by removing paint with the fingers and bits of cloth. Slightly dampened paper was placed over the completed drawing and rubbed gently to produce the print.

77

COLOR MONOTYPE, GLASS BASE

Red, Black, and Gray

This print, made on the same base used in the previous monotype, was painted directly on the glass. A drawing under the glass served as a guide for the proper placement of the oil-based paints applied with brushes. If oil colors other than black are employed, there is a slight tendency for the oil mixed with the pigment to spread out and form a light tone around the edges of the color. This is not particularly objectionable if not excessive; the use of silk screen process colors will eliminate this problem, but the color quality leaves much to be desired. The printing procedure is the same as for No. 76.

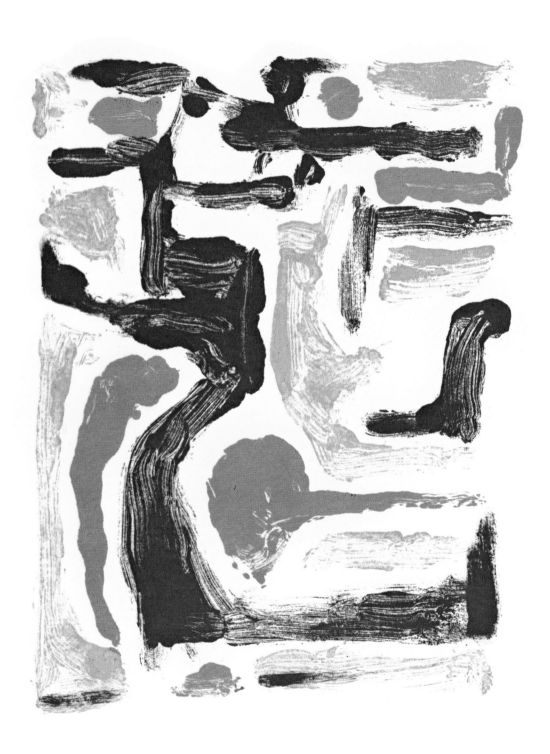

78

MONOTYPE, METAL BASE

Black Abstraction

The possibilities for invention and experimentation are almost un-limited with this technique. A piece of sheet metal the same dimensions as the area wanted in the final print is inked solidly with black printer's ink applied with a brayer. For this print narrow strips of typing paper were laid on the surface of the metal plate to create various rectangles over which torn bits of paper doilies were placed. Other strips were laid over the doilies. Line work was then added by drawing directly into the wet ink with a pointed tool. With dampened printing paper on top, the plate was run through the press. Then by carefully lifting up just one end of the print, it was possible to remove some of the paper strips. The process was repeated at the other end of the print. Plate and paper were then run through the press again. The light gray tones are the result of this second run through the press, some of the ink having been removed with the paper strips. To produce the edition needed for this volume, the procedure had to be repeated for each print.

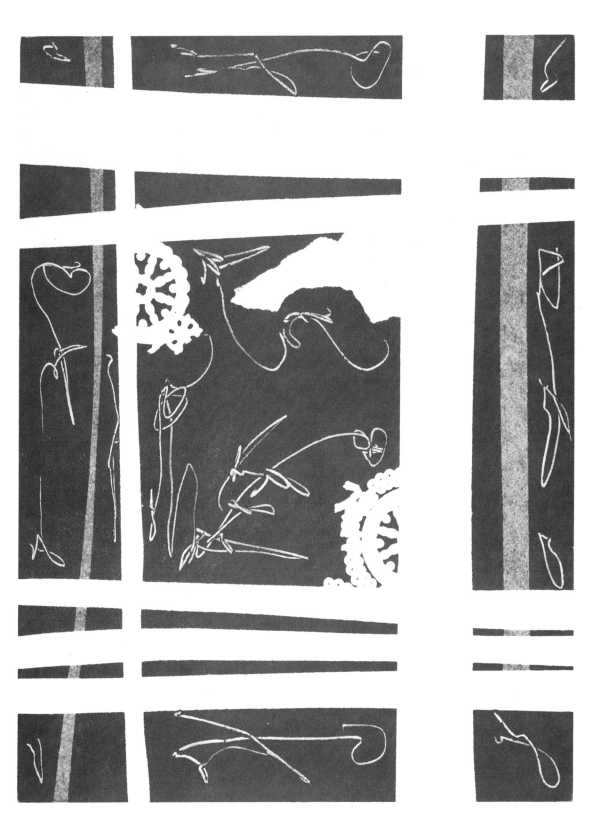

79

COLOR MONOTYPE, METAL BASE

August

This abstraction was produced on a large sheet of stainless steel. Enamel paint, silk screen colors, and oil colors were all used. The consistency of the paints ranged from thick to thin. Turpentine was used as a thinner, and the colors were dripped on, spattered, and manipulated with brushes until the desired effect was secured. A fairly heavy paper was then laid over the design and rubbed on the reverse side to obtain the finished product. This method, aside from its use for monotypes, has great potentiality as a starting point for painting.

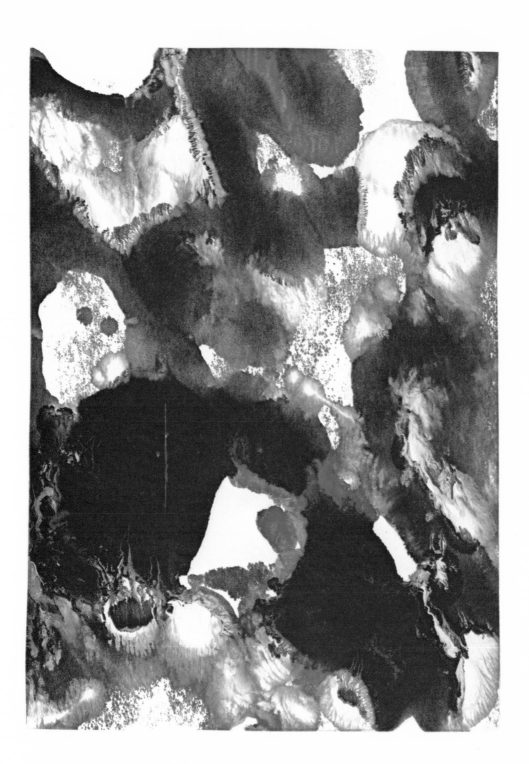

80

TEXTURE IMPRINT

Pierced

The prints produced by this method are sometimes called intaglio monotypes. Robert Broner is the innovator of this process. A copper plate, such as that used for etching, or other stiff base is surface-inked with solid color. When printed, this will serve as a background tone. Before printing, however, a variety of textured fabrics that have been cut into shapes to create the artist's design are inked. Each fabric cutout may be inked with a different color. To create more variety and give more freedom in positioning the fabric, overlapping can be employed. These cutouts are then placed in their proper positions on the inked metal plate, and the whole is run through the etching press.

The technique used for this print differs but little from that described above, but some changes and restrictions occur because of the need for more than one or two prints. Any material that will take ink could have served as a base for this print. In this case cardboard with a piece of cheesecloth glued to it, then shellacked, formed the the plate for the background color. The fabrics chosen for their contrasting textures were mounted on separate pieces of cardboard and also lightly shellacked. These were then cut into the desired shapes, inked separately, and placed on the inked base plate with tweezers. The printing paper was placed on top and printed as above, with one run through the press producing all the colors. No two prints are identical though they may be similar.

This method, like several other techniques discussed, would seem to the author to be better adapted to supplying color and texture in combination with the more traditional means of creating form and pattern.

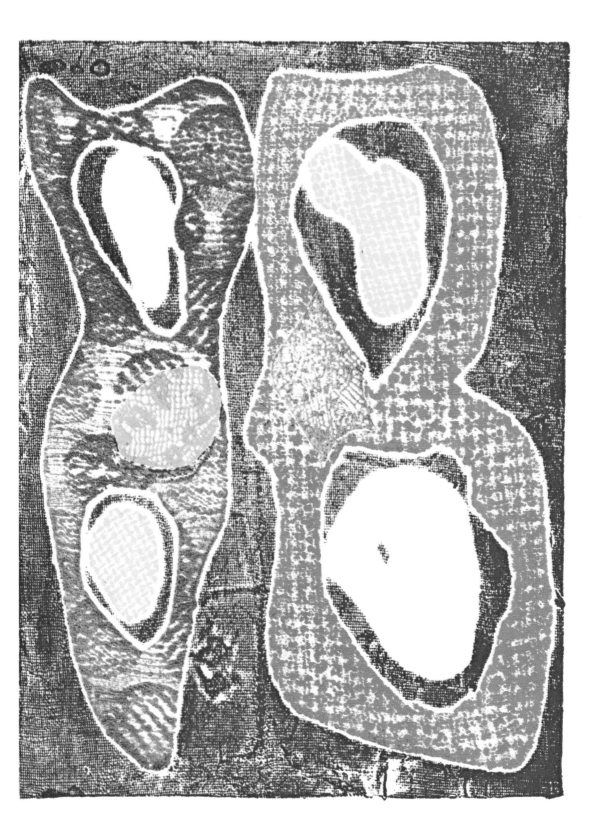

81

COLLAGRAPH

Façade

The word *collagraph*, a term used less than ten years, is not yet in the dictionary. It first appears in an article on the graphic work of Glen Alps, noted West Coast printmaker, who is largely responsible for developing this technique.

In this method the design is carefully constructed by firmly gluing cutout shapes of cardboard, cloth, sandpaper, foil, and other textured materials to a Masonite or cardboard base. In effect, what has been created is essentially a textured collage (see explanation of print No. 31). The process limits the amount of pictorial realism that can be expressed; consequently, most of the prints are highly stylized or abstract in character. On completion of the glued-up form, the entire surface is coated with shellac to facilitate inking and wiping the plate in the same manner as for other intaglio processes. Printing is executed on an etching press. The advantages to the artist in working with the medium are two: first, he can produce large, powerful images in a relatively short period of time; and second, his investment in plates is very little.

Textigraph, a variation of collagraph, is the name given to prints produced the last few years by the Frenchman James Guitet. He builds up a complete plate using various textiles and plastic materials and coats the surface with a plastic film to prevent the ink from being absorbed into the cloth. A soft ink is employed, and the plate is wiped with a plastic sponge. Paper cuts and paper relief prints are made the same way as collagraphs but are relief printed.

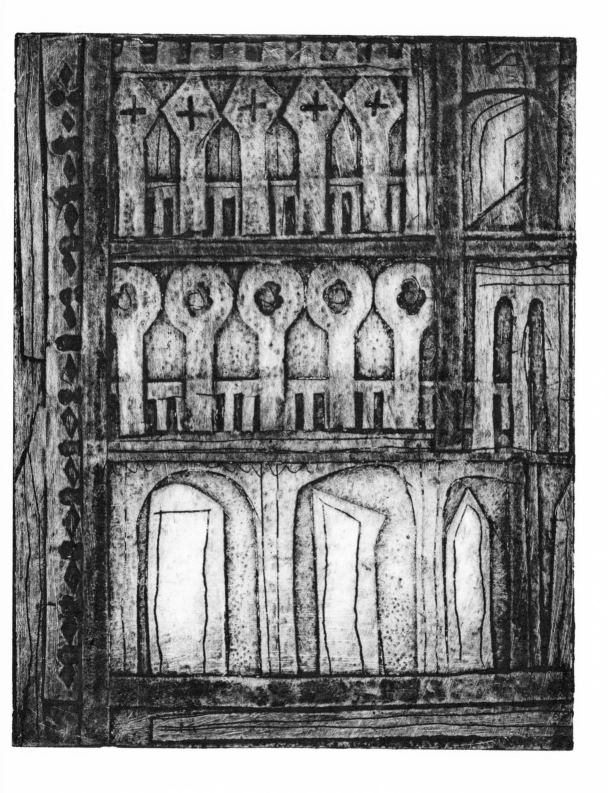

82

CELLOCUT

Directions

In the mid-forties some of the national art magazines were calling attention to the graphic work of the American artist Boris Margo for his origination of the process known as cellocut. As he tells it, the original idea came as a result of working with celluloid and plastics in the construction of murals. Using scrap materials left over from these jobs, he engraved them and later printed them. Eventually it occurred to him to prepare a printing surface by coating a Masonite panel with a varnish made of celluloid dissolved in acetone. Using either intaglio or woodcut tools, the artist then cut his design into this surface, the thickness of which was controlled by the number of layers of varnish. Plates which he produced in this manner could be relief or intaglio printed. Margo states that he designs directly on the plates, developing the idea as he goes along. In some of his more complex prints as many as fifteen plates were used.

The abstraction presented here is a four-color print. Three plates of Masonite were prepared by coating various parts of the surfaces to create abstract shapes. These were then inked with a brayer and relief printed on a proof press. The fourth plate, also coated Masonite, was engraved with a linear pattern and intaglio printed over the other three colors. The fine, irregular dots of surface texture are the result of minute bubbles on the intaglio plate.

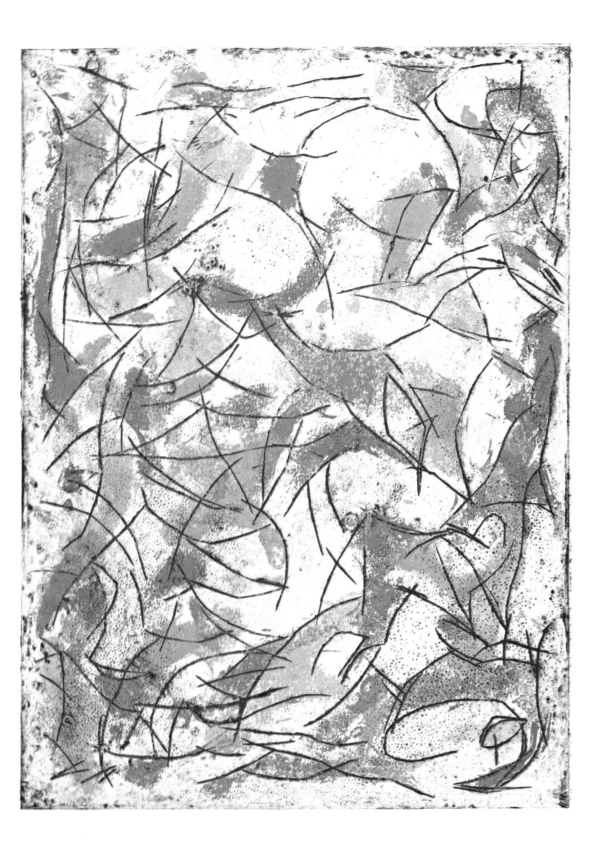

83

METAL GRAPHIC

Time Dissected

Metal graphic or metal print is a complex print technique developed by the German artist Rolf Nesch around 1932. The procedure differs from the usual engraving methods of cutting into the metal. Nesch, instead, uses bits of wire and metal with interesting shapes and textures and builds up a composition by soldering these materials to a zinc or copper plate. More recently he has produced his prints by simply resting the materials on the base plate without soldering. Each successive print can be a different composition just by rearranging the pieces prior to printing.

Because the plate surface is uneven, inking is usually executed with small rollers, applying ink to the base plate and the raised portions. Complex color prints can be produced by using several plates, or the various colors can be applied to one plate. The printing, performed on the etching press, requires great care due to the possibility of the rough plate cutting the paper.

For this print several old clocks were procured and from these a variety of flat pieces with interesting shapes were selected to form a design. Once established, these parts were fastened to the standard copper engraving plate. Background and raised areas were inked with black applied with a brush for the background and four colors applied with small brayers for the other levels, just one run through the press being needed to print all the colors.

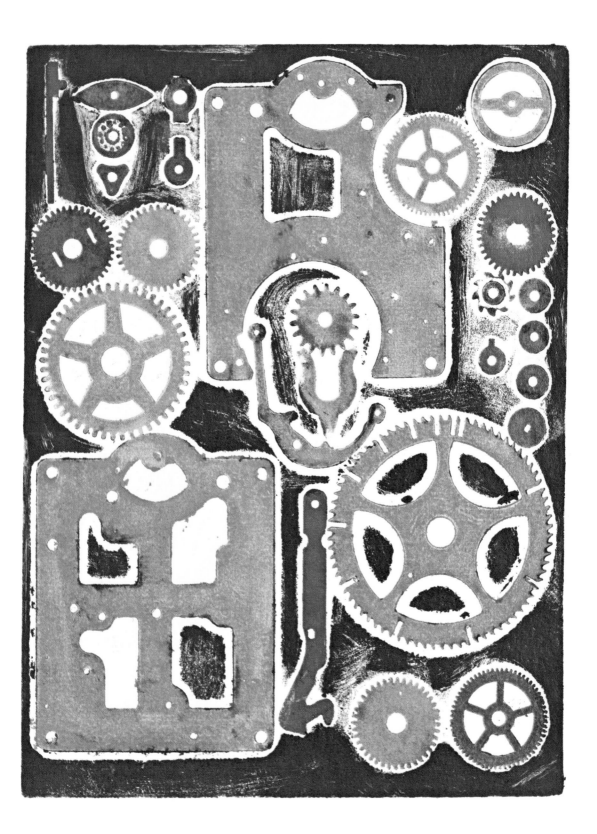

84

EMBOSSED PRINT

Erosion

To emboss means to decorate or cover with designs or patterns raised above the surface. Laymen are familiar with examples of commercial embossing on paper in such items as paper napkins, valentines, letterheads, and in the seals used on important official documents.

The technique, while not new in the field of printmaking, was never very popular or widespread. It is, however, currently in vogue among *avant-garde* graphic artists. The first use of embossing in printmaking occurs in work of the eighteenth-century Japanese, who used it in conjunction with a full-color image to produce texture. Embossing in connection with printmaking does not appear in Europe until the end of the nineteenth century, when a few examples appeared in a French publication. Other than commercial applications, nothing significant was produced until contemporary printmakers such as Harold Paris, Ezio Martinelli, Leonard Baskin, Rolf Nesch, and others started to experiment.

Presumably any system which involves building up or lowering a surface into which damp paper can be molded may be used to produce an embossed print. A variety of terms is used to identify what may be either an inked or uninked embossing. Some of the terms in use today are *embossed print, inkless embossed, gauffrage, glyptograph, inkless intaglio, and embossed intaglio.* Several techniques are used to build up a metal plate, creating a bas-relief. One method of raising the surface of the plate is to build it up with patterned layers of cardboard and then coat it with a layer of glue and gesso. Boris Margo, in another method, carves into celluloid sheets and then coats them with copper. These are then stamped, uninked, into paper. Michael Ponce de León anchors such crude materials as pebbles and chains to a metal base which he then stamps into thick, dampened paper, using his hydraulic press capable of exerting five tons of pressure. The epoxy print, named and developed by Harold Paris, uses still another method of making a plate for embossing. The raised design is built up on a metal plate with a hard epoxy

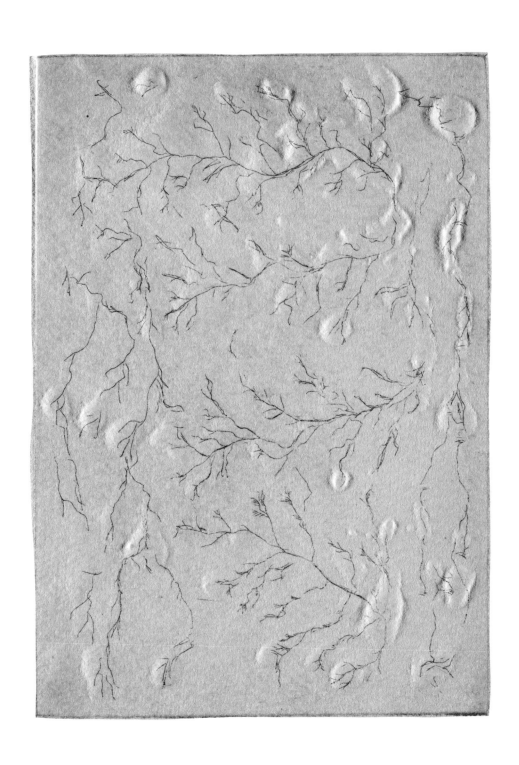

glue which can be molded, cut, and fashioned to suit the artist's needs. Over this raised surface is placed a dampened sheet of heavy paper covered by a thick layer of felt, and then plate and paper are subjected to great pressure in a press. On drying, the paper duplicates the form of the plate on which it was pressed.

The embossed print included here was produced by first printing a very light line etching. After the ink had dried, the paper was redampened, and the print was run through the etching press a second time on a plate which had been built up by brazing pewter to a copper base. No. 84a is a specimen of inkless embossing made from the plate used in producing print No. 83.

85

COMBINED PROCESSES

The Square

In 1835 George Baxter had patented a process for making prints that would imitate oil paintings. His aim was to popularize art through a wide distribution of cheaply priced prints. An aquatint or mezzotint served as the foundation over which as many as twenty colors were printed, using a separate wood block for each color. His technique was the forerunner of the combined-processes methods used today.

This print is a combination of all three basic printing processes. Linoleum blocks, a lithograph, and a combined etching-engraving were printed to produce a single visual image. The four colors were relief printed from separate linoleum blocks on a proof press. To produce the shaded areas, a metal lithograph plate was prepared and then printed on a lithograph offset press. The last step was the addition of the line work achieved by overprinting intaglio on the colors and shaded areas with an etched and engraved plate. During all these various steps the paper was kept damp. The blocks and plates were all produced by the traditional methods described elsewhere in this volume.

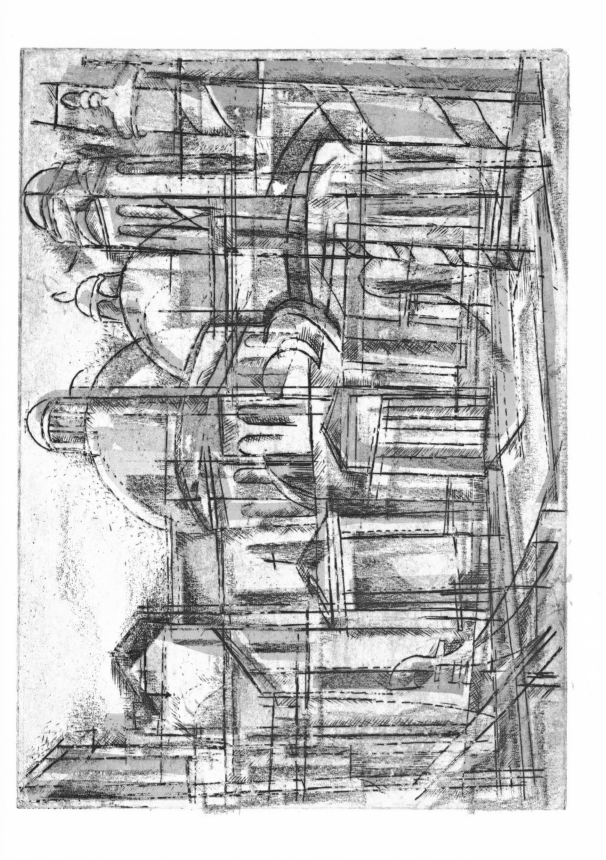

CHILDREN'S PROCESSES

This category of prints deals with a group of techniques suitable for children of grade-school age. However, this is not to imply that they cannot be used profitably by older students. Their chief value for use by youngsters, other than the purely creative aspects, lies primarily in that expensive equipment is not necessary and that the techniques are adaptable to those of limited skills. The size of the prints in this set is small and was determined by the format of the work as a whole, but there is nothing inherent in the techniques themselves that should prevent youngsters from producing much larger examples.

Printmaking methods suitable for children are also to be found in the other sections of this text. Linoleum cuts and monotypes are cases in point; they have not been included in this section because they are so widely employed by the professional.

86

HAND PRINT

Personal Data

This first printing technique offers children an excellent opportunity to release some of their pent-up physical energies in a nondestructive way. Watching youngsters at play, one observes that stamping their hands and feet is as natural as breathing. What child with wet or muddy hands has not been tempted to push them against a clean, clear surface? Hand stamping is an exercise producing images using ink and paint rather than mud. One color may be used, or several. The fingers, entire hand, or both hands may be employed. The technique allows some control, and with care, simple pictorial forms can be produced. Once a satisfying image has been made, it should be possible to repeat it. In this example three colors were applied using the side of the fist, the knuckle, and the finger tips.

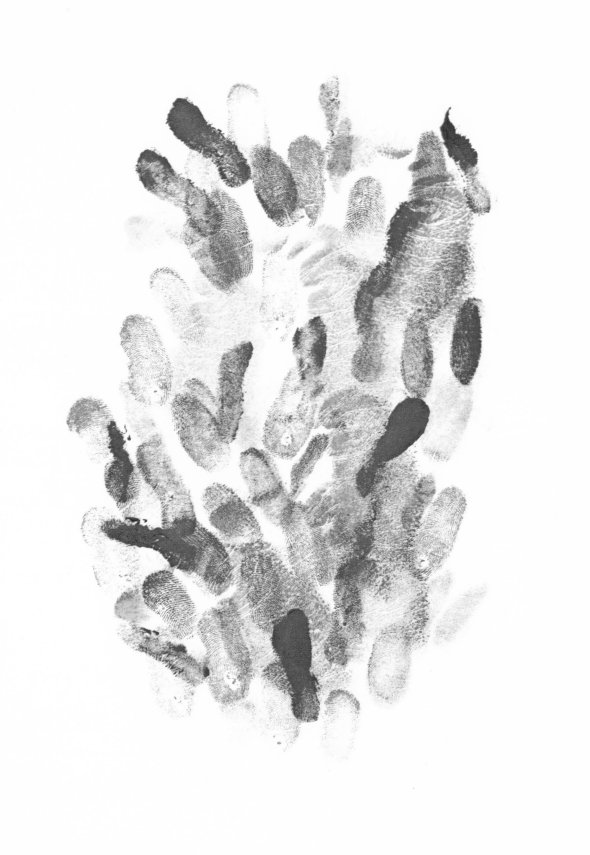

87

POTATO PRINT

Bugs

In the past forty years, millions of potatoes have been sacrificed to the cause of art. Potato prints, invented by some unsung hero, have been turned out by the schools in incredible quantities. All that is needed is a good, solid potato. Cut it in half, and the white flat surface can be incised with a variety of metal implements to remove the background. Simple designs can be scratched on the surface of the potato, and when the background has been removed the high areas of the potato can be used in the same way that a rubber stamp is used. The traditional stamp pad, in this case, can simply be a piece of folded cloth or several thicknesses of newspaper soaked with poster paint, or a small saucer containing a thick mixture of opaque water color or water-based inks. Prints can be produced in one or more colors.

A large potato was used to make this print. The face of one half was used to print the gray areas. The face of the other half produced the shape for the red splotches, and the edge of the same half gave the brown lines. The potato was very firm at the start; by the time fifteen prints had been made, it started to soften and a definite loss of form was perceptible.

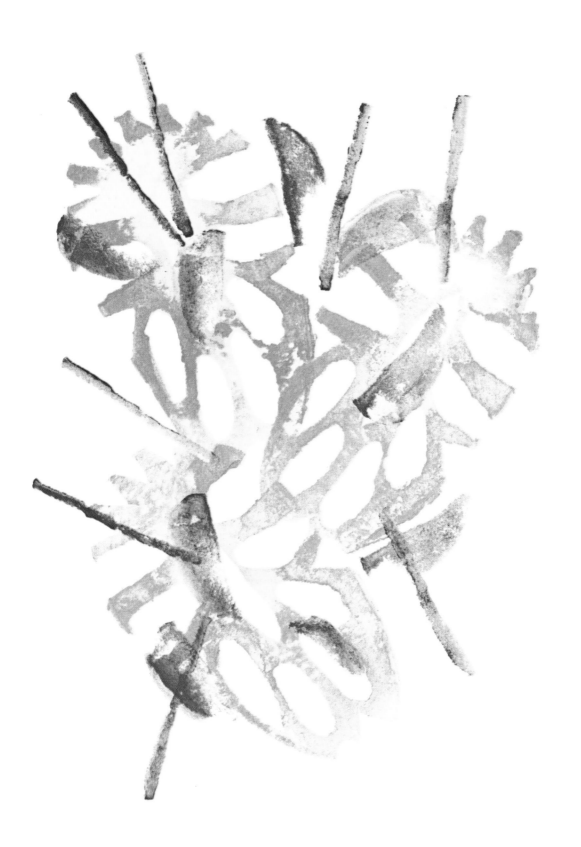

88

STAMPED PRINT

Spring Downtown

This process yields a more complex print, and it has been produced not by increasing the technical problems but simply by expanding the range of stamps employed and combining them into one visual whole. Such diverse objects as balls of twine, leaves, bits of bark, and many other textured materials make it possible to produce effects of wide variety. The possibility of using nature materials for imprinting goes back to the early fifteenth century when the so-called nature prints were produced by blackening leaves with soot from a flame, placing a leaf sooty side up, and rubbing the back of a piece of paper placed over the leaf to produce the impression. These were not very durable, and it was not until the mid-nineteenth century that printers developed the technique of impressing the leaves and other materials into soft metal plates from which electrotypes were made that could be employed on commercial printing presses. The motives underlying these methods were in the interest of science rather than art, but it is revealing that sometimes what is considered a contemporary technique or device may actually have its roots buried deep in the past.

To create the print, several small blocks of wood, a cedar spray, and the end of a small metal tool were used as stamps. These were inked with a brayer and then individually stamped on the paper.

OTHER SUBSTITUTE MATERIALS

String prints are made by wrapping string, twine, or cord around the cylinder of an inking brayer. If this is done so that the strings cross over each other, a wide variety of patterns can be obtained. Prints are produced by rolling the string-covered brayer first on the inking slab and then on paper. Hand stamps are constructed by wrapping cord or twine around small, flat blocks of wood. These can be inked in the same manner as a rubber stamp; or, if they are large blocks, they can be inked with a brayer and impressions obtained by use of a press.

228

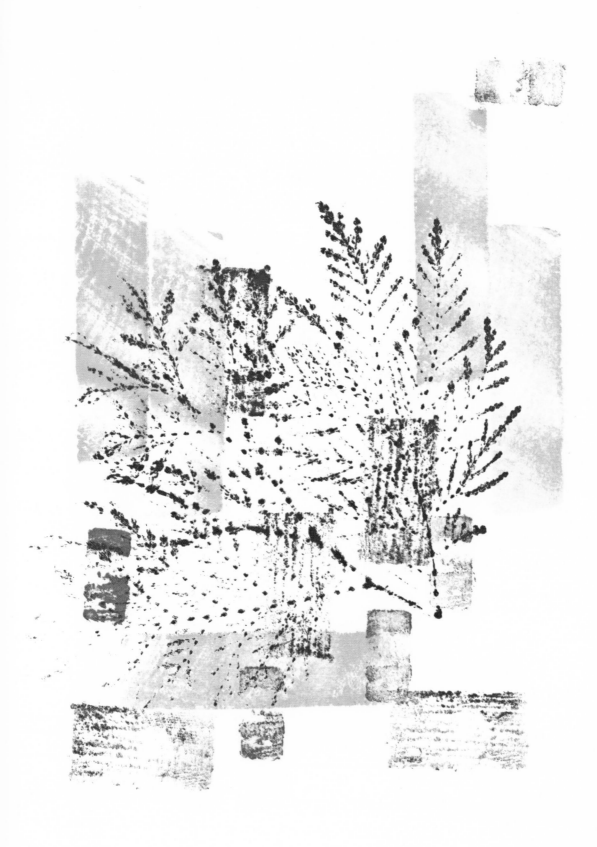

Stick printing done by children for a long time utilized the ends of small square, round, or triangular sticks which were inked one by one and then pressed on the paper to create the patterns. Usually squared paper was furnished to help the youngsters stay in line. A variation of this method is now used in which match sticks are glued to a small block of wood to create a design. The block is then inked and stamped to create either repeat patterns or individual pictures.

Blocks for printing can also be made by driving various-sized nails part way into a block of wood. They must be driven in so that the heads are of uniform height. Ink is applied to the heads and these blocks are then printed by hand stamping.

89

CLAY PRINT

Garden

These prints are simple to make and offer possibilities for graphic expression to the very young. A wood frame about one inch high and the size of the print is laid on a flat surface. Moist clay is then pressed within the confines of the frame, which is later removed, and rolled flat. This gives a printing surface into which, while damp, can be pressed all manner of objects to create an indented pattern. When a satisfactory design has been achieved and the clay has dried, a brayer is used to apply oil paint to the plane surface of the clay. The paper is placed down on this and rubbed by hand to produce the print. In the present example, the following items were impressed into the clay: a pliers, scissors handle, bottle tops, and pieces of wire and wood.

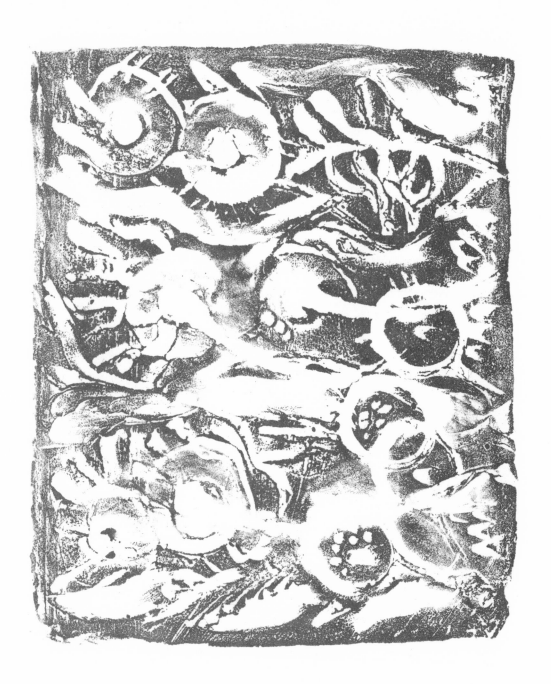

90

CLAY PRINT, MODELED

Phantom Shapes

To produce a variation of this technique, the clay can be modeled into shapes much in the manner of the old-fashioned gingerbread cookies. These individual forms, made in the shapes of people, simple animals, or trees, can then be arranged on a firm surface to create the fundamental design.

For this print the clay was flattened out prior to cutting and forming into shapes. A small pointed stick was used to incise a linear pattern on these forms, giving some interest to areas that would otherwise have been silhouettes. Printing follows the same method used in No. 89.

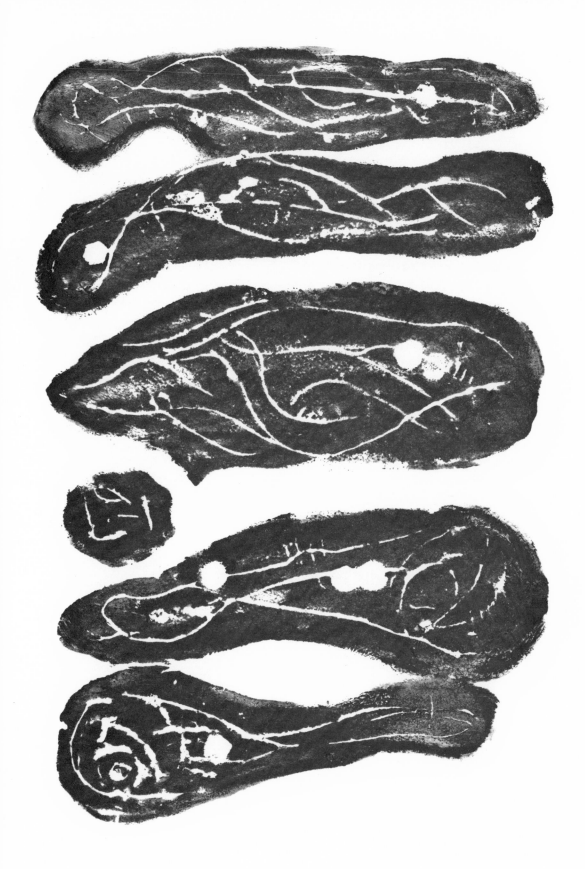

91

PAPER PRINT

Umbrellas

Towards the end of grade school most youngsters have had considerable experience in working with cut and torn paper. Consequently, applying these skills to create prints should offer no difficulties. To make paper prints a firm surface is needed on which the cut and torn shapes can be pasted. The print size is determined by this base. After the forms have been mounted and dried, the block is inked with a brayer.

In the example shown, the shapes were cut from heavy drawing paper and glued to a piece of thick cardboard. The paper was just thin enough to allow the brayer to ink not only its surface, but also to reach the background areas. However, the edges of the paper shapes held the brayer away from the background that immediately adjoined them, causing a light area around each form. Impressions were taken by rubbing the back of the printing paper with a spoon.

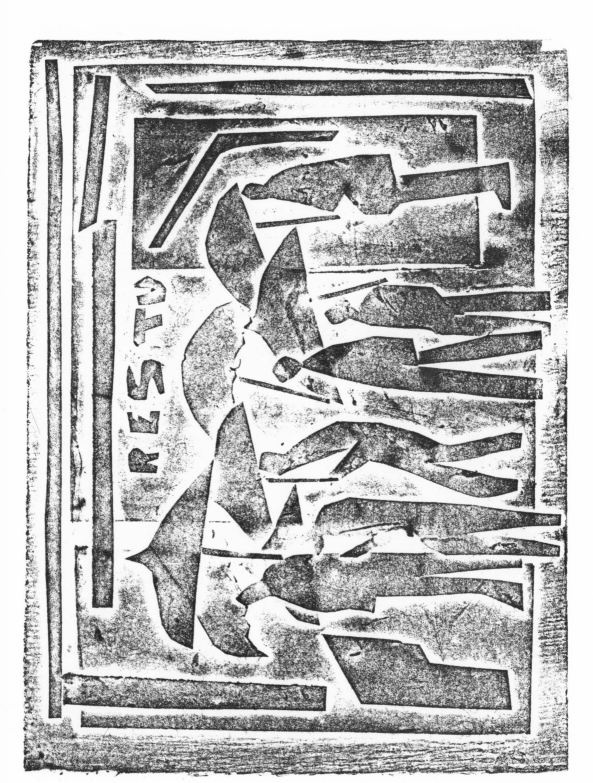

92

TEXTURE PRINT

Split Peas

A variation of the preceding is the texture print. The difference lies in that a variety of surface textures have been employed to create patterns. The printing block for this process was a plywood panel on which were mounted split peas, string, cheesecloth, emery paper, and bits of varied-textured fabrics. Plastic wood was also used in some areas to create a rougher surface. All of the loose materials were held in place with Elmer's Glue-All. Inking was done with a brayer, and the impressions were made by hand rubbing. Because of the irregularity of the printing surface, a fairly tough paper was used.

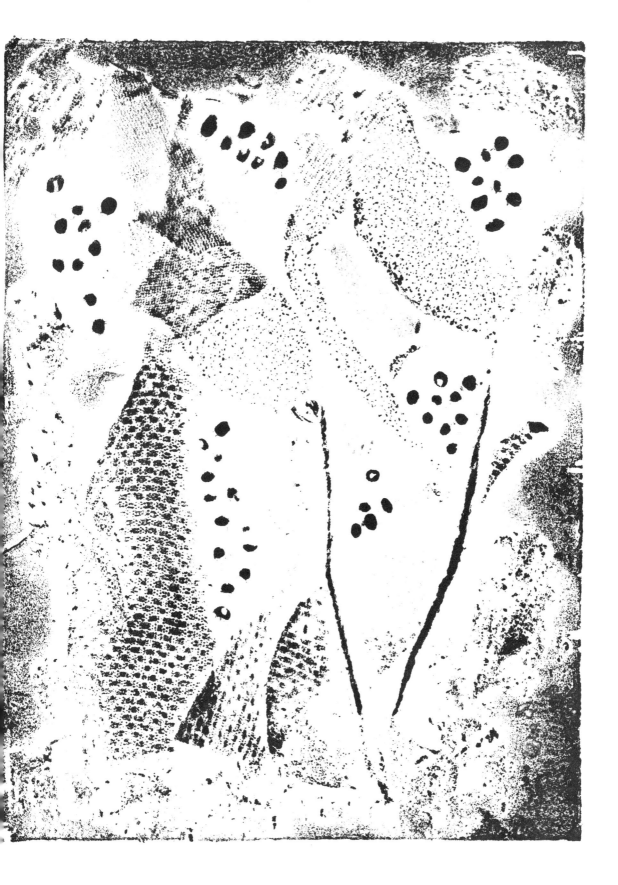

93

RUBBING

Griswold

Before television, children often amused themselves by placing a piece of paper over an old Indian-head penny, rubbing over it with a pencil, and watching in fascination as the Indian's face appeared on the paper. In this simple process of printmaking a variety of textural surfaces is substituted in lieu of the penny, and the rubbing is produced with colored crayons rather than a pencil.

The materials used for textures in this print were: a section of a weathered wood beam, the bottom of a skillet, and an old, handmade brick. Ordinary wax crayons were used for rubbing. For another method of producing rubbings see the description for print No. 75.

An interesting variation of the rubbing technique developed by Erik Hoberg uses, in place of other textured materials, a woodcut block which has had a design cut in the surface. Paper is held in place firmly on the uninked cut, and wax crayons are used to make the rubbing. After the colors have been applied, black water color is brushed over the entire surface and, being resisted by the wax, is deposited only on the clear areas of the design. Once the water color has dried, the print is pressed with a warm iron, which fuses the crayon and water color and completes the process. Brilliant color and strong contrasts are possible when this technique is used. Still another variation is to arrange any materials that are relatively flat, such as leaves, grasses, or cloth, to create a pattern. Over these is placed a sheet of paper. In this case the textured design is obtained by rolling a lightly inked brayer over the surface of the paper.

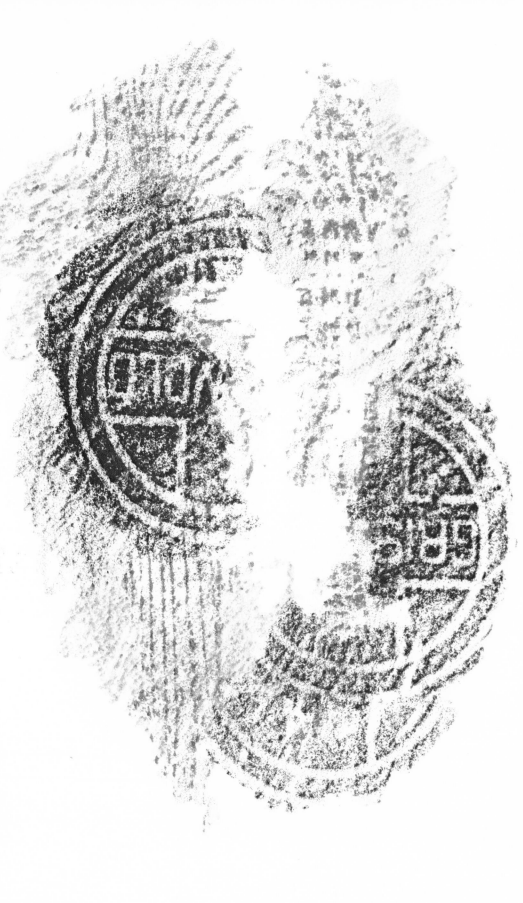

94

STENCIL PRINT

Rotten Stump

Two simple types of prints can be produced using the stencil technique. In the first, a shape is either torn or cut from the center of a piece of paper or cardboard. This is then laid on another sheet of paper. Color is applied by brush, roller, or spray to produce the final print. This is a cutout stencil in which the image is in color.

The second, or pattern stencil, is just the reverse. In this type of stencil, cutout shapes of paper or cardboard are placed on the printing paper where they serve as masks. After the color is applied around the edges of the stencil, it is removed, and the image is revealed as a silhouette the same tone as the paper.

This stencil print demonstrates the use of both methods, the cutout and the pattern. Color was applied with brushes and a brayer using printing ink.

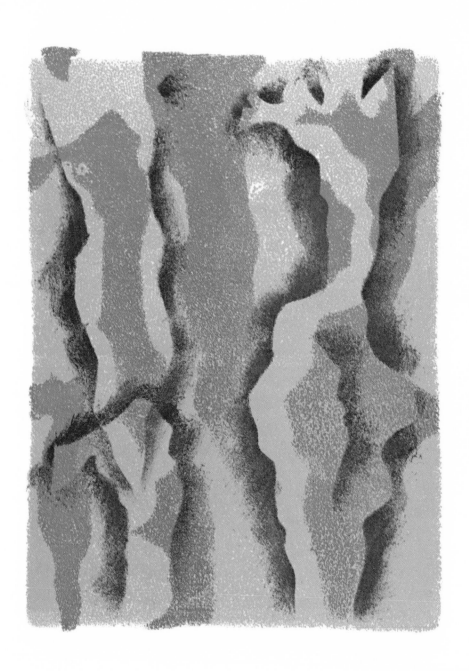

95

SCREEN PRINT

Industrial

This technique stems directly from the silk-screen and serigraph methods employed by professionals. The silk-screen method is basically an improved form of stenciling. For children simple materials and techniques are important. The basic equipment is a wood frame or an embroidery hoop over which is stretched a piece of silk, organdy, or cheesecloth. Nonporous material is anchored to this surface, creating a pattern. The screen frame is then placed over a piece of paper, and paint or ink is forced through the open mesh of the screen with a squeegee. The nonporous areas prevent color penetration at these points. Various materials can be employed to block out areas of the screen. Patching fabric can be ironed on the surface; masking tape, cut or torn, can also be used. Another method is to use newsprint shapes which adhere to the frame with the ink used in printing.

The example shown is a five-color screen print. All of the above-mentioned materials were used as blocking agents in the production of the five screens. In making some of the screens the inking was around certain blocked-out design areas, while in other screens the inking was through perforations in a block-out sheet of paper. The printing was executed with screen inks.

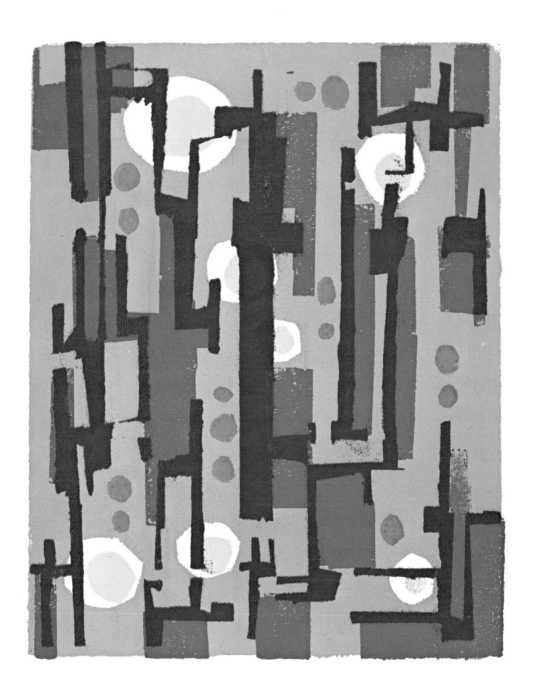

96

TRANSFER MONOTYPE

Tools and Machines

Transfer monotypes are sometimes called transfer drawings even though the monotype principle is the basis of the method. A metal or glass plate is first rolled with a smooth, thin layer of printer's ink; in the present case black ink was used. The paper to be printed is placed on the freshly inked area of the plate. Drawing or making the transfer is accomplished by marking on the reverse side of the paper with a dull-pointed tool. By rubbing with the thumb or a spoon it is possible to produce a limited range of tones. Not too much pressure is needed to achieve the desired transfer. In this print a Japanese paper was the selection for the final print. The pointed end of a paintbrush handle was used to create the line pattern.

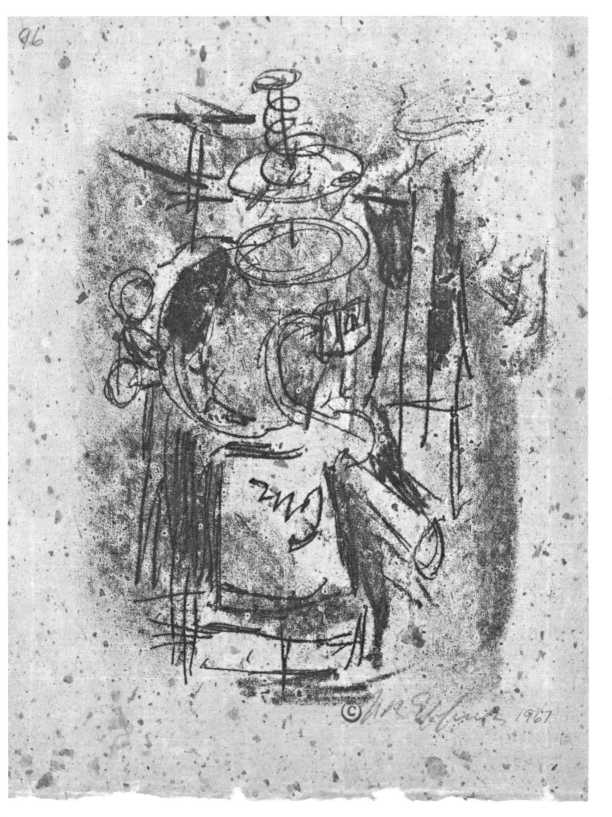

97

FLOATAGRAPH

Dancers

Marbled paper has for a long time been associated with the making of books, in which it was used for covers and end papers. The original process is rather complicated, but it has the distinct advantage that the design can be controlled. This is a process that is limited to the making of decorative papers and is described in detail in bookbinding texts.

In the easier substitute method, which is the basis of this print-making technique, the accidental plays an important part. A drawing is first established and applied to the paper with a brush and rubber cement. In the meantime, a large tray is filled with water, and on this surface oil colors thinned with kerosene and vinegar are floated and manipulated with a brush or stick to simulate the graining of marble. As soon as the color pattern is established, the paper is carefully placed on this surface. The oil paint will adhere only to those areas not blocked out with cement. Upon drying, the rubber cement is removed. Depending on the design, successive blocking-out stages could be undertaken to create a highly complex print. In this print the simple pattern needed only one blocking out.

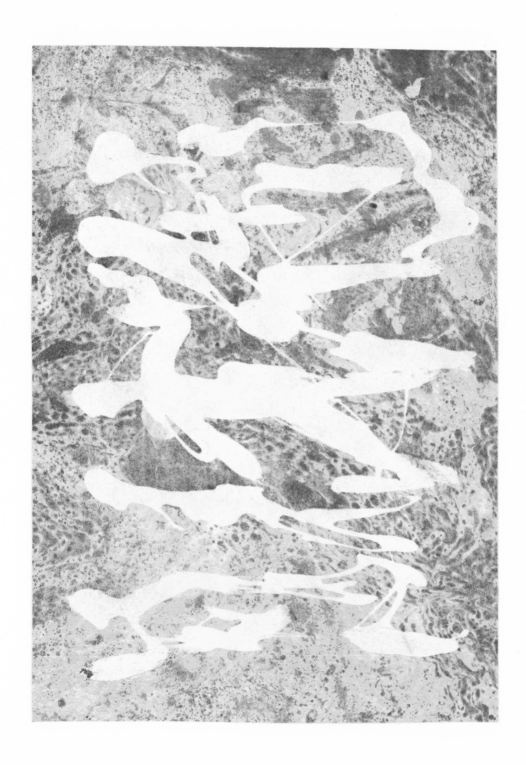

98

FOIL PRINT

Twigs and Pebbles

The image is made on a sheet of copper foil which is temporarily stapled to a very stiff piece of cardboard. With a blunt tool, such as an orange stick or a large nail, the design is drawn with firm enough pressure to make a definite groove or depression in the foil. If ink is applied to the side with the indented lines and the surface then wiped off in the intaglio manner, some ink remains in the lines. Soft paper is applied and rubbed by hand to force the paper into the grooves. If the foil is then removed from the cardboard and turned over, the raised lines on that side can be inked with a hard rubber brayer and printed by hand pressure in the relief manner. The print shown here is an example of the latter method.

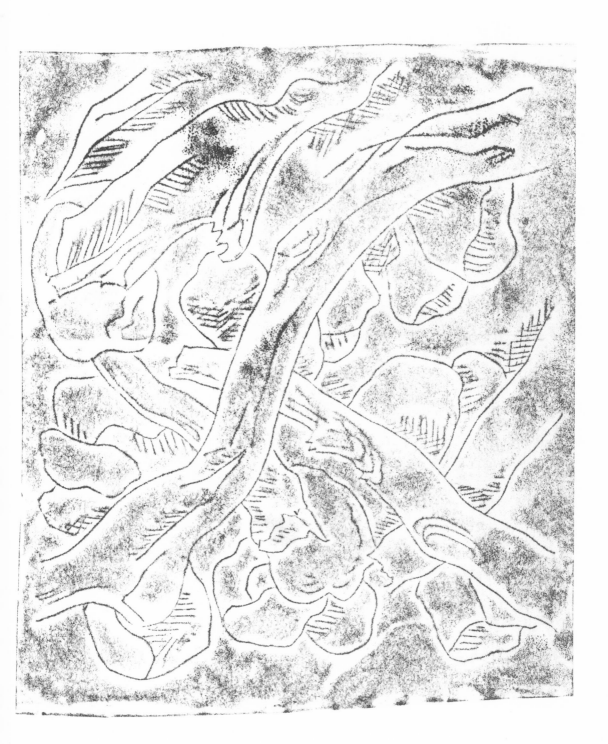

99

GLUE PRINT

Still Waiting

In this technique a hard surface, such as a piece of stiff cardboard or Masonite, is needed. On this base a drawing is produced by using either airplane glue or rubber cement. The material is applied directly from the tube. When this is thoroughly dry, the surface can be inked and printed by the usual rubbing methods. *Still Waiting* is a two-color print; the black was printed using rubber cement as the printing surface, and the olive green was printed from a plate prepared with airplane glue.

A variation of the glue technique was introduced in Massachusetts by Professor George Swinton of the Smith Day School. In this technique a mixture of rabbit-skin glue is mixed with molasses. The mix should be syrupy in consistency and, when poured over a glass slab, should jell almost immediately. When set, the design is cut into the jelled surface. Those parts which are not to print can be peeled from the glass. The design remaining on the glass is inked and printed in the relief manner.

Another way of building up a relief surface is suggested by Peterdi in his book on printmaking. The design is painted on firm cardboard or Masonite with enamel. Before it sets or hardens, sand or sawdust can be squashed into this wet area to build up a relief pattern. Upon drying, the drawing can be further refined by cutting or sanding.

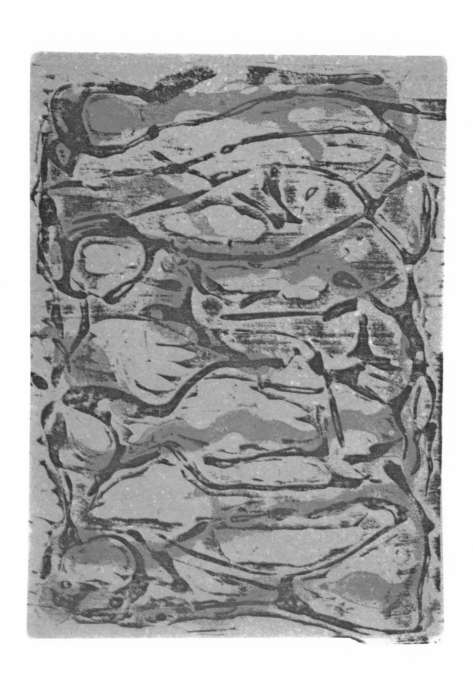

100

PLASTER RELIEF PRINT

Nets

This technique is very popular with children. In this method the printing base can be prepared in two ways. A mixture of plaster of Paris can be spread out on a piece of Masonite or stiff cardboard. It should be smoothed out and allowed to dry. This is the simplest way to produce the printing surface. The second technique, which is capable of producing a smoother base on which to produce the drawing, is made in the following manner: a simple one-inch-high wooden frame the size of the print is placed on a sheet of glass; plaster of Paris is poured into this frame onto the glass base; after drying, the plaster can be removed and the smooth surface next to the glass used as the printing block.

Whichever method is employed, the plaster surface, after drying, should be painted with black ink or black water-color paint. A pointed tool, such as a nail, paring knife, or the end of a compass, can be employed to scratch the design or drawing into the plaster to create the image. The block used in this example was made from patching plaster, and the design was cut with an awl. Inking was done with a brayer and the impressions were made by rubbing with a spoon.

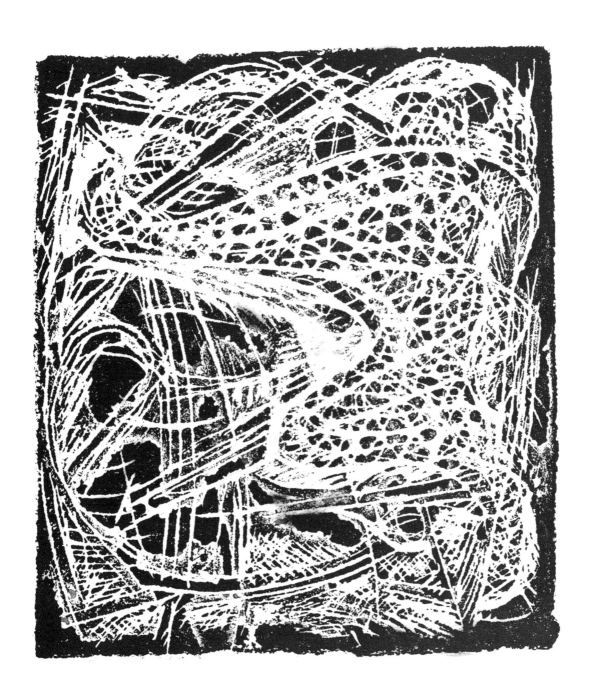

101

PARAFFIN PRINT

Chatter

Paraffin prints were first developed in 1928 by Shelby Schackleford as a novel and easy way of creating the effect of a wood engraving. The paraffin did not yield a large number of prints, but produced all that she needed for her work in book illustration. Photoengravers prepared plates from these original prints for commercial printing methods. Her prints have been displayed in professional galleries, but the ease of cutting makes this technique particularly suited to youngsters. Therefore it is included in this group.

The first step is to prepare a small wooden frame about one-half inch high. This is placed on a flat surface. Paraffin is melted, poured into the frame and left to harden. A little scraping and polishing with a cloth produces a glasslike surface on which to engrave or cut. Any of the woodcut or engraving tools may be used. After the drawing has been made, it is inked with a soft brayer, using standard printing ink. The paper is placed on the surface, and the print is obtained by rubbing. One aspect of this technique which is difficult to control in other relief processes is that light gray tones can be produced by partially removing the ink from the surface of the paraffin with a cloth. The slippery nature of the paraffin makes this possible and gives another tonal dimension to the print.

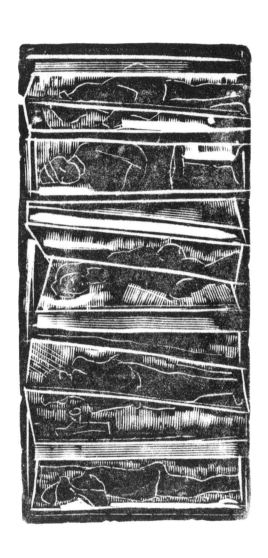

SELECTIVE BIBLIOGRAPHY

For more precise information along technical lines it is suggested that the reader consult the following selective bibliography.

AUVIL, KENNETH W. *Serigraphy*. Prentice-Hall, New York, 1965.

BIEGELEISEN, JACOB ISRAEL, and E. J. BUSENBARK. *The Silk Screen Printing Process*. McGraw-Hill, New York, 1941.

————, and MAX ARTHUR COHEN. *Silk Screen Stenciling as a Fine Art*. McGraw-Hill, New York, 1942.

BLAND, DAVID A. *A History of Book Illustration*. The World Publishing Company, New York, 1958.

BLISS, DOUGLAS P. *A History of Wood Engraving*. J. M. Dent & Sons, London, 1928.

BLUM, ANDRE. *The Origins of Printing and Engraving*. Charles Scribner, New York, 1940.

BROWN, BOLTON. *Lithography for Artists*. University of Chicago Press, Chicago, 1930.

BUCKLAND-WRIGHT, JOHN. *Etching and Engraving*. Studio Publications, New York, 1953.

CAHN, JOSHUA BINION. *What is an Original Print?* Print Council of America, New York, 1964.

CURWEN, HAROLD. *Processes of Graphic Reproduction in Printing*. Faber and Faber, London, 1934. Rev. ed. Dover, New York, 1958.

DEHN, ADOLF A., and LAWRENCE BARRETT. *How to Draw and Print Lithographs*. American Artists Group, New York, 1950.

ELISOFON, ELLIOT. *Color Photography*. Viking Press, New York, 1961.

EVANS, RALPH M. *Eye, Film, and Camera in Color Photography*. John Wiley and Sons, New York, 1959.

Focal Encyclopedia of Photography. Focal Press, London, 1956.

GERSHEIM, HELMUT and ALISON. *The History of Photog-*

raphy From the Earliest Use of the Camera Obscura in the Eleventh Century Up to 1914. Oxford University Press, London, 1955.

GRIFFITS, THOMAS E. *The Technique of Color Printing by Lithography.* Faber and Faber, New York, 1948.

———. *The Rudiments of Lithography.* Faber and Faber, New York, 1951.

HAYTER, STANLEY W. *New Ways of Gravure.* Pantheon Books, New York, 1949.

———. *About Prints.* Oxford University Press, London, 1962.

HELLER, JULES. *Printmaking Today.* Henry Holt, New York, 1958.

HIND, ARTHUR M. *Guide to the Processes and Schools of Engraving.* British Museum, London, 1933.

———. *A History of Engraving and Etching.* Dover Publications, New York, 1963.

———. *An Introduction to a History of Woodcut.* 2 vols. Dover, New York, 1963.

HOFER, PHILLIP, ed. *The Artist and the Book.* Harvard Department of Printing and Graphic Arts, Boston, 1961.

IVINS, WILLIAM M. *How Prints Look.* Metropolitan Museum of Art, New York, 1943.

JOHNSON, UNE. *Ten Years of American Prints: 1947–1956.* Brooklyn Museum, Brooklyn, N.Y., 1956.

LUMSDEN, ERNEST S. *The Art of Etching.* Dover, New York, 1962.

MAN, FELIX. *150 Years of Artists' Lithographs.* Heinemann, London, 1953.

MAYOR, A. HYATT. *A Guide to the Print Collections.* Metropolitan Museum of Art, New York, 1964.

MORROW, B. F. *The Art of Aquatint.* Putnam's, New York, 1935.

MUELLER, HANS ALEXANDER. *Woodcuts and Wood Engravings: How I Make Them.* Pynson Printers, New York, 1939.

NEWHALL, BEAUMONT. *The History of Photography.* Museum of Modern Art, New York, 1949.

OTA, KOSHI. *Printing for Fun.* McDowell, Obolensky, New York, 1960.

PETERDI, GABOR. *Printmaking: Methods Old and New*. Macmillan Co., New York, 1959.

PHILLIPS, WALTER J. *The Technique of the Color Woodcut*. Brown-Robertson, New York, 1926.

PLATT, JOHN. *Colour Woodcut*. Pitman, New York, 1938.

POLLACK, PETER. *The Picture History of Photography*. Harry N. Abrams, New York, 1958.

RASMUSEN, HENRY. *Printmaking With Monotype*. Chilton Co., New York, 1960.

SACHS, PAUL J. *Modern Prints and Drawings*. Alfred A. Knopf, New York, 1954.

SHOKLER, HARRY. *Artists Manual for Silk Screen Print Making*. Tudor, New York, n.d.

STADLER, OLIVER. *Modern Japanese Prints*. Charles E. Tuttle Co., Rutland, Vt., 1956.

STEPHENSON, JESSIE BANE. *From Old Stencils to Silk Screening*. Charles Scribner's Sons, New York, 1953.

STERNBERG, HARRY. *Silk Screen Color Printing*. McGraw, New York, 1942.

STUBBE, WOLFE. *Graphic Art of The Twentieth Century*. Praeger, New York, 1963.

TRIVICK, HENRY H. *Autolithography, The Technique*. Faber and Faber, London, 1960.

WHEELER, MONROE. *Modern Painters and Sculptors as Illustrators*. The Museum of Modern Art, New York, 1936.

ZIGROSSER, CARL. *Six Centuries of Fine Prints*. Garden City Publishing Company, New York, 1939.

———. *Prints*. Holt, Rinehart and Winston, New York, 1962.

At work making one of the prints on the etching press.

ABOUT THE BOOK

Something about the background, range, and scope of *101 Prints* is given in the author's Introduction (pages 3–8), but additional comments on the unique nature of the original and the efforts to reproduce it may be of interest.

The original *101 Prints* was published in an edition limited to fifteen copies, and the location of fourteen of the fifteen originals is given in the Introduction. This edition is reproduced from one of the originals, the set owned by the Topeka Public Library.

The edition which you hold in your hands may properly be called a "book." There is some doubt, on the other hand, about the accuracy of the term "book" in describing fully the originals. Each of the fifteen originals was, for want of a better term, a "set." Each set was enclosed in a specially designed and constructed slip case or box, some of cardboard and some of birch plywood, with two major "sections." One section contained the text; the other, the prints.

The text was set in type (by hand) and printed in four-page forms, folded in eight-page signatures, gathered or collated, and together comprise one of the major sections.

The prints, comprising the other section, were a collection of originals, each produced individually, separately, and by 101 different processes. Each print was placed in a transparent plastic envelope, for protection.

For many reasons, it was impossible to reproduce this edition by the methods and in the form of the originals. The originals are enough to defy imagination. As one reader of an original set said, "If I didn't see it, I wouldn't believe it. If someone told me he planned to describe all the print techniques known, I would tell him that the idea of having all that information in one volume is a good one. If he told me that he planned to show examples of each technique, I would have to express some reservation about obtaining and reproducing 101 examples. If he told me that he planned *to produce 101 prints*, each illustrating the

261

different methods, I would tell him to forget it. Nobody in his right mind would undertake such a project. It's the one-of-a-kind of thing that has to be measured in man-years, not man-hours. But here it is. It should be published (or somehow made available in a form suitable for distribution) for those interested in print history and methods. In saying that, however, I know, as you must, that it couldn't be published with all the originals, that the effect of the originals could only be approximated, and that the problems of doing that would be formidable indeed."

Without counting the years of background, experience, and training to undertake a project of this magnitude, the author says of the original edition:

> This book has been almost five years in the making. There have been two trips to Europe and several months' research in New York City. Most of the writing and art was done during summers in Wisconsin, while winters were devoted to the production part of the job, besides carrying on the usual work of running an art department, in Emporia.
>
> Printmaking, printing of the text, and binding were all done by me with the assistance of the individuals mentioned in the text. The fundamental aim was to produce a convenient, useful, and exciting reference tool using nothing but the finest materials available both for appearance and durability. The binding, done by hand and sewn on raised cords, features an oasis morocco leather back and gray washable binders cloth and has hand-sewn headbands. The special dustproof box is constructed of birch plywood nailed and glued and covered with gray binders cloth.
>
> Four cameras, three enlargers, three binding presses, and five kinds of printing presses were used. And there are nearly fifty kinds of paper used in the project including the all-rag handmade paper used for the text itself.

The problems of producing the present edition from the original were indeed formidable. The production details were, to say the least, challenging. A basic plan was worked out, with continuous modification of details throughout every step, sometimes by trial-and-error experience, sometimes by realizing before it was too late that a particular approach would produce an unsuitable result.

The most striking difference between this edition and the original

One of the "sets" of the original fifteen-copy edition, showing the text and, separately, the loose prints.

is the general appearance of the "package." The original is in two major parts, text and prints. This edition has the text and the prints together, in one volume, with the reproduction of each print facing the text which describes it. A preliminary plan to produce the book in two volumes, with the text in one volume and the prints in another, was abandoned, because one volume would be easier for the reader to handle. It was also concluded that it would be more "relevant" to have the text facing the print. Major aspects of the production of this edition include the following:

TYPOGRAPHY: The text was set on the Linotype in twelve-point Caslon on a fourteen-point body in the Printing Division of the University of Oklahoma Press. The main heads (titles) were set Monotype by Jaggars-Chiles-Stovall, Inc. of Dallas in eighteen, twenty-four-,

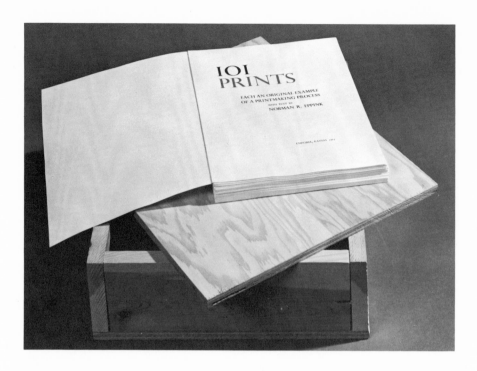

The original text, in unbound forms, and the plywood box made for the whole "package." (PHOTOGRAPH BY JOHN NESOM)

and thirty-point Times Roman—all of which are approximations of the Perpetua face of the original edition.

ENGRAVINGS: The engravings from which the embossing was done for the printing of letterpress-printed pages were by United Graphics Incorporated of Tulsa.

OFFSET NEGATIVES: The camera work, stripping, and platemaking for the offset-printed pages were done by the Printing Division of the Press and by United Graphics Incorporated.

All the printing was done by the Printing Division of the University of Oklahoma Press, mostly by offset. Through the use of only two printing processes, letterpress and offset, and a combination of the two, an effort was made to achieve the effect of the original prints.

INKS: Two shades of black, the conventional process inks (process

264

black, magenta, yellow, and blue), and five flat colors were used. In addition, some illustrations were "printed" without ink to try to approximate the "impression" of the original prints, and a separate press run was made to varnish certain pages.

PAPER: For the original fifteen-copy edition, only the text was printed on anything resembling a standard sheet, with the prints themselves being on almost 101 different kinds of paper, everything from photographic paper to high-rag-content handmade sheets of various shades and hues. For this edition, three kinds of paper were used: 70# Mohawk Superfine Softwhite, 70# Mohawk Superfine White, and 50# Kromekote Cover, coated on one side.

BINDING: The printed sheets were shipped to Kingsport Press, Kingsport, Tennessee, where they were cut, collated, sewn, cased in, and slipcased. The book has a three-piece binding, with Columbia Mills' Hopsacking on the front and back covers and Riverside Vellum on the spine.

Between the typesetting and slipcasing of the finished book were 101 hundred details.

INDEX

All numbers are page numbers